BILLION DOLLAR PAINTER

BILLION DOLLAR PAINTER

The Triumph and Tragedy of

THOMAS KINKADE,

Painter of Light

G. ERIC KUSKEY

with Bettina Gilois

WEINSTEIN
BOOKS

NOTE TO READERS: In recounting the events in this memoir, chronologies have been compressed or altered and details have been changed to assist the narrative. Where dialogue appears, the intention was to re-create the essence of conversations rather than verbatim quotes. Names and identifying characteristics of some individuals have been changed.

Printed in the United States of America

Library of Congress Cataloging-in-Publication Data is available for this book.
ISBN 978-1-60286-244-9 (hardcover)
ISBN 978-1-60286-245-6 (e-book)

Published by Weinstein Books
A member of the Perseus Books Group
www.weinsteinbooks.com

Weinstein Books are available at special discounts for bulk purchases in the U.S. by corporations, institutions, and other organizations. For more information, please contact the Special Markets Department at the Perseus Books Group, 2300 Chestnut Street, Suite 200, Philadelphia, PA 19103, call (800) 810-4145, ext. 5000, or e-mail special.markets@perseusbooks.com.

Editorial production by *Marrathon* Production Services. www.marrathon.net

Book design by Jane Raese
Set in 12-point Dante

FIRST EDITION

2 4 6 8 10 9 7 5 3 1

FOR MY FATHER,

whose writing has always inspired me

Contents

Preface

They say a picture is worth a thousand words.

This is a story about a picture worth four billion dollars.

It is the unbelievable true story of Thomas Kinkade, who grew an art empire from nothing but his talent, and I was there to witness it. It is a story of faith and the American dream, miracles and madness, addiction and greed in a business gone haywire; the most successful art business in the world. It is a story of one man, the Painter of Light, who painted cottages and trees, birds and brooks, glades and mountains, sunsets and oceans. You've seen his work in galleries and on calendars. He painted a world that does not exist; a world without trouble, a world without pain. A perfect world painted by one imperfect man, Thomas Kinkade, and it brought about his fall.

I worked closely with Thomas Kinkade for sixteen years. I was also his friend. Together we created a billion dollars in sales. And my experience of him is one I will never forget.

The story is still hard for me to tell. It's strange for me to step out from behind the curtain to tell this extraordinary story, but I feel it must be told. It's the story of a truly amazing rise to fame and fortune, the behind-the-scenes of which are hard to believe. It's the story of one man whose life journey was a miracle, and whose dreams, despite all the money and success, slowly destroyed him. And it is a story of warning for us all—not to forget that we are only human.

Prologue

Ten Almaden Boulevard is the most prestigious business address in San Jose, California. It towers over the downtown business district like a moored steam liner, with seventeen stories of glass and steel fronting the street, and a gaping three-story glass foyer that looks like it could swallow its visitors whole. Big corporate tenants like Merrill Lynch, Kidder Peabody, and Citibank have leased full-floor suites in this building. If you're at Ten Almaden, you're big time.

The day I arrived for a meeting in early May 1994, I wasn't going to visit a national brokerage firm or an international bank branch. I was going to visit the offices of a painter. But not just any painter: Thomas Kinkade, the Painter of Light. The only artist ever to be traded on the stock market.

I had driven my Volvo station wagon up from Santa Barbara and parked in the attached garage, taking the polished brass elevator to the ninth floor. From the minute the elevators opened, the opulence was staggering. Everything reeked of money. I had been an art rep for a few years, and had experience with licensing artists' images for greeting cards and calendars and many other products. I was used to making deals in cramped gallery offices, turpentine-smelling studios, and industry trade shows. Nothing could have prepared me for the wealth of this company. It had recently been renamed Media Arts Group Inc. from its previous name, Lightpost Publishing. The company's acronym, MAGI, gleamed on a polished stainless-steel plaque at the reception desk, lit dramatically with studio lighting. Everything did indeed seem magical.

A friendly young receptionist announced me over an intercom, and another smiling assistant approached and led me toward the conference room, where she said my meeting was already waiting for me. We walked across the marbled floors, through the warm cherrywood-paneled hallways with wainscoting and brass accents, beneath soft pools of gallery lighting, and past the long stretches of glass windows that afforded a stunning view of the entirety of San Jose.

I knew that Thomas Kinkade was staggeringly successful, but nothing had prepared me for the sense of limitless wealth that pervaded every inch of the Media Arts offices. There wasn't a single person in the art publishing business who didn't know the name Thomas Kinkade. I was in awe of him, and couldn't help but steal glances around the hallways in hopes of catching a glimpse of the Painter of Light.

When we reached the conference room, I was ushered to a thirty-foot glass conference table, upon which a silver tray of tall glasses with ice and a decanter of water stood. The three men on the other side of the table stood and reached out their hands to greet me. I shook everyone's hands, nodding to each.

"Eric Kuskey. Good to meet you."

Dan Byrne, senior vice president of marketing, a tall, burly guy with bushy hair and a grizzly bear's handshake, smiled an affable smile, pumping my hand vigorously.

"Welcome to the chocolate factory."

"Where's Willy Wonka?"

"Painting in the garden."

Marketing director Kevin Sacher, a robust man with a tousled head of hair, stood beside Dan. He had joined Media Arts from the Franklin Mint, and he and I had crossed paths a few times at the trade shows. Kevin, who had just moved to San Jose from Philadelphia, had called me to tell me he was working for Thomas Kinkade. I remember feeling a little jealous of his good fortune. I was an art representative and he said the company was seeking to diversify, and promised to bring me up at the appropriate time, so I could introduce the artists I represented. He kept his promise, and here I was. He shook my hand and

introduced me to Ken Raasch, who asked me to show them my samples. I sat down facing the three men and opened my briefcase to show them the work of one of my artists, Nancy Faulkner.

Ken Raasch was notably different from the other two. Dan and Kevin were midwesterners, with an understated quick wit and an ironic gleam in their eyes. Ken hailed from Northern California, and was dressed impeccably in a finely tailored Italian suit and stylish Italian shoes. His hair was perfectly coiffed, and his golden tan suggested a life of wealth and leisure. He had a stick of lip balm and a bottle of eye drops in front of him, and used them both repeatedly throughout the meeting. I displayed my transparencies, catalogs, greeting cards, and hundreds of color copies. Ken gave the materials his full attention; he said he was pleased with what he saw, while the other two men nodded approval. Ken said that they were adding more artists to their program to meet all tastes in the art market. He added that this could work out well for us all.

I glanced at Kevin, and he winked at me and smiled. Things were going well. Part of me couldn't believe it; to be invited to become part of Thomas Kinkade's company was like winning the lottery. It just didn't get any bigger than Thomas Kinkade.

"So, what is your business plan with adding new artists?" I asked.

Ken explained that Media Arts was expanding its roster in order to diversify. Since the company had gone public, the pressure to show a quarterly increase in profits was enormous. Ken believed that Media Arts could replicate Thomas Kinkade's success with other artists, and that diversification was the way to feed the Wall Street beast. He thought they had a winning formula that could be applied to artists of all kinds, meeting the different tastes of all kinds of art buyers.

Ken told me that he had recently acquired David Winter Cottages, a company that offered small collectibles by the famous British artist David Winter. The artist's miniature cottage company had been struggling for years, and in looking for new blood, Ken had acquired the sinking ship for a great deal. I was thrilled that this wealthy and well-resourced company was now interested in my artist. So why stop

at Nancy Faulkner? Media Arts wanted to expand into the collectibles business, and for good reason. The Bradford Exchange, a company that specialized in selling figurines and ornaments, collector plates and music boxes, was the biggest in the business, and Thomas Kinkade was their best-selling artist. As far as sales in collectibles went, Thomas Kinkade was considered superhuman. He was the one percent of the one percent; nobody sold like him. He was the Donald Trump of artists.

While Ken studied the portfolio, I decided to ask, "So, what other licenses do you guys have? Any other deals in the pipeline?"

Ken said they were more focused on growing the art business.

"The Bradford Exchange is your only license?" I asked, surprised. Ken responded that they didn't have time for licensing. I told him it seemed to me they could be doing a lot more than just licensing Kinkade's imagery with the Bradford Exchange. Ken listened with interest.

"I'd love to help you guys land some licenses, if you're interested," I said.

Ken considered for a moment and handed the materials back to me, saying they would give it some thought and be in touch.

We ended the meeting with pleasantries, and I felt it couldn't have gone better. We were all in our thirties, with growing families and eager to build our careers. At that moment, these three men seemed like the nicest guys in the world. I packed my materials into my briefcase and drove back to Santa Barbara, excited by thoughts of all the potential artists I might bring to this company.

But I wasn't prepared for the call I received a week later from Dan Byrne. He said there was good and bad news. The good news was that they were interested in my artist Nancy Faulkner.

There was a pause. I swallowed.

"What's the 'but'?"

Dan said that Ken was more interested in me. I was stunned, feeling light-headed with excitement.

Dan said Ken was offering that I become head of licensing at Media Arts for Thomas Kinkade. He also wanted to buy my company. It took me a moment to find the words.

"I don't know what to say. I'll have to talk to my wife . . ."

I could sense him smiling on the other line. We both knew I was in.

Within a month, I had convinced my wife to see the wisdom in the move. We rented out our house in Santa Barbara and found a place in Los Gatos, near the homes of Thomas Kinkade and Ken Raasch. I drove the family up to San Jose in the Volvo, my three kids strapped into their car seats, heading for our new adventure.

How much of an adventure it would be, I could have never imagined.

It was the beginning of the wildest ride of my life.

What Dreams May Come

Into the darkness they go, the wise and the lovely.
—EDNA ST. VINCENT MILLAY

Wallace Road forks off into the green meadows that roll down from Golden Chain Highway, on the northern outskirts of Placerville, California. This is where the blue blossoms and redbud trees grow, and the elderberry bushes buttress the unfenced road. Where deerweed and yarrow and fescue sprout in knee-high pasture patches, and sunlight bathes the leas and creeks and rivers that trickle and run through El Dorado County.

This is the landscape of Thomas Kinkade, the mountain paradise where he painted in his first studio tucked into a curve on Wallace Road, only miles from where he grew up in a trailer home. This is the duality of the paradise of Thomas Kinkade's childhood that formed him as a man; where "imaginary" was the only form of dinner he often had to eat. In his mind, the rundown singlewide in a dilapidated trailer park on the outskirts of town became an idyllic countryside home.

In reality, Mary Ann Kinkade was working three jobs and barely getting by when she moved her three children—Katherine, Thomas, and Patrick—to the trailer after Thom's father, William "Bill" Thomas Kinkade Jr., had walked out on them. The destitute trailer park on the

outside of town, with its unkempt surroundings, became, in Thom's retelling, a happy home surrounded by a paradise of lush woods and moss-covered rocks, with fond memories of Tom Sawyerish days fishing in a nearby pond.

Born William Thomas Kinkade III on January 19, 1958, in Sacramento, California, Thom barely knew his World War II veteran father. In those early years, Bill Kinkade was bouncing from job to job, one of them at McClellan Air Force Base. Bill frequently came home drunk, if he came home at all. When Thom was barely six years old, Bill abandoned his family (it was his second marriage), and Mary Ann was left with nothing but a Nevada divorce. Destitute, the family was forced to leave Sacramento proper to seek an affordable living situation in an outlying area of the city, and Placerville became the rescuing haven that took the family in.

The landscape surrounding Placerville created the idyllic childhood setting that formed Thom's vision of the world for the rest of his life. The natural beauty of the countryside, the wide-open fields and majestic mountains, developed Thom's sensibility in a way that no city could have. He and his brother played cowboys and Indians, chased each other in tag, and wrestled until the red-gold sunset darkened the El Dorado peaks and ebbed the light over the Sacramento Valley. On rainy days, Thom lined up his crayons and pencils on the coffee table in the living room and played "studio" while his brother was the assistant, handing him his colors. Even then, Thom drew all that he knew: the hills, the flowers, the dales. At night the family spent time together playing board games, checkers and backgammon, and on Sundays they went to church.

Thomas Kinkade always found the beauty in things. I believe that he had to, in order to escape the difficulties of a fatherless childhood spent in penury. In his mind and in his art, the ordinary became extraordinary. As many trailer parks tend to belie their humble status by calling themselves "manors" and "estates" and "villas," so Thomas Kinkade had a way of making bad things seem good, and good things seem better.

Understandable for a man who as a little boy spent his evenings waiting for his mother to come home, hoping she would be bringing food that night. He used to sit in the little window of the trailer and look out through the lacy curtains his mother had sewn. If she was carrying a brown paper bag in her arms, it meant they would get to eat that night. If she didn't have a bag, they would have to go to bed hungry. He felt so excited when he saw her walking toward the trailer with that bag in her arms, it was like Christmas every time. He swore that when he grew up he would never go hungry again.

He never blamed his mother for their hard life. He knew she did what she could. She was all alone raising three kids with no help; her family was far away. Working three jobs, she was hardly home. Sometimes she fell asleep at the dinner table, she was so tired. All the kids worked to help out and bring in money. Thom had a paper route from the time he was twelve years old, and brought home every nickel to his mother. The memory of the scarcity of his childhood never left him; for the rest of his life, going hungry was something Thom feared.

Ironically, the Kinkades lived in California's El Dorado County, a region known for its natural mineral wealth. Nestled in the rugged foothills of the Sierra Nevada Mountains, Placerville was the heart of the gold rush in the 1840s, where only ten miles from its town center, John Sutter found gold flakes running through his sawmill. Placerville was named for the placer deposits of the alluvial sands of gold in the riverbed of the Spanish Ravine, which ran through what is now the center of town. Along with the gold rush came the fortune seekers, and with them the villains and crooks for whom Placerville became known as "hangtown." As the county seat, Placerville housed the courthouse. Many a thirty-minute trial ended with a ne'er-do-well dangling at the end of a rope from the hanging tree at the center of town.

The legends and lore of El Dorado, the history and its attending nostalgia, deeply affected and influenced Thom in those early years. Mentally escaping to another time was often the only means to relieve the mundane reality of his present moment. And he could escape most effectively and profoundly by drawing; specifically, drawing nature. He

had nothing else; his life revolved around school and nature. Nature was in his blood from an early age, and the fantasy of those idyllic days gone by became part of his DNA. It was his most passionate subject for his entire life.

Thom loved to draw, and his mother claimed he could draw before he could walk. Drawing made him stand out, gain attention and approval, and was a means of escape. He told me how his skill became a tool for survival. He used to draw caricatures in school. There was a teacher that everyone hated, and kids paid Thom to draw a funny picture of him. Thom started selling caricatures of all the teachers the kids didn't like, and it was the first time he understood that he could make money doing what he loved to do. It was his first glimpse that art could be a way out of poverty. After that, he was known as "the kid who can draw."

When Thom was eleven years old, a local painter by the name of Charles Bell took him on as an apprentice and showed him the first basic techniques Thom needed to master in order to become the painter he wanted to be. He sold his first landscape painting that year, for $7.50.

The idealized visions of Placerville from Thom's memory became the key inspiration that fueled his paintings until he died. The babbling brooks, the wooded groves, the cottages—not trailers—in the forested glens, the warmly lit homes—not the singlewide without electricity— exemplified the transforming imagination he brought to the world, to escape a childhood touched by significant disappointments and difficulties. But the Thomas Kinkade I knew always had an ebullient spirit; a remarkable sanguine disposition that sought to do good, feel good, and see only the good.

Thomas Kinkade eventually would leave Placerville, but the humility and simplicity of life there never really left him. It was there that he also met the love of his life, and brought her along on his life's journey. In 1970, while Thom was on his paper route, tossing newspapers into driveways from his bicycle, he saw a beautiful blond young girl, Nanette, standing by a moving truck that had just brought her family to town. He stopped his bike and stared. She noticed him and smiled

back. Seeing Nanette was like seeing a radiating light coming from across the street. Her golden hair and her beautiful smile captured Thom's heart. They were both twelve years old.

From the beginning, Nanette fell for the young boy with a buoyant sense of humor, a penchant for hope, and the desire to see the positive in the world. She knew who Thom really was on the inside from the very beginning, and she would always know that boy no matter what later happened in their lives. To Thom, Nanette was the beautiful vision he craved; the idea of beauty that redeemed the world. They had a sweetheart romance, walking hand in hand in Placerville, reading poetry under the sheltering oaks along the riverbanks, and writing each other secret love notes; notes they saved in all the years that followed. Best friends from the beginning, he was Tom Sawyer to her Becky Thatcher.

Nanette had traveled the globe, as far afield as the Philippines and Japan, and regaled Thom with stories of the Orient and flying through monsoons in bomber planes, during her father's years in the military. Her stories set Thom's imagination on fire and made him want to know the greater world outside his quaint hometown. At the same time, Nanette was transported by Thom's imagination, his enthusiasm for everything in life, and of course his great talent. She had never known anyone with the passion and the outsized dreams of this small-town boy. To hear him tell it, it was a wonderful romance, and I saw it as the closest thing to the ideals Thom held on to for most of his life.

Nanette was a nurturer and a caretaker, and she must have sensed Thom's need for protection from himself. Being an artist always comes with the risk of rejection, and Thom was sensitive to that more than anything else. Nanette had a calm, supportive way about her that gave him the protection he needed.

Thom's lowly beginnings never hinted at the heights he would someday rise to. Nanette wanted to be a nurse and have a family, and they dreamed of a life together, he painting at his easel with children underfoot. She wanted to make Thom happy, and he thrived with her

tacit support and acceptance. Any artist is engaged in a fundamental process of creation; turning the inner vision into an external reality. Thom had that ability in spades. It dazzled Nanette to hear him spinning his visions for her and for their future. They spent hours lying in the grass, looking up into the undefined blue sky of their future, planning for the life they would have together someday.

But they never dreamed of making millions. Nothing in Placerville could have prepared them for what was to come. Thom wanted to provide for his family, but he never thought he would own luxury properties and generate billions of dollars with his art. He just knew he wanted to be the greatest artist in the world.

In 1974, Glenn Wessels, a genuine fine art painter and a founding member of the Bay Area Figurative School, moved into the neighborhood. Glenn was in his late seventies, a widower, and had recently been in a jeep accident, with his friend Ansel Adams, that left him frail and ailing. He needed help around the house and studio, and a companion. At age sixteen, Thom gladly stepped in as a helping hand and apprentice to the artist, who in exchange provided him with his mentorship. In fact, Wessels became the father Thom never had.

Wessels was an artist of stature and substance, and Thom couldn't have been more lucky to have him as a mentor. Wessels had been trained at Académie Colarossi in Paris, and studied with Karl Hofer in Berlin and Hans Hofmann in Munich. He was worldly and erudite, and a significant California artist. He had been an art critic for the *San Francisco Fortnightly*, and an art editor for the *San Francisco Argonaut*. Governor Edmund Brown named him California State Commissioner of fine arts. He served on the board of the San Francisco Art Institute and the Oakland Museum, among others. And he poured all of that experience into Thom.

Thom and Wessels spent hours talking in Wessels's studio, and Thom was enthralled by the stories of his days in Paris, and his friendships with Ernest Hemingway, Pablo Picasso, and Gertrude Stein. Wessels told Thom that being an artist was a form of priesthood, a notion that ironically would become true in Thom's career. Wessels's stories

of the romance of the life of the artist overtook Thom's imagination, and he dreamed about living a life like that with Nanette someday.

Thom cared for Wessels, running errands, helping him in his house as well as with his paints in the studio. Wessels talked to Thom for hours about art and life and passion. Wessels believed that life was a banquet to be feasted on. He counseled Thom not to let social conventions hold back his curiosity about the total human experience; advice Thom heeded for the rest of his life. Most of all, Wessels made Thom believe in himself. He mentored him in landscape painting and technique. And he made him see that he could one day be an important artist.

When it came time for Thom to graduate from high school, Wessels insisted that Thom study art at the University of California at Berkeley, where Wessels had also studied and taught. In 1976, Wessels made the trip to Berkeley with Thom, to be on hand for his interview.

Thom and Nanette had to put their future plans on hold when Thom left Placerville for the first time, to commence his freshman year at the university in Berkeley. They knew they wanted to be together one day, but for now their relationship had to wait, as Thom needed to pursue his art studies.

Thom's roommate was a young artist named James Gurney. The two bonded immediately, and Gurney became a good friend and fellow prankster, both of them sharing a boisterous sense of humor. The young men spent all their time sketching and scheming up humorous pranks. They dressed in identical workmen's overalls with the same name tag and called each other "Jackson." They would wear the uniforms into biker bars, sit down, and start sketching people without their permission, risking a bar brawl. They became known as the "two-headed monster"; their stunts included dive bombing into pools and pouring a shellac J on a friend's doorstep and setting it on fire.

At Berkeley, Thom discovered the airbrush and quickly set out to make it his new tool, telling everyone he was going to blow away anyone else who had ever used it, coining the term *blowawaymanship*. But after dribbling over a caricature of comedian Jonathan Winters,

he gave up on the instrument and focused again on painting. Two years into his studies at Berkeley, Thom decided he wasn't the right fit for the school's indulgently liberal environment, and decided to leave Northern California to continue his studies at the Art Center of Design in Pasadena, more than seven hours away from his hometown by car, making it even harder to see Nanette for several years.

At Art Center, the atmosphere was very competitive; Thom was challenged to continue to develop his painting skills, and to live the artist's life, sporting a beret everywhere he went. Jim Gurney followed Thom to Pasadena and also enrolled at Art Center; the two rented apartments in a rundown complex in East Los Angeles, continuing their bohemian ways and constant pranks.

Thom painted prolific still lifes and landscapes of the hills above Pasadena. On the side he delivered pizza on his motorcycle to support himself. His conquests in the coed dorm became the stuff of legend, but he never really liked any of the girls he conquered. All he ever talked about was Nanette. By the time he had been gone from Placerville for years, she had found a new suitor: a fellow nursing student at California State University, where she was studying. But Thom still put Nanette on the highest pedestal.

One day, Thom heard that the relationship with the nursing student had soured. While riding horseback with Nanette, both she and her boyfriend were thrown from the horse, and he had fallen on top of her, breaking her leg. With new hope, Thom began wooing her again, taking frequent drives to see his "golden girl." During that time, Thom painted a masterful "memory painting" of himself and Nanette out on a moonlit walk, in the style of Whistler's *Nocturnes,* in pale blues with soft shadows, capturing the misty glow of hazy night under the moon. And he won the love of his life back.

Concentrating on his studies at Art Center, Thom found inspiration in the Hudson River School's romanticized landscapes, and began selling his own work at galleries around Los Angeles. It was at the Art Center that Thom also began to become aware of the contradiction between maintaining the integrity of the artist's vision and the need

to earn a living, having a desire for commercial success. While Thom wanted to be successful, he also always talked about wanting to make a difference in the world with his art.

After two years at the Art Center, Thom and Jim both decided to quit their studies and make their dreams come true. They set out to travel across the country, riding train boxcars like hobos for months, and sketching everything they saw. Their collective work became a book called *The Artist's Guide to Sketching*.

To fund the completion of the manuscript, they sought work in the film industry and were both hired to work on a movie, *Fire and Ice*, directed by Ralph Bakshi. Bakshi hired Thom, despite his lack of professional training, because he thought Thom was already a good painter. Thom negotiated the salaries and vacations for himself and Jim, and impressed Bakshi with his business acumen. Bakshi took a liking to Thom for his country boy aw-shucks posturing, which didn't fool him much. He was immediately impressed by how much Thom already knew in his art.

Painting backdrops of fantastical landscapes, over seven hundred in all, Thom connected with the imaginary power of filmmaking. He also picked up the airbrush again, which he now mastered, rendering mists and moon glow for his background painting. It was here that he became a showman, and first recognized the potential of the imaginative element in landscape painting. Touched by the magic of Hollywood, he started calling himself the Painter of Light. Just as inspired as Thom, Jim Gurney went on to create the successful illustrated book series *Dinotopia*. Both of them reached the pinnacle of success in their fields, and they remained friends for life.

With the publication of the manuscript, and money in his pocket from his work on *Fire and Ice*, Thom called Nanette on the phone one day and proposed to her. They were married on May 2, 1982, in a chapel in Placerville, and moved into a small house on the edge of town. Ironically, a few months after their wedding, Glenn Wessels died at the age of eighty-seven. Thom was able to put his mentor to rest and take on his mantle, using the artistic gifts Wessels had given him.

Nanette, now a practicing nurse, supported them both in those early days. During those years, Thom continued to develop his craft and even took on a brush name, Robert Girrard, under which he began experimenting with Impressionism. He set himself up in a little weather-beaten cottage on Wallace Road, painting small landscape paintings, which he sold in the parking lots of the local supermarkets. He had begun the life he had always dreamed of.

<p style="text-align:center">❖</p>

Walking down Wallace Road is like entering a fairy tale. There's something about the way the light dances through the flickering leaves that must have felt like a hidden garden in heaven for Thom. His studio stood at the bend of the road, near a big red barn on an adjoining farm. It was a humble wooden cottage with a smokestack, log walls, and wood-framed windows that blended into the forest behind it.

The studio would always smell strongly of his art supplies. Thom used to talk about how much he loved the musty, pungent smell of oil and turpentine in a painter's studio. He remembered experiencing it for the first time in Glenn Wessels's studio and feeling that there was something wild and exotic about it, something sensual even. It always made him want to paint.

The studio was a bare open room with a concrete floor and naked white walls lined with shelves that held numerous paintings and canvases. Thom had a desk with a globe on it and a stuffed deer head just above it. On the floor was a stuffed stalking fox, and beside it the statue of a white marble cherub that supported the wooden box with Thom's paintbrushes, all lengths and thicknesses, sticking out like the quills of a porcupine.

Day after day, Thom sat on his swivel stool, wearing an apron and holding a paintbrush in his left hand and a palette in his right. Day after day, his brush danced over the canvas, leaving indelible trails of color and light. Nanette's work as a nurse continued to support them, and

Thom painted and continued to sell his work outside of supermarkets and also to some of the local gift shops in town.

Thom might have been content with this life. He should have been nobody in particular; just a local artist selling his wares to gift shops and galleries around Placerville, and finding collectors and fans among the chance pedestrian visitors to Carmel-by-the-Sea for the Sunday art fairs. If two things hadn't happened, this would have been the case. But they did happen, and both events changed his life.

<center>❖</center>

On a spring day in 1987, Thomas Kinkade loaded his easels and canvases into the back of his red vintage 1965 Ford pickup truck at five in the morning, the way he always did, and went off to the Carmel Sunday art fair. He had been up all night framing paintings, in the morning wrapping them gently in rags and blankets. Thomas was going to take his supplies and set up an easel at the fair, so people could watch him paint and buy his art. He filled his canvas bags with a rainbow assortment of tubes of oil paint and clean brushes, and packed a new palette. On this April morning, the day that would change his life, there was a bite of frost in the mountain air as he tied down the tarp over the back of the truck. Then he got into the cab, started the engine, and drove off, disappearing down Wallace Road, the early sun lighting his way.

<center>❖</center>

Rick Barnett was also nobody in particular, a Northern California boy who lived the carefree California life. He was tall, blond, and blue-eyed, with the looks of a movie star. And he was one of the best vacuum cleaner salesmen in the Kirby Vacuum Company. He had an all-American wholesomeness, a boy-next-door sincerity in those blue eyes, which just seemed to make people open their wallets and buy vacuums. He was that tall six-foot-three handsome stranger standing in an open doorway of a sleepy suburb tract house in Salinas or Fremont, smiling

his winning smile, and asking if the woman of the house wanted a carpet-cleaning demonstration. Nobody could sell like Rick Barnett.

Kirby vacuum salesmen are trained in the hard sell. Access is the first necessity for success; getting inside a house where people are vulnerable and can't escape. The longer you're in, the more you can wear down defenses. Unpacking countless vacuum implements and spreading them throughout the room, dumping salt over rugs and floors, rearranging furniture for the vacuum demonstration force the potential buyer to allow the salesman to take hours to go through his routine. And the longer the exposure to the sell, the more likely it is to close.

By the end of the demonstration, the homeowner is frightened, pressured, manipulated, and guilty—not to mention feeling responsible for the salesman meeting his quota and winning a vacation. Buoyed by last-minute deals, discounts, and financing rates, the salesman closes the deal. And Rick was the best of the best. His charisma and sincerity engendered trust in those he was selling to. Whether it was vacuums or paintings, Rick Barnett was brilliant.

<center>⚘</center>

Thomas Kinkade met Rick Barnett on that spring day in 1987, at the Carmel Sunday art fair in Carmel-by-the-Sea on a picturesque flower box promenade of quaint wine shops, trinket stores, and art galleries. Every Sunday, vendors set up their tables along the sidewalk filled with arts and crafts, homemade jams, pastels, watercolors, and paintings. Thom sat on a stool in front of his easel, wearing his French beret, and painted the Carmel street scene to look as though it was a hundred years ago. In his rendering, the cottage-thatched roofs were more crooked than the real ones; the Tudor beams on the buildings more uneven and quaintly bending into the stucco walls. In Thom's painting, Ocean Street was empty; only a horse-drawn carriage stood in the distance as the early morning light touched the trees and flowers.

Within minutes, Thom drew a crowd. His brush darted over the canvas as though it barely touched it. He dipped it into a dollop of

colors that magically became sprays of luminous daisies and begonias in the window boxes of the shops. You could hear murmurs and gasps of awe as Thom's brush transformed the canvas into a magical land from a distant time. It was as if he saw things that were invisible to the naked eye; people saw a vision of the street that only he could conjure with his paintbrush.

That same morning, Rick Barnett stepped out of the Carmel Pipe Shop and unwrapped his Sunday cigar, sliding the burnished leaf under his nose to capture the cured essence of brandy. Vacuum sales were good to Rick, and his pockets were lined with his commissions. Clipping the head and drawing the fire through the bundled leaves, Rick puffed the cigar gently to life, tossed the match, and walked down the street, toward the white tents of the Carmel Sunday art fair dotting the distance.

Rick always described how he had stopped, transfixed, when he came to Thomas Kinkade's booth. Thom's easels were covered in landscapes and quaint city scenes, painted in his stunningly colorful, romantic realism. Rick stood and watched, along with the other impressed onlookers, as Thom slowly created a masterpiece before their very eyes. The more his brush passed over the canvas, the more he created what seemed like a window into another world: a parallel universe similar to the one they were standing in at that very moment, and yet heightened into a sentimental depiction of imperfect reality.

Rick watched as Thom smiled and answered questions, never taking his eyes off the canvas. People asked him how he could paint such beautiful images. Thom kept dabbing the canvas, speaking softly and smiling as people watched him. He liked to explain his process to his admiring public. He told them that he stepped into the painting; that there was no boundary for him on the canvas, as though he couldn't feel his brush on the linen. He told them that his paints were like beams of light to him, penetrating into another world, and that the world would then come to life.

Rick was stunned. How could a painter of this magnitude, of this level and extraordinary skill, be sitting on a foldout stool, displaying

his masterpieces from the back of a pickup truck? Rick took a quick inventory of the paintings, saw how many there were, and that one was more masterful than the next. And with the price tags dancing in the ocean breeze, he got an idea. He could sell these paintings. His mind made quick calculations. How many could he sell in a day? How many could Kinkade paint in a week? How much were they worth? How many people could he get to buy them? Certainly more than the haphazard foot traffic of Carmel's Sunday collectors. Rick was thirty-four years old, and still selling vacuums. Selling paintings would be a lot more dignified and a lot more lucrative. As long as he put his sales genius behind it, he couldn't go wrong.

Rick stepped forward and introduced himself. He told Thom that he felt his work was the best he had ever seen, and that he should be represented in all the galleries of Carmel and beyond. Then he spontaneously offered to represent Thom's work, if he would agree to make Rick his exclusive art dealer. He said he was in sales, and that he thought he could get him exhibited in museums across the world.

Thom stopped painting, looked at Rick, saw the fire in his eyes and heard the intense conviction of his words. Thom scanned this tall, handsome young man and saw the confidence of his stance, felt the freshness and charisma. As Thom told it, there was something about Rick; something familiar that he recognized: a feeling as if he had met him before.

Rick pulled a business card from his jacket pocket, handed it to Thom, and asked him to give him a ring. And with that, Rick turned and walked away. Thom sat on his stool and turned the card in his hand. It read RICK BARNETT. KIRBY HOME CARE SYSTEMS. He looked up and watched Rick disappear down the street.

Neither man's life would ever be the same.

☬

Ken Raasch was nobody in particular, either. He was an entry-level executive with a small finance firm in downtown San Jose. He had been hired despite his lack of formal training in the field of accounting, and

was making a modest living while dreaming big. Part of making a modest living meant that he was living in his mother's house with his newlywed bride and a baby. He couldn't pay his parking tickets back then, but he was always an impeccable dresser. Even if he wore an off-the-rack suit from a discount store, it gave him the look he desired. It was always his firm belief that if you looked successful, then success would follow.

Ken dreamed of starting his own business, and he would sit in his mother's house with his wife, Linda, and talk for hours about his plans, dreaming up schemes and new ideas that Linda always supported. Money was an issue for this young couple, but Ken reassured her of his big plans for the future, and the houses and cars they would own one day. Then one day, in 1988, Linda showed Ken a wedding invitation that had just come in the mail. A friend of theirs was having a seaside wedding in Carmel-by-the-Sea. The future was just beginning, and they had no idea how much things were about to change.

<center>⚜</center>

In the summer of 1988, Nanette and Thom had just welcomed their firstborn daughter, Merritt Christian Kinkade, into their lives. It was a happy summer with their growing family. On the day of their friend's wedding, Thom's mother, Mary Ann, stayed with the baby so Thom and Nanette could attend.

The wedding was set along the seaside of Carmel-by-the-Sea, and Thom and Ken Raasch found themselves seated at the same table. They introduced themselves and talked about their work. Thom told Ken about his art practice, and how he had been selling his work to galleries around Carmel, Monterey, and San Jose with the help of his personal art representative, who was a former vacuum salesman. In fact, Rick Barnett was so successful at selling Thom's art in galleries that within a year he had quit his job at the Kirby Vacuum Company.

While the wedding festivities went on, Linda and Nanette sat chatting about their newborn babies, and Thom told Ken about his desire

to create a business of reproductions with his paintings. Rick Barnett was selling originals to galleries, but Thom wanted to make lithograph copies and greatly expand the number of times he could sell an image. Ken thought it was a great idea. Ken hadn't even seen his work yet, but there was something about Thom that made Ken believe in him. Thom was passionate, sincere, and ambitious. When Thom talked about his ideas, Ken's imagination was lit on fire and he could share in Thom's vision. And on that very day, at that very wedding, they decided to go into business together, Ken offering to raise the capital to fund Thom's dream.

❧

Six months after their meeting at the seaside wedding, Thom and Ken were to be found in the garage of Thom's modest Placerville cottage every day, wedged between paint supplies and easels, both of them hovering over the latest lithographs back from the printer. Ken had borrowed $30,000 from his mother, and he and Thom had formed Lightpost Publishing, their art replication business. Every cent went toward paper, printing, and gas. Thom would paint one of his bucolic scenes, and Ken would take it to be photographed and sent to the printer to produce a series of lithographs. These he would sell at art fairs and galleries, from Placerville to Carmel-by-the-Sea.

By this time, Nanette had quit her nursing job to devote her time fully to taking care of baby Merritt. The pressure to support the family now rested on the success of Thom and Ken's mutual endeavor. Every day they pored over transparencies, judging the first proof, comparing the strike-off, their heads inclined over the image. They inspected the magenta values, and discussed the color registration of brooks and meadows and the virtue of cerulean blue. Thom was a perfectionist. And Ken was learning fast. Nothing left the garage for reproduction until it was perfect.

The space was small and crammed full of frames and rolls of canvas, and it smelled strongly of art supplies. For Thom, the world

of ink and oil and enamel was his natural element. He had created works of art with potent chemical elements for years, and had been elbows-deep in oil paint and turpentine since he was a young teenager. Ken valued the perfect creases of his neatly pressed pinstripe suits. He was accustomed to the sterile cleanliness of an accounting office. To get his hands dirty from charcoal smudges or ink spills was a new experience for him.

But determination drove them both forward every day, as they sought to create the perfect lithograph of one of Thom's works of art. At first they printed a hundred copies, which Thom would number and sign by hand. Then Thom and Ken framed them together and stacked them carefully with tissue paper between each one, loading them into boxes. On weekends, Thom and Ken and Rick filled up the back of Thom's vintage pickup truck with all the art for sale, pile into the front seat, and drive to Carmel-by-the-Sea to offer up the latest works.

In addition to the Sunday art fairs, once in a while a gallery would take a work for sale. However, many of the owners were increasingly wary of the sweetness of Thom's images. And the punch of the hyper-realism didn't show well next to their more sophisticated interpretive artists. Art fairs were more successful for selling his art, and art expos even more so. Anytime Thom could interact with the buying public directly, there was no stopping the sale of his work. People loved his ebullient spirit, his friendly, easy manner.

He shook hands with everyone, smiling easily in his down-home unpretentious way. He joked with husbands about bringing their better half, and the couples would fawn over him, declaring how much they loved his work. He was humble and grateful for their compliments, and asked them which works they liked best.

If the wife said she loved the gates the best, then Thom turned to the husband and ribbed him: "If you love peace, then you'd better love the gates, too, sir, or you'll find yourself locked out one day." And everyone laughed.

"Remember, the wife is always right," Thom added, and the couples laughed some more.

"Well, thank you and you make sure to visit my booth and take some information cards and some flyers and some brochures. They've got all kinds of good stuff to look at and take home. God bless," Thom said. And he would turn and shake the hands of the next person waiting to speak to him. He made people feel special. He pulled them into his world for just a moment, and, more often than not, they'd end up buying whatever print they could afford.

When a print of Thom's was sent to a gallery in New York or Miami, often the response was either a yawn or a snub. Most of the dealers were put off by the intangible quality of what they called "cheesiness." Not so at the street art fairs and the expos. If Thom shook hands with someone, it almost always guaranteed a sale.

❦

Creating and selling the reproductions of Thom's artworks was a painstaking, laborious, and time-consuming process, but the three friends were slowly building a fan base for Thom, and making enough to get by after a good two years of hawking lithographs at art fairs.

Then, in 1991, a rep for the collectibles giant, the Bradford Exchange, saw Thom's work displayed at the Art Expo New York and recognized in him the perfect kind of artist for the collectibles business. He instantly made Thom a proposition, asking him if he would be interested in selling his work through Bradford. Thom had to ask what that was. Like anyone selling art, the three friends had assumed that galleries and art fairs were the only ways to sell a painting. The Bradford executive explained that they reproduced paintings by famous artists on collectible items such as plates and mugs and music boxes—just like they did with Norman Rockwell's work. Thom loved Rockwell, and his interest was piqued.

The rep laid a copy of *Parade* magazine on Thom's display table and showed him the Bradford Exchange's full-page ad on the back. He told Thom that their weekly ads in *Parade* cost them millions to run, but because they advertised in publications with the widest circulations in

the country, their exposure and their customer base were huge. The rep felt strongly that Thom's work would appeal to their customers. He conjectured that if they put his beautiful cottages and forests and glades onto collectible plates, he would be selling in the millions in no time.

Thom, Ken, and Rick had a meeting back home in Thom's garage to discuss the Bradford Exchange's proposition. Rick liked the sound of the volume of sales. Ken had never sold anything through a big business before. And all Thom had any experience selling, before selling his art, was pizza. So the three of them educated themselves about royalties and collectibles.

The Bradford Exchange was offering them a small but healthy percentage on the sale of any merchandise, and they had to make a decision. They looked at the statistics the company sent them. All products were tested ahead of time, and no image would be offered to the public on a plate before the Bradford Exchange was secure that the work would sell. The fact that they felt strongly that Thom's work would sell was very convincing. Ken argued the strongest for making the deal. This became among the most important decisions Ken made early on, because it opened a gateway to the new world of limited edition collectible stores.

Ken argued that they didn't need to sell art in galleries. That galleries were stuffy and snobby. They called the work "cheesy," and they hated it. They only bought a few at a time, and acted like they were doing them a favor. Thom's work was beautiful; everyone who bought his paintings and his prints loved them. Why did they need to go through galleries that hated the work? The Bradford Exchange would not only be a great source of revenue; their ads would promote Thom's work like no other medium.

In 1991, Lightpost Publishing signed a deal with the Bradford Exchange. Thom's cottages went up for sale on 8½-inch collectible plates all over America, and business began to explode. Sales doubled overnight and never stopped climbing. Even with a modest royalty, the sales through the Bradford Exchange quickly brought in hundreds of thousands per year, and would ultimately more than double in size, creating a very important source of revenue and exposure for the Painter of Light.

With the sudden income, the company moved the operation from Thom's garage in Placerville to a large warehouse on Charcot Avenue in San Jose. Workers were hired to help assemble frames, package paintings and lithographs, catalog inventory, and box up and ship all the new collectibles that were moving out in droves.

In that same year, Thom and Nanette's second daughter, Chandler Christian Kinkade, was born. Thom had already painted a picture in her name the year before, in 1990, in anticipation of her birth. He called it *Chandler's Cottage.* It was a lovingly painted work of intense detail, depicting a thatched-roof cottage with white stucco and timber framing, with rounded corners and oddly shaped windows, giving the cottage a fairy tale–like appearance. The cottage stood perched along a stone walkway with a single streetlamp illuminating the dusk, and a lush garden of blooming flowers spraying in all directions in a pandemonium of color. In the background a hazy, muted sky loomed with hovering clouds and a stand of majestic trees beyond.

In 1990, he also painted a picture in honor of his firstborn daughter, Merritt, called *Evening at Merritt's Cottage.* Since Merritt loved sunsets, Thom painted a cottage deeply nestled in a garden and fenced by a brick wall, with a gate with two pillars and lights to the left and right illuminating the entrance. A soft, rosy orange glow radiated in the sky above the cottage and the darkening ground. Inside a flowering garden, blooming rose vines and trees dappled the image with soft white blossoms that excited the otherwise settling evening darkness. Just like Chandler's cottage, Merritt's glowed bright with warm light from every window.

Thom was painting in themes, taking certain subject matter and reproducing it in variations. Besides the cottages, he also began to turn his painter's eye to well-known cities. He traveled to places like New York's Central Park and the Boston Common, and San Francisco's Fisherman's Wharf. In images such as *Skating in the Park* (1989) and *Boston, An Evening Stroll Through the Common* (1991), Thom captured the distinctive feeling of each city with exquisite detail, depicting the ice

skaters and bare-branch trees in Central Park and towering apartment buildings along its borders, or the glistening streets beneath the glowing streetlamps in Boston's illuminated square.

❧

The sudden increase in income finally relieved pressure from Thom's burgeoning family, and they moved from Placerville to San Jose. Their new home had more bedrooms, more children in the neighborhood, and was closer to the Charcot company location. By now Thom's sister, Kate, had left Placerville and gotten married, and his brother, Patrick, had gone on to study at Berkeley. Only his mother, Mary Ann Kinkade, remained in Placerville, though she was a frequent visitor to see the grandkids. Thom and Nanette had to pinch themselves. Here was the dream, the one they had talked about for so many years, coming true before their very eyes. They had dreamed that Thom's art would someday support them, and the new collectors were not only steadfast, they were voracious.

Every Sunday, Thomas Kinkade and his collectibles were seen on the back of *Parade* magazine, in the weekly full-page ad the Bradford Exchange took out. Inserted into every major newspaper in the country, the exposure was huge, and Thom's art struck a nerve with America. Sales climbed and climbed.

The significance of the huge sales statistics of the Bradford Exchange didn't escape Ken and Rick and Thom. They knew then that they had found their demographic; that the buyers for Thom's art were not the highbrow art collectors and galleries; they were the steadfast middle-American Christian ladies with Hummel figurines at home. Not discerning art aficionados, but the unsophisticated sentimental mother with a station wagon full of kids. The traditional American midwesterner who didn't frequent art galleries, but who would like to think of herself as loving art. These women had diminutive Lladro figures praying in their curio cabinets at home, and Norman Rockwell ornaments hanging from their Christmas trees. They wanted to see

the world as whole and good, and they believed in America. And they began to buy Thomas Kinkade collectibles like crazy.

Through the Bradford Exchange, the Painter of Light sold ornaments and figurines, plates, music boxes, and mugs to a growing fan base. The collectibles business, together with the limited edition art publishing, began gaining critical-mass profits. Within two years, sales quickly went from $1 million to $20 million. The three friends had hit the jackpot.

No one could have been prepared for the sudden wealth. With the stakes raised high, a jostling for power began among the three founders. Because of his initial investment of $30,000, and since he was the largest shareholder, Ken felt he had proprietary rights over the company's decisions, and sought to fund new avenues for the formula they had stumbled on. Thom saw his art sprawled across the back of *Parade* and saw his personal artistic vision turned into millions. And Rick, who lived in Monterey, set himself up along the waterfront near the pier, separating himself from Ken's day-to-day business, and essentially creating his own fiefdom, to concentrate on his representation and sales of Thom's original art.

The Charcot warehouse location wasn't considered adequate anymore as a corporate headquarters. Ken convinced Thom that Ten Almaden Boulevard, the swankiest address in San Jose, would be better suited for their burgeoning company. Thom agreed, as he usually did, and withdrew to his studio, focusing on his paintings, and making an appearance at Ken's Almaden headquarters perhaps four times a year.

As the millions poured in month by month, the three company founders, who had once huddled together in a garage, became their own separate satellites.

❧

I lived in Santa Barbara at the time, where my wife and I had met in high school. We had three kids and owned a small ranch with gorgeous valley and mountain views. I was an artist's representative with

my own company then. I was also acting as a consultant for the Bradford Exchange. I was charged with finding new artists to add to their collection in hopes of replicating the success it was having with their already established artists. And by 1993, no one was more established, or selling more, than Thomas Kinkade.

It was the year Thom painted one of his iconic paintings, *The End of a Perfect Day*, in which he depicted a rustic stone cabin nestled in the inlet of a secluded lake, framed by distant snowcapped mountains. The entire image glowed golden, with light from the cabin spilling out onto the outside deck where a rocking chair stood waiting, and a small wooden dock with a fishing boat tied on, and ducks floating in the softly rippling waters. His most prominent originals, as this one became, later sold for $500,000 or more.

I traveled to Niles, Illinois, a suburb of Chicago, where the Bradford Exchange was headquartered, to meet with their senior vice president of product development and the new-artists team. Dan Byrne had been with the Exchange for a long time, and his recent departure for the Thomas Kinkade Company was still the talk of all the trade shows.

Sitting at the conference table with the executives, I laid out my images for this visit, showing them new artists I thought they might respond to. I showed them images of puppies, eagles, and kittens, but they remained unmoved. When I asked them what they were looking for, they said they were really only interested in finding someone just like Thomas Kinkade—and he was "unduplicable."

I didn't sell them on any of my artists that day.

Later that same year, I got a call from my friend Kevin Sacher, inviting me to come up and present my artists to Ken Raasch and the team at Media Arts. I couldn't wait to meet with the rocket of success that was Media Arts Group and Thomas Kinkade.

It was 1994. Things were going so well that the three nobodies were drunk with success, and could still hardly fathom what they had on their hands. For Thom, his dream had come true. He and Nanette had once invested all they had into printing lithographs of his earliest

paintings, in order to explore the duplication process as a way to expand the profit made from a single work of art. Now this dream had reached unimaginable heights. Rick had far surpassed his former vacuum sales days, and was never looking back. And Ken finally had his opportunity to get what he had always dreamed of: to be a successful businessman. Ken persuaded his partners that their success was only the beginning. He wanted to add other artists to the roster. He wanted to expand the formula, and he felt art replication was where it was at. To finalize his dream, he made his pitch. He reasoned that since the company had reached $30 million in annual sales, they should take it public.

By the time I had my interview, the original company name, Lightpost Publishing, a term taken from Thom's paintings, had been changed to Media Arts Group Inc. and begun trading on the Nasdaq as MAGI.

And so the three nobodies became the three kings. And for the first time ever, an artist went public on the stock market.

Numbers Don't Lie

Risk comes from not knowing what you're doing.
—WARREN BUFFET

My first day on the job at Ten Almaden, I moved into my new corner office with its wide wall of windows overlooking San Jose. I felt as if I had arrived. The room was luxurious, with warm fabric wallpaper and a cherrywood desk. I sat in my executive swivel chair, stretched back, and took it all in. Everything was new: a brand new Apple computer, a brand new phone system. My assistant cheerfully said, "Good morning, Mr. Kuskey," and answered the intercom every time I buzzed.

Once I settled into my new digs, James Lambert knocked on my door. He had been assigned as my mentor, and promised to show me the company's offices. James was a former youth pastor, very tall and thin, with long blond hair; a handsome guy who looked more like a surfer than a vice president of publishing. He had a smooth, soft-spoken, understated manner that made him very easy to be around. His specialty was the printing of the art, and he had a close relationship with Thomas Kinkade as a result. James spoke of Thom as an acolyte speaks of his master, with reverence and adoration, and I was eager to hear anything he had to tell me. I had yet to meet the elusive Painter of Light, who preferred to stay ensconced in his studio as opposed to being surrounded by the bustle of the office.

As James and I walked through the honeycomb of offices, he introduced me to everyone. I shook more hands than I can remember. Everyone was friendly, and seemed genuinely happy to be working there. We visited the marketing department, with its spreadsheets and projections on the walls, and easels covered in charts and statistics. We walked through the graphics department, with its drawing tables and young men and women hunched over stencils and color transparencies. We dipped into the executive office suites, where I shook hands with Ken Raasch, who welcomed me warmly to the company. We stopped in at Dan Byrne's office and made plans for lunch. I went into Kevin's office, grinning from ear to ear; I gave him a bear hug and thanked him again for making it possible.

At lunchtime, Dan, Kevin, sales vice president Paul Barboza, and I walked out of the marbled hallways and into the sunny streets of downtown San Jose. We grabbed some sandwiches and sat on a bench on the sidewalk, watching the bustle of the city around us. I was giddy with my good fortune.

In the days to come, I threw myself into work. I set about to decipher what could be done with the Thomas Kinkade brand and images. I perused the library of his art and familiarized myself with the sales history of his work. I drew up calendars of releases, past, present, and future, creating a map of all the images coming out of Kinkade's body of work. I investigated how the company sold the art and what their formula was. It was like nothing I had ever encountered, revealing unbelievable diversification and stratification possibilities. I believed one image could be used for fifteen to twenty different products, maybe more. It was exciting for me to try to crack the code with regard to what Thomas Kinkade's fans would want to see. After the first two weeks, I finally had a short list of products for licensing, which I set about to put into motion.

I also scoured every other artist and venture Media Arts was developing, and soon realized Kinkade's work was the only art that was best positioned for licensing. Obviously, Kinkade was the powerful, driving revenue force behind the company. A fleeting thought crossed

my mind about the work of the other artists being marketed for "diversification": Susan Rios, David Winter, and even Nancy Faulkner, the artist I'd brought with me. Deep down, I wondered whether the public would care about their work the way they cared about Thom's.

From the beginning, I felt strongly that this was a Thomas Kinkade company; that without him there wouldn't be a company, and nothing to diversify. But since going public, they had hung up the MAGI sign. They had removed Thom's original company name, Lightpost Publishing, and merged all business into a subdivision of Media Arts. Gone was the name that reflected the heart of the business. Media Arts proclaimed itself as a marketing and media business—not the business of Thomas Kinkade.

It had been Ken's vision to go public and to diversify, and on paper it seemed to make sense. Ken and other executives at the company felt Thom couldn't possibly expand beyond the business he was doing, and the need to show a quarterly profit on the Nasdaq loomed large. They believed the lifeblood of the company was the publishing of art—the limited and open edition reproduction of original paintings in various forms such as lithographs, giclées, posters, cards, and books—by a variety of artists, not just Thomas Kinkade. They had made it to Ten Almaden because of the publishing success; living the big time, the company making $30 million a year, they were feeling rich. They had to feed the monster by diversifying, and they believed this goal was impossible as a single-artist company. They thought publishing Kinkade's art was a model that could be duplicated, and that artists like Susan Rios, with her frilly, colorful interiors and beach scenes, and Howard Behrens, with his cobblestone images of seaside villages along the Riviera and the California coast, would continue the model of success Thom had set a precedent for. Ken also wanted to sell film clips from Hollywood movies as CinemaClips collectibles, looking to expand the company's offerings. In selling Thom's images, the company had become such an effective sales machine that the executive team believed any artist or product could be pushed through its established distribution channels—as though they were selling toothpaste or mouthwash.

By the time I arrived, Susan Rios and Howard Behrens weren't performing the way everyone had hoped. CinemaClips was a failure. And David Winter Cottages, a financially troubled asset when Media Arts acquired it, had essentially eaten up all of the company's profits.

Two weeks after I came on board, Ken called me into his office for the first time. I had immersed myself in work so deeply that I had hardly noticed fourteen days had gone by. I announced myself to his assistant, Bernie, a salty older lady with a wry sense of humor who guarded Ken like she was minding Fort Knox.

Ken sat in his spacious corner office behind his massive desk, gesturing for me to take a seat. I took a chair across from him and smiled. Ken thanked me for coming. I said I was glad to have a chance to talk with him, since we really hadn't had time since I joined the company. Ken leaned back in his chair. He looked uncomfortable. He asked me how long I had been at the company and I told him it was two weeks already. He nodded, as though buying time.

I told him I felt like I had just gotten there. And that I was excited to be here. He didn't return my smile. I could feel that something was up. He leaned forward and looked me straight in the eye. He said he wanted to tell me something, but he didn't want me to freak out.

That made me nervous, but I tried not to show it. I promised not to freak out and asked him what was the matter. He said something bad was going to happen that day. I felt my grip tightening on the armrests of my chair. Was I being fired after only two weeks?

Ken struggled to find the words. He said he was about to deliver the worst news the company had ever had. I nodded numbly. Where was this going?

Ken said Media Arts was going to lay off about a third of its workforce.

There was a tingle in my hands and I tried to swallow, feeling both relief and then dread. I wasn't being fired, but maybe this was worse. I had just moved my entire family up from Santa Barbara to San Jose, and I had sold my company to Media Arts.

Ken looked miserable, but tried to put on a good face. He told me

there was nothing to worry about and that it wouldn't affect me. He promised me I wouldn't be going anywhere. But he was going to have to let a hundred people go today. And he felt he should let me know before he did it.

I couldn't hide my shock.

Ken looked toward the inner offices and said he was worried about the other people in the company. His voice began to break, and tears welled up in his eyes. He said he cared about every one of the people working in the company. And he was going to have to break one hundred hearts that day. And that broke his heart. It was awkward for me to sit across from this man I hardly knew and share in his deep emotions. At the same time, thoughts raced through my head. "What does this mean?" "Is the company going under?" "Have I just made the biggest mistake of my life?"

Ken added that there was one more thing.

I didn't think I could take much more.

He said we would have to move out of Ten Almaden, and into our warehouse space on Charcot Avenue—not right away, but in a month or so.

I nodded and thought, "There goes my corner office."

October 16, 1995, came to be known as Black Monday at MAGI.

❧

I had heard of the Charcot Street location only in rumors, and the rumors were not good. Charcot was an industrial area in the wrong part of town. Kevin and James and I took a drive a few days later to have a look. We saw an industrial park with nondescript buildings, browning grass, and empty parking lots. It wasn't the marble foyer of Ten Almaden or the brilliant sunlit downtown area. It was a blighted area near a railroad track, and word was that it wasn't safe to walk the streets. Whereas our neighbors had been J.P. Morgan and Citibank, they were now CB Tool Supply and Critchfield Mechanical.

We parked at the back doors and went inside. It was a high-ceilinged

cavernous warehouse, with no walls and no partitions. It looked a little shabby for a warehouse, and a lot shabby for offices.

We all stood looking around. Kevin tried to sound optimistic, saying they were going to roll on some paint and make it look better. I thought it would take a lot more than paint. Kevin was trying to be hopeful, saying they would build partitions and make offices. But I pointed out the offices would have no windows and no spectacular city view. James wryly added that at least there would be the noise from the train rolling by every fifteen minutes.

Despite its ugly-duckling appearance, the warehouse was bustling with activity. Charcot was the shipping and receiving center of the Media Arts operation, and trucks were rolling in and out without pause. Forklifts were driving through the cavernous space, hauling stacks and stacks of wrapped canvases and lithographs. Boxes were stacked up to the ceiling, and a smattering of workers kept things moving. There were no windows and no views to the outside. The cavernous space echoed and jangled with noise. I was horrified.

I said I would miss downtown and the marble foyer. Kevin agreed he would miss the nice restaurants. James said he would miss the easy access to banks and shopping.

As much as we were being reassured that everything was going to be all right, I felt I had made a terrible decision. I had been given a lot of company stock, partially as payment for MAGI having purchased my company. The stock had plummeted the moment Wall Street caught wind of the financial trouble at Media Arts; suddenly it was worthless. I couldn't shake the sense of dread.

Anxious thoughts were racing though my mind. I had just uprooted my family from our beautiful ranch home in Santa Barbara, where our extended families lived, and relocated us to Los Gatos. My wife felt isolated, and because she had not been able to get to know the players, she wasn't quite sure what to think about the born-again vibe at the company. She had expressed her reservations openly to me, saying she thought it felt phony. I reassured her. And reminded her of the solid salary and benefits I was now receiving. She took the

check, but she never bought into the dream. How was I going to tell her this?

Standing in the warehouse at that moment, we looked at each other, thinking the same thing: "Is this the death knell of the company?"

That night I went home and polished up my résumé.

<center>❧</center>

Days later, I received a phone call from Thomas Kinkade himself. It was the first time we had spoken; we had never even met. I held the phone to my ear, standing in my soon-to-be vacated office.

"Thom. It's great to talk to you," I said.

Thom told me he had heard all about me, and that I had a lot of experience. He said he felt that I would be bringing a lot of new dimension to the company. There was a mellifluous quality to his voice, instantly calming and reassuring. I thanked him and told him I appreciated him saying that. He told me he just wanted me to know how happy he was to have me on board.

I was thinking, "Does he believe I'm going to quit?"

Then he said he would like me to come to his studio in Monte Sereno, to give us a chance to talk. He said he wanted to hear more about the licensing business.

I said, "Sure, Thom. I'd love that."

Going to meet Thomas Kinkade was like going to meet Howard Hughes; he seemed that elusive. Despite all the company's woes, I was honored and excited to be granted a private audience with the legend himself.

I left downtown San Jose in my Volvo driving on Highway 17 and headed directly toward the Santa Cruz Mountains and followed a circuitous route off the highway, ending up at a winding Ridgecrest Avenue in Monte Sereno. The street was the crown jewel in the surroundings of Los Gatos, where Thom lived on his four-acre compound. Nestled against the eastern base of the Santa Cruz Mountains, Monte Sereno, Los Gatos, and Saratoga, known as the golden triangle

in Silicon Valley, are among the wealthiest neighborhoods in America. I wound through the majestic stands of oak and redwood trees and almost missed the gate. Buzzing the intercom, I announced myself and heard Thom's voice.

"Drive up by the cottage and park."

The heavy iron gates slowly opened, and I drove through with anticipation. Dappled light danced over the circular drive. I headed past the front entrance of the main house, a two-story creamy yellow stucco structure with white wainscoting, gabled roofs, and stately Palladian windows. I parked in the driveway and saw a path to my left leading to a charming restored 1930s cottage, which adjoined the main estate. This was Thom's studio, Ivy Gate Cottage.

When I got out of my car, I was overcome by the scent of jasmine and roses as I walked the narrow cobbled path to the cottage. I knocked.

"Come in!"

I opened the door and hesitantly looked inside. There was a fire roaring in the stone fireplace, making the polished wood floor gleam. The smell of paint and linseed oil permeated the room, and paintings were stacked up against bookcases filled with art books. Striking original paintings by other artists hung prominently beneath studio lighting. The French doors admitted light into all sides of the cottage, allowing shafts of sunlight to fall over the worn but elegant leather sofa and chairs on the garden side of the large room. Antiques were scattered about the bookcases and shelves, and a stuffed fox stood by the fireplace.

Thom sat on a stool facing his easel. He had a large physical presence, over six feet tall, over two hundred pounds. His head was a little too large for his body, and his hands were small. He sported a thick chevron mustache, its ends growing down over the corners of his lips, a decade out of fashion. His hair was neat and combed like a little boy's, and his cheeks glowed with a red hue. He wore blue denim jeans, boots, and a plaid shirt. All he needed was a straw hat and a reed of grass in his mouth, and the country-boy image would have been complete.

Surrounding him, on tables and stands, were hundreds of paint tubes and more paintbrushes than I could count. Palettes stood in various states of use, covered in fresh and drying oil paint with prisms of tints and hues spreading out their rainbows of color. He also had a cold can of beer perched next to him. I had heard Thom was fond of his drink now and then, but it was a warm day and I didn't think much of it.

Thom kept his eyes on the canvas as I entered. "Welcome to my humble home, Eric," he said.

"It's a beautiful studio," I said.

"This is where I live. I only visit the big house when the girls let me in," he chuckled.

I laughed and stopped at a wall across the room in front of Thom, which was covered in what seemed to be a hundred photographs; references for his paintings. He had several photographs taped to the wall beside his easel, and occasionally glanced at them as he worked. Stacked behind him were numerous canvases in various states of completion. He had a large wooden box with a door, shelves, and a heating element, in which he kept paintings to dry. Thom was known for painting in many layers, and he needed to dry them in between adding new colors. One painting might have up to fifty layers of paint. These layers were said to give the paintings that Kinkadesque quality: their familiar texture and dimension, and of course their famous glow.

I sat across from him and watched him paint for a while. It was stunning to see how effortlessly he found and mixed his paints, plucking out just the right brush and using it to dab at the painting in what looked like a haphazard fashion. Yet as I watched, the painting came more and more to life. It was fascinating to see.

To his right was a painting propped up on a drying rack: a gorgeous image of a lighthouse set against a rocky shore with the spray of the water hitting the rocks and exploding on the shore. A white fence bordered the narrow perch where the lighthouse stood, and a light post illuminated the path. The lighthouse was lit bright golden from inside, offset against a turbulent sky and sea. Thom noticed me looking at it.

"That's going to be called *A Light in the Storm*. It's an allegory of Jesus's proclamation 'I am the light of the world.' John 8:12."

"It's fantastic," I said. The painting would become one of his most famous images.

"How do you make the image glow like that?" I asked him.

"Layers and layers. It can take me up to three hundred hours to paint a painting."

I calculated in my head. "Isn't that over two months?"

He nodded, and began to tell me about his process of painting. He said that after getting all the layers of the painting down, he got to a point late in the process when he put in the light in a painting. He pointed to the canvas he was working on at that moment. It showed a sunrise over water. He told me how he found the center of the source of the light. It was the sun on the horizon in this painting. Then he explained he would now add the strongest, lightest color to that light source. His brush dabbed a bright white spot into the middle of the already painted sun and clouds. It looked like an accident, and I was concerned that he had just ruined the painting. But his brush kept gently dabbing at the white spot. He demonstrated how he would not feather out the paint, and keep it strong, but subtle enough so it wouldn't dominate the image.

As he spoke, his brush made a light, scruffy dabbing sound as the sun began to glow more sharply. He told me that as he brought the sun into clarity, he liked to let the radiating light come out from it, like God's radiance; his glory just breaking through.

His paintbrush slowly spread the bright white spot into light feathery lines emanating from the sun. The sun and the clouds around it began to glow. I was amazed at the transformation.

"You see? It's not paint anymore. It's light. The white in the paint will keep that light burning bright. That's what I try to do. I leave the light on." He chuckled.

It looked amazing. The paint had literally transformed from an oily, formless substance to light emanating from the painting. He told me that people thought he used luminescent paint, but he didn't. I asked if he had studied this technique, and he explained that he did use a paint-

ing technique that brought out the light in a painting. He surrounded the light source with lots of intense dark values and then dropped the nearly white light source into the middle to make it stand out. The dark underpainting was done in warm values, while cool tones were used on top, the contrast giving them a glowing appearance. He had learned the technique from studying the likes of William Turner, who himself was originally called the Painter of Light. But he said it was his work on the animated movie *Fire and Ice* that had finally taught him to master the manipulation of color and hues into glowing tones. It was movie magic in art.

"The light is the last thing I paint," he said.

He showed me how he touched any of the points of light in an image with four or five very bright white- and yellow-hued paints, to give them the appearance of glowing. He explained how, in a low-light setting, these spots of paint were always the last points of light to remain luminescent. That's why he always brightened the light at the top of a candle, or the light emanating from a lighthouse or the sun, or the light gleaming off the headlight of an old car.

"The light becomes an allegorical contact point for me. I imagine that whoever would buy this painting one day, might be someone who felt like the light has been overcome by the shadow of dark clouds in their life. I hope to let a new day begin to dawn for that person, through this painting. I want to touch people with my painting. That's why I paint."

Then he asked me if I remembered the paintings that hung in my parents' house when I was growing up. I said I remembered them well. He then told me most people remembered the paintings hanging on the walls in their childhood homes. He asked if I remembered liking the paintings and I said, "Yes and no." Some of them were odd to me. I didn't understand them. In fact I thought they were a little disturbing. I remembered that I didn't understand why the sky was black in one, or where the water flowed to in another. He asked if they made me feel weird or good. And I told him the ones I didn't understand made me feel weird.

"Do you want your kids to look at paintings that make them feel happy or weird?"

I told him that of course I wanted them to feel happy.

"That's what I want the world to feel from my art. I want everyone to feel happy."

He smiled and turned his attention back to his canvas.

"Tell me about this licensing thing," he said.

I had brought a briefcase full of samples, showing Thom's paintings mocked up on various greeting cards and stationary and gift items. He looked through them thoughtfully.

"How does it work?"

I told him we would sell a license of an image to licensees like Hallmark, for instance, and they would then put his image on products they sold in their stores. Like greeting cards or stationery. The greeting cards would then get his name out there. I called them introductory products. You put your image on a greeting card, and it familiarizes the public with your work and leads to an actual art purchase.

He sifted through every image. "I like them all. Where do we start?" he asked.

I told Thom that in the world of licensing, there was no better product than the greeting card. It showed the art, and also elegantly told a little story. He turned one of the cards I'd had printed up in his hand. It showed one of his paintings with a cottage in the snow and deer nearby.

"It does tell a story, doesn't it?" he mused.

I explained that on the back we would have the copyright and his name clearly printed. Also, that we would put the company address on the back with the phone number, so people would know where to find us. So that prospective manufacturers could call us in case they wanted to use the art on their products.

Thom pulled four paintings from his stack and set them up, side by side. They were wintry scenes depicting snow-covered cottages, with warmly lit windows casting a glowing light that illuminated the forest and animals, while smoke rose from the chimneys.

"What was your happiest day of the year, Eric? What day held the most anticipation? The most pent-up excitement as a little kid?"

"It was definitely Christmas."

"Exactly. I want to do Christmas cards. I want to be the Painter of Christmas."

He looked off into the distance, seeing it all in his mind. He asked if we could print Christmas calendars. I told him we could. He asked if we could print Advent calendars. I said, "Absolutely." Thom's mind raced and he paced the room. I could see the visions dancing in his mind. He was brilliant; for every one of my ideas, he had ten. He said he wanted to do ornaments, and collections of miniature villages, and collectible replicas of cottages that would light up. He thought we could do stockings, tree skirts, coasters, wrapping paper, and Christmas lights.

"We can do all of those things, Thom."

He stopped and looked back at me and smiled.

"We will, Eric. We will."

❦

A month after Black Monday and the announcement of the layoffs, a hundred employees slowly made their tearful exit from the company. The Charcot warehouse had been under constant renovation as Media Arts built partitions and offices, and remodeled the space to house the hundred or more refugee employees who remained. Wall Street reacted positively to the belt-tightening and the stock started to edge back up. Although I dreaded leaving my posh downtown San Jose office, I was relieved things seemed to be moving forward and I didn't have to return to Santa Barbara anytime soon.

It was my visit with Thom that had bolstered me the most. He understood the potential of licensing so well that I immediately went to work to put the plans into action and scheduled meetings with important licensees. Thom and I planned to travel to Kansas City together within the month, to meet with my most important client, the Hallmark Company.

Days after I met Thom at his studio, I filled in Ken on my licensing plans. Bernie had decided she liked me by now, and let me inside without an argument; I considered myself lucky. No one got past Bernie. If she didn't like you, it seemed like memos got lost and meetings were cancelled.

Ken was sitting behind his large desk, dressed in a finely tailored suit as usual. Motioning me to take a seat, he continued his conversation with someone from Wall Street. I took a moment to take in the surroundings. His office was sumptuously decorated with an antique gold couch as the centerpiece. I was afraid to sit on it for fear it might break. Pictures covered his walls: Ken with his employees, Ken and Thom, Ken and his family, and Ken with dignitaries in local government.

Ken finally got off the phone, turned to me, and asked how my meeting with Thom went.

I told him I had enjoyed it very much, and that Thom was on board with my ideas, and had many of his own. I just had to put them into action. And I wanted to bring Ken up to speed on what we decided. He asked me to go ahead and tell him everything. Ten minutes turned into two hours, as I sat and told him all my plans. I explained how a licensing agreement worked. And I explained the simple economics of licensing agreements; how they earned money and how they could be built into a multimillion-dollar royalty income stream. How licensing would introduce new customers to Thomas Kinkade, who would someday buy his art. How it would supercharge the marketing by putting Thomas Kinkade out there on a calendar on a wall, and a mug on a desk, or a bookmark in a book, and allow people everywhere to stumble across the art. I could see the lightbulb go off in Ken's eyes, as he realized the magnitude of the income potential. "And we can do this globally. It's universal. We can go everywhere," I said.

He was excited, and that was flattering and encouraging to me. He had listened and fully understood, on a business level, everything I was trying to do. We bonded from that moment on, and became fast friends and allies. He understood my vision and he supported it. And

I supported his in turn. At least I tried as much as I could. Diversification still looked good to everyone on paper; I thought maybe the company's layoffs were simply bad luck. Having Ken behind me was going to be very helpful in my plans to expand the company's licensing program quickly.

I had arrived at the company too recently to know that Black Monday wasn't just bad luck. It was caused by management choices; specifically choices Ken, with the full support of the board, had made. In order to grow its rapidly expanding operations and to fuel the diversification schemes, Media Arts had arranged for a bridge capital loan with Levine Leichtman Capital Partners, an investment management firm. Since the diversification schemes were now failing and David Winter Cottages had wiped out the company's cash reserves, Media Arts couldn't meet the terms of the loan, and Levine Leichtman was threatening to foreclose. This was the impetus for Black Monday. Something Ken would eventually get blamed for. But I didn't know that yet.

I left his office that day with the feeling I had just been handed a chance to hitch my star onto his wagon. Little did I know he was also hitching his star onto mine.

<p style="text-align:center">⚜</p>

Charcot Avenue was fully renovated by the time I moved into my new office, and I was impressed by how much they had achieved only a month after Black Friday. The warehouse had been converted into organized offices with sections and partitions and cubicles. It was nothing fancy, but being there in the center of the operations was interesting to me. I got to observe the inside workings; how everything was done. I saw the forklifts moving back and forth, revealing just how healthy the art business was. And I also saw it was Thomas Kinkade's work, as opposed to that of the other artists, that was shipping out all day long.

Still, Wall Street wanted more. Even with the steady painting and lithograph business, and the revenue from the Bradford Exchange,

the stock market demanded not only a turnaround from the red, but constant profits and a steadily increasing income. The pressure never let up. The other diversification artists weren't performing, and the licenses I was working on would take a while to get up and running. But things had to turn around fast—and the answer seemed to come falling out of heaven.

Dan Byrne, the executive vice president of Media Arts Group, had seen a demonstration at a printing shop of a new process called the canvas transfer system, in which a photograph could be transferred onto a canvas, creating the look and feel of a real painting. It was the latest innovation in printing technology, and Dan had gone to have a look. He watched a demonstration of this cutting-edge technique; the process entailed lifting the ink off a printed lithograph and affixing it to a blank canvas, creating a work of art, bumps and all, nearly indistinguishable from the original. Only one artist at the time was using the technique with success, a landscape painter named Marty Bell who ironically specialized in painting Cotswold cottages. He was replicating his images with the canvas transfer system and offering them for sale.

Dan brought the brochures and videos back to the company and made the executive team all have a look. Thom was present for the meeting, and he was the first to immediately understand the implication. Thom asked whether we could make a product that looked and felt like an original work of art, but wasn't an original. Dan confirmed this was true. Thom then asked how many we could make. Dan said we could make as many as we wanted. They knew what it meant in that moment.

They had stumbled onto the Holy Grail.

⚜

I believed in diversification; at least I wanted to. On paper it looked right enough, but in reality, Thom's consumers were so ravenous and faithful, it was like making money by accident. People bought anything he put out. Ken, along with most of the executive management team,

sincerely thought that dynamic was duplicable. But they were wrong. Thomas Kinkade's sales were anything but normal. In retrospect, it seems that the logic was influenced by Thom's immediate, amazing marketplace value and success. They must have thought Thom's success was a normal art business phenomenon, or at least something that happened periodically. But Thomas Kinkade only happened once in a lifetime, if that.

While most of us were chatting with our colleagues in the Charcot Avenue cafeteria, there was a secret conversation brewing. Rick Barnett, who only came in for occasional meetings from his outpost in Monterey, where he kept a separate office, was having discussions with Thom, his wife Nanette, and members of the board. They were worried about the necessity of the move to Charcot Avenue. Wall Street had lost confidence since Black Monday, and they knew the company had just had a near-death experience. They began to see that the company's strategy of diversification was flawed. And, as is often the case, the CEO becomes the fall guy, even if the board approves all decisions made.

This came true for Ken. To appease Wall Street's concerns, Ken eventually stepped down as CEO of Media Arts. The company went through a period of uncertainty regarding who the next CEO should be, but ultimately installed Bud Peterson, chief financial officer. Bud had never planned on becoming CEO, but coming from the CFO position, he knew the numbers and everyone, including Ken, felt this would be best for the company. It would satisfy Wall Street and Ken could retain his position as chairman of the board. Bud was a true force at the company through many years of growth and related turbulence. He was always level headed and steady with his decision making. Even so, Bud only lasted a year in this position before new CEO candidates were eventually being considered again.

Thom had been all for diversification. He was exhausted, creating up to fifteen masterpiece paintings a year, and appreciated the idea that some of the load could be taken off his shoulders. Diversification had promised him more time on his motorcycle, more vacations,

more time to enjoy his life and newfound wealth. Each masterpiece painting took months to complete, and he would work on several at a time, as well as the many *plein air* paintings, landscapes he painted in one afternoon. The last thing he wanted to do was sit behind his easel and paint nonstop night and day, as he was doing then. But diversification didn't reap Thom those benefits.

Only in retrospect did everyone at the company realize how foolish they had been to think other artists would sell in these quantities. All profits clearly came from one source. The money coming into the company was coming from the sales of Thom's art, while the money leaking out had nothing to do with Thom. David Winter Cottages had been a huge toilet flush, with some $20 million down the drain. With that deal alone, the company went to zero profits.

Now Ken was talking me up to everyone who would listen. Licensing and my related strategy became part of his plan. I respected Ken as a man with a good heart and a kind disposition, and I appreciated him as a great supporter who championed everything I did. Time showed the licensing to be a much more profitable business, and the canvas transfer system even more so. These two moneymakers became the way in which the company climbed back out of its hole.

The first day Thom stood before one of his canvas transfers, Dan Byrne told me how he had marveled at how perfectly it resembled the original painting displayed on an easel next to it. The two pieces were indistinguishable from one another; one was a perfect replica of the other. It went against everything the modern art world holds sacred: the notion of scarcity; the concept of the original; the value of uniqueness. But Thom didn't care about all that. The possibility of recreating an original work of art—the ability to make it look identical to the original, and to reproduce that original ten, one hundred, or one hundred thousand times—was exhilarating.

He walked up to the reproduction and ran his hand reverently over the canvas transfer, feeling the bumps and bulges of paint, just like they could be felt on the original.

"It feels so real," he breathed.

Thom must have felt the very power of the creation of life in his hands. With the help of a machine, he had recreated himself, recreated the spark of genius in his own work, and duplicated it without leaving a trace of the process. The effect was mesmerizing, irresistible, and powerful.

Thom walked over to his easel, grabbed a palette, and dabbed some colors on it: yellow, gold, white, orange, and dollops of luminescent paint. With his paintbrush he dotted a few dollops of color here and there, touching up the points of light on the copy so that they positively glowed. Thom turned.

"We'll hire some artists to retouch every painting and make it original."

Rick chimed in that we could call them highlighters.

Thom nodded and smiled back at him. *"Master* highlighters."

<div style="text-align:center">❦</div>

Soon I was watching those master highlighters at work in the Charcot facility. First, teams of people prepared the canvas transfers along a production line. They took prints made from photographs of Thom's paintings and laid them in trays and brushed glue on them. When the glue dried, they lifted the glue, which held the ink from the print, and affixed the glue film onto a blank stretched canvas, and coated it again. Huge blowers were set up in dust-free rooms, similar to the rooms in which medical supplies are made. It was essential that the environment be impeccably clean, so that no canvas transfer was ruined by a speck of dust. The workers wore clean white suits with gloves, hairnets, and goggles, and huge ceiling vacuums filtered the air. The transfers were hung on racks to dry. As soon as they were ready, they were sent down the hallway to the master highlighters, mostly women personally trained by the Painter of Light himself, who highlighted the paintings by hand.

Then the reproductions were wrapped in brown paper, taped up, packed in cardboard edges, and slid into boxes. They were loaded

into the warehouse ready for shipping, stacked twenty feet high. Re-productions of paintings in all colors and sizes were piled high at the loading docks, no different than if they were crates of iceberg lettuce. Eighteen-wheelers pulled up at the loading docks, were loaded to capacity, and drove out into the distance. This went on every single day at Charcot Avenue. While Rick, Thom, Ken, and the board of directors and executive team were still arguing over diversification, the canvas transfer scheme was a selling machine that hummed on autopilot, a vibrant life of sales that brought the steady money in.

I watched the process evolve with a mixture of feelings. I was in awe of the machinery and the sheer volume of sales. The process was flawless and the products were stunning and truly indistinguishable from the originals. I also knew enough about the art business to wonder about the edition sizes. Charcot was pumping out editions in so many shapes and sizes that I couldn't count the volume. I was puzzled about how this was possible, but I was also pleasantly surprised. This new technology had opened up a door that allowed people to buy Thom's art in a way that had never existed before. We were pioneers. And I was making a nice paycheck in the process.

At first, the reproductions of original paintings were sold in editions limited to, say, 2,500 prints, for an average of $1,200 apiece. In time, with multiple editions released per image, the total edition number became 10,000, and then 30,000. MAGI had already established a loyal base with its collectibles, and now it couldn't sell the reproductions fast enough, as the delivery vehicles hauled off the artwork by the truckloads. Within a few months, the company opened a large flagship Thomas Kinkade Gallery in the Valley Fair Mall in Santa Clara, to showcase the new canvas transfer products. Business went through the roof.

❧

It was a year of big changes. From my family's move to Los Gatos to the near-death experience of Black Monday, to the biggest recovery I

could have ever imagined a company making from the brink of losing everything, all because of the introduction of the canvas transfer system. Thom and Nanette had their third daughter, Winsor Christian Kinkade, that year. We spent occasional barbecue afternoons at their house with the kids in tow, and a feeling of happiness and family time pervaded, watching our kids play in the garden. We shared lots of laughter and companionship then, even if I had to listen to my wife's skeptical analysis on the way home at the end of the day.

There was something about Thom she just didn't trust. And I could never persuade her otherwise. Perhaps there were too many contradictions, and too many conflicts in the whole mission-based mandate of the company. "Sounds like a bunch of voodoo to me," she always said. We were Catholics, and as such I was not part of the large born-again clan at Media Arts. That actually made me somewhat of an outsider. And for my wife, it all felt a little too contrived.

<center>❧</center>

In September of 1995, I traveled to Kansas City, Missouri, with Thom, Nanette, and Dan Byrne, to introduce Thom to my Hallmark contacts at their corporate headquarters. Terry Sheppard, Thom's videographer, also came along. His job was to document all Thom's events and edit them into a video library for the record books. We were signing a deal for the first license I brought to the company. Hallmark rolled out the red carpet for us at their corporate headquarters. We went from the Hyatt Hotel, traversing the famous Skywalk, which years earlier had tragically collapsed, over to Hallmark, where we were met by the executive team. We toured their massive facility, met artists and graphic designers, sales and license VPs, and company dignitaries. Everyone treated Thom like royalty.

After the signing of papers, we had an extended meeting in which we discussed the plans for the products we had in mind. When the meeting concluded, Thom was whisked away downtown to the Country Club Plaza, where a Thomas Kinkade Gallery was located.

A crowd had gathered for a gallery event, to see Thom speak. Thom took the microphone so naturally, and began speaking to the audience so confidently, that I was thrilled to be able to watch him, and to see the crowd respond with so much adoration. It felt like something important was happening, that I was witnessing something significant. Thom was effortless and masterful in his speaking. He was a natural-born orator. He spoke about his faith, but he didn't preach. He was funny, and told several jokes. He went on to talk about his love for Nanette and their love story, and the audience fell in love with him. I was deeply impacted by hearing him speak, and enjoyed being part of the mosaic. I mingled with the crowd afterward, feeling proud to be one of the business people who supported him. I was helping Thom "make it all happen." It made me feel important, too. It was intoxicating.

<center>☬</center>

After the event in the Country Club Plaza, the Hallmark executives treated us to dinner at the Plaza III, known for having the best steak in Kansas City. The Hallmark people were quite conservative, and Thom and Nanette complemented their values perfectly. They appeared to be the poster couple for what Hallmark stood for. I was struck by Nanette's poise and savvy; she had a quiet strength that never boasted, and she knew just how to present herself and support Thom in his role as the legendary Christian artist. She was the perfect wife supporting her husband, and she did it out of conviction and belief. She drew attention away from Thom's drinking, which I had heard could be excessive at times; toned down his jokes if they got too boisterous; and spoke of him glowingly as a husband and father. Things couldn't have gone better.

After the dinner, we shook hands with the Hallmark folks and said our good nights. As they left the restaurant, Thom nudged me and Dan and Terry toward the back of the building, where there were two limos waiting. He told Nanette we were heading out on the town. Confused, I heard him tell her he would see her later, back at the hotel.

She got into her own limo and looked out at me. I remember the look on her face—in fact, I've never forgotten it. It left an indelible impression. I saw a mixture of sadness and concern, but no anger. She spoke to me directly.

"Be careful."

Then we drove off in our own limo, heading out into the night. It didn't seem like this was the first time this had happened to Nanette. And Thom looked as if he felt he could finally be himself, after hours of being the Painter of Light for Hallmark.

As he thrust a beer toward me, I asked, "Where are we going, Thom?"

"We're going to have some fun."

He called to the limo driver and asked him what the best bar in town was.

We ended up at Harpo's in the college town area of Kansas City. The place was jam-packed with twenty-somethings quaffing beer and colorful cocktails. The music was pumping, and Thom looked like he was in his element. We sat at a table, Dan and I drinking a beer; Terry was drinking along and running his camera, while Thom had another scotch and looked around, yelling over the noise.

"Isn't this fun?"

I nodded without trying to speak. Thom laughed, knocked back his scotch and ordered another, happy to watch the crowd and nod his head to the music. I looked at Terry and his camera, and wondered how many of these nights he had captured already. In that moment I saw something in Thom for the first time: his other side, his duality. It came as a surprise to me. I had only seen him a few times since I joined Media Arts, and he was always the model of what I imagined him to be: the Painter of Light. But on this night I realized there wasn't just one Thom; there were two. Thom was the Painter of Light who had a mission to give people joy and peace with his art, but when the alcohol came out, the rip-roaring Thom emerged. He clearly believed he was put on earth to have a good time; to laugh with friends, to drink, to dance, to enjoy himself.

I was happy to see it. I didn't know Thom was such a fun guy. Thinking of him as an almost missionary figure had clearly been a misconception. Thom was a regular guy; the guy you wanted to watch *Monday Night Football* with. He was a baseball, rodeo, Bud Light, straight-shot-of-whiskey kind of guy. He was uproariously funny, and he didn't have a mean bone in his body. That night I saw that Thom was a life force. He had a light inside that lit up everyone around him. I didn't see the harm, and I didn't see any contradiction. I knew his belief in God was deep. He also clearly thought believing in God didn't mean you couldn't have fun. It made him more human to me; more approachable. I was relieved to see that side of him. Our long-standing friendship was kindled that night over booze with Thom the fun guy, who was the life of the party.

"We're going to do some great business with Hallmark, aren't we?"

I nodded again and grinned. It was great to see Thom so pleased with what I had brought to the company. Thom smiled back.

"And we're gonna have fun doing it!"

Then suddenly he got up and jumped on the bar. He started dancing, shaking his two-hundred-plus-pound frame, yelling at the top of his lungs.

"Drinks on me for everyone in the house!"

A huge cheer went up in the whole bar, a hundred or more kids clapping and laughing. Thom handed the bartender his platinum American Express card.

When he came back to the table, he sat down and grinned at my shocked expression.

"Thom, that's gonna cost you two thousand dollars," I said.

He nudged me playfully with his arm, laughing.

"Don't worry. We'll earn it back with all the business you just made us with Hallmark!"

He was right. Within two years, Hallmark was generating royalties in the seven figures.

The Pride That Always Comes First

The dip of the light meant that the island itself
was always left in darkness. A lighthouse is for others;
powerless to illuminate the space closest to it.
—M. L. STEADMAN

Within six months of the layoffs, the company stock price didn't just rebound; it soared. By 1996, all memories of the setback of 1995 were gone. The replication machine at Charcot was humming, the honeycomb quietly pumping out the honey, and profits grew and grew. Memories are short, and the bitter taste of the impending disaster that nearly was had already faded into the remote past. Black Monday had come and gone. The belt tightening had allowed Media Arts to make their loan payments and save face with Wall Street. And within one year, with the explosive success of the canvas transfer system, the profits doubled, then tripled.

Ken's focus shifted toward the day-to-day nuts and bolts work of running a public company. Every three months he held an investor call, during which he had to disclose the company's reports, talk about the previous three months' business, and project the next three months' performance. The pressure was always on to grow,

and Ken's job was to manage the company's relationship with Wall Street.

Ken, along with his publishing team, also managed the production of limited editions, overseeing the process of determining the edition size of each release to meet the ever-growing demands of the public, without violating the foundational tenets of the limited edition art business. By 1995, the company was printing editions of 50,000 prints, which quickly grew to 100,000 in 1996.

These increases posed interesting challenges pertinent to the standards of the limited editions art industry. How did you create a certificate of authenticity and still call it a "limited" edition, when the print runs were so high? The executive team in charge of publishing at Media Arts ultimately had to decide how many editions to print of any one size: perhaps 50,000 of a 12 × 18 inch size print, another 50,000 of an 18 × 27, and 50,000 more in 24 × 36. Increasing the edition sizes and numbers was one way to increase profits, and a good part of the boom after 1996 was the increase in printing of lithographs and canvas transfers alone. Within that year, the company's sales grew from $25 million a year to $50 million a year.

I shook my head, hearing the numbers. On some level it just seemed unreal. It didn't make sense, the way nothing adds up when it's too good to be true. But it paid the bills, and it wasn't my department. I had no jurisdiction in this area myself, and I had to believe that the other side of the office knew what it was doing.

I concentrated on my side, which was bringing in licensing agreements at the brisk rate of about one a month. In licensing, which is not restricted by any rules of the limited editions business, the higher the number, the better; the greater the volume, the more licenses, the better. In the first two years I spent at Media Arts as their senior vice president of licensing, I secured over seventy-five licensing agreements. After finalizing the strategic relationship with Hallmark, I went on to sign multiple calendar agreements, most notably with Day Dream, the biggest calendar company in the world at that time, coincidentally run by Chip and Chris Conk, friends of mine from col-

lege. And Thomas Kinkade soon became the number one–selling calendar at Wal-Mart.

After calendars, I went on to construct licensing contracts for music boxes, Christmas ornaments, miniature lighthouses, barns, and cottages. These pieces were all sculpted and detailed to resemble the images from Thom's paintings with great accuracy, and some were manufactured in limited editions with their own certificates of authenticity. It became a huge business.

Licensing is an entirely different animal from the limited edition prints business. Limited edition prints, which was the business of the canvas transfers, is based on the premise of supply and demand; it is necessary to limit the edition numbers to control the supply and thereby create the demand, and also to create the market value. Licensed products are essentially the opposite. It is the goal of licensing to sell as many given products as possible. Calendars, cards, Christmas tree ornaments—the highest volume of sales is the goal. Some licensed products, such as the collector plates, were also released in limited numbered editions, and they also did very well. But for the most part, licensing means taking an image and selling the use of that image to a producer that manufactures the actual licensed product and pays a royalty fee for the privilege.

I advocated to Thom that licensed products act as introductory products. Not everyone could afford a Thomas Kinkade print or canvas transfer painting. But they could buy a $10 set of cards, or a $15 ornament, or a $20 book. I hoped that having the images around in their homes would make people aspire to owning a painting one day. He understood the concept immediately and supported it fully. And the conversion rate later proved to be gigantic. Seeing that calendar every day reminded the person of Thom's imagery, and indeed eventually inspired them to own one. In that sense my division, though separate, fully supported the limited editions art business the rest of the company was occupied with.

In that year, Thom continued to develop his recurring themes in paintings. He painted *Winsor Manor* in honor of his third daughter's

birth: a stately Tudor-style home glowing lavishly from the inside with towering old-growth trees surrounding it, suggesting age and history. Once again a lamppost stood to the side, illuminating the path to the home, which was dappled with sunlight filtering through the trees. He also painted *Rose Gate* in honor of Winsor, depicting what was a frequently recurring image in his paintings of a gate; in this case, a set of the two pillars of a stone wall, covered in rose vines that led the eye toward a hidden home tucked away among blooming bushes and trees, and a soft hazy distant sky. Always the light played the biggest role, creating hot spots that attracted the gaze and pulled it into the image. *Lilac Gazebo* was also painted in Winsor's honor; it was one of many of what would become his romantic gazebo series, showing a Victorian-style gazebo in delicate framing, covered in a cascade of blossoms, set along a meandering path leading to a stone stairway into the woods.

❦

While Ken spent half of his available time at the company managing executive affairs, he now spent the other half hanging out with me, busy with the business of licensing, and the excitement of its fast success. We were together constantly, traveling to Japan, China, Taiwan, Germany, France, Italy, Mexico, and England. We grew very close in that time, and my wife and I and our three kids were occasional guests at the Raasch home in Los Gatos.

The potential for licensing products was seemingly endless. We even created an Avon catalog cover, which featured an electric waterfall, for which the opening order was 600,000 units. Avon catalogs are the focus of the Avon business. They act as the meeting place and the ordering center for Avon customers and sales reps, much like a store does. Avon sold beauty products, but also jewelry and gifts. Subscribers would wait eagerly to receive the catalog in the mail every year. And with an illuminated Thomas Kinkade waterfall on its cover, sales from the catalog reached over a million units. To be on the cover of

the Avon catalog, normally reserved for superstar beauty brands, was a huge coup for us, and even newsworthy at the time.

Licensing didn't just mean decorative trinkets and calendars. It also meant books. I forged an entire strategy for book licensing, creating products that ranged from gift books to message books to art books. Art books were published through Abbeville Press, a prestigious publishing house for art, architecture, and design, and were meant to be objects of beauty to be displayed on a coffee table.

Thomas Kinkade gift books were generally inexpensive, smaller-format books you could give as gifts to your grandmother or aunt for Christmas. Message-based books like *Simpler Times*, which was published in 1996, contained Thom's personal messages about life and faith and family, such as "Choose your color—decide that joy is the hue you want your heart to be" and "My life shines with God's radiant blessings when my heart is the color of joy."

I was intimately involved in establishing both the ideas and the content of those books, acting as the central point of coordination between Thom, the writer, and the publishing company. I worked out licenses with publishers, I hired writers and sent them out to Thom for interviews. One writer in particular, Ann Christian Buchanan, was especially good at distilling Thom's long stream-of-consciousness interviews in which he spoke about his vision of life, which I liked to say was a little bit like catching butterflies: so many of them get away, but you might be lucky enough to catch a few.

In the summer of 1996, my wife and kids decided that, after one year in San Jose, they were tired of the Northern California rain and wanted to return to Santa Barbara. They missed their old home, and their schools, and their grandparents. Besides, my wife thought certain people at the company were simply not to be trusted. We agreed that going back would be best for everyone. So I stayed in San Jose during the week and went home on weekends.

❧

I was spending a lot of time with Thom in his studio in those days. I came over for a full day about every few weeks, and we went through all the events and products and books we were licensing, and cooked up many more. He enjoyed those sessions with me, because with me he could dream. He could talk about what he wanted to do, and brainstorm new ideas. I never came to him with problems. More and more, he opened up to me and talked about his life as well. It made us grow closer as friends. By that point we were more than colleagues. And the more we ended those sessions with a few beers, the more Thom opened up to me. He always had a whiskey by his side, and always offered one. We always went for a drink after a day of brainstorming, often to continue our talking. Drinking was just part of being with Thom. I didn't question it; he was a man of the world. He enjoyed a good cigar, too; it came with the package. He had an outsized personality and he liked to live large. I felt like there was nothing holding him back, in anything he wanted to do.

This lack of limits was one thing I loved about Thom. He saw no boundaries; no rules to the game. He was free from the usual "I can't" and "I couldn't" that restrict the ordinary person's mind. He saw it all in his inner vision, and then I saw it come true. It made him creative, and it made him successful. Greatness comes from thinking out of the box; highly successful people all share this quality of accepting no boundaries. And I loved sharing in Thom's creative vision. It also made him fun to be around; he was the rebel with a good heart. The world was his game, and he played it just how he liked it.

❧

One day when I was watching Thom paint, he began to tell me about how the light entered his life when he was saved at an old-fashioned tent revival in 1980, at the age of twenty-two. He told me he was acting out as a college boy back then, being rebellious. He was just into having fun, and I knew that with his personality there wasn't any other way. But I also knew that he worked very hard at his art. He told me about

those college days, laughing about coining the term *blowawayman-ship*, and talking about his friendship with James Gurney. He mused at how they had both become so successful, when they had started out as pranksters. Perhaps it was their very freedom, their rebellion, that gave them the courage to defy the limits that hold back most people, and excel in the way they both did. College was a time for him to be young and silly, and he wasn't going to church then.

"Were you raised in the church, Eric?" he asked me.

I told him I was raised Catholic.

"Ah yes, Catholic. So you believe in the pope and all that stuff."

"All that stuff, yeah," I said.

It was always amusing to me how the mention of being Catholic drew an instant pause. But Thom forgot about my being Catholic and went on with his story. He told me his mother was a strong Christian in the Church of the Nazarene, and how she had raised him very strictly in the church. Even though he had strayed, the values were still deep inside of him. Then one day while he was still in college, Thom walked into a tent where a preacher was talking to a crowd. He listened to him for a while, and suddenly felt the Holy Spirit moving inside of him, telling him to go forward and be saved. And he did. With all of his heart, and on his knees, he gave his life over to Jesus Christ. Thom got saved that day, and he said his art got saved along with him. That was when the light had entered his life, and that was when his paintings became devotions to God and Jesus. From that day on, he had a mission and a purpose for his life and for his art. I was touched by his story.

"That's beautiful," I said.

"You probably don't have that in your religion," he replied.

"It's the same religion, Thom. We're all saved by grace." I smiled.

He winked at me. "Yeah. But you have to go ask the pope first."

At that moment his six-year-old, Chandler, came into the studio and asked him what he was doing. His girls often strayed into the studio to watch him paint. He always took a moment to explain his painting to them, taking them on his lap and showing them the light.

"See the light, Chandler? That's God's light. Right?"

Chandler looked at the painting and nodded. Light was a common subject of discussion among Thom and his girls, who now ranged from ages ten to one. Thom pointed out the light wherever he saw it—in the clouds, on the horizon, in his paintings—the way some fathers might point out a cute puppy or an airplane.

"Look, kids, there's God's light!" he'd say, and they would all crane their necks to see where their father was pointing this time. It was sweet to see their wide-open eyes, taking in the miracle their father pointed out to them, like a constant reminder and affirmation of God's presence in their lives.

If the kids strayed into the studio, Nanette came and rounded them up again, in her usual chipper manner. And Thom always remarked how beautiful she was, or how he would be nothing without her. It always struck me how sweetly Thom and Nanette treated each other when they were together. He always complimented her, and she expressed her support of him at every turn. As they appeared in public, so they were in private. Nanette also made me feel very welcome, with a greeting and a smile every time I saw her. She asked about my wife and the kids, and sent her regards. She knew how important the licensing business was to Thom and treated me very well.

Thom and Nanette's youngest daughter, Everett, was born in that year, 1998. Both of our families had four kids by then. "Kids" was always the big subject among us all, even though our families hardly saw each other anymore, since my wife and children were back on our ranch. I was making the five-hour commute every week, which after a time became a monthly plane ride, between San Jose and Santa Barbara, and that kept everyone happy. I found it just as easy to work from home using the phone, and traveled to San Jose to see Thom for the occasional meeting.

❧

When we published *Lightposts for Living* in 1999, letters began pouring in to our publisher, Warner Faith, a division of Warner Books and

Time Life, Inc. Thom's adoring fans wrote how much he had changed their lives, how they had been healed looking at his paintings, how they had regained hope and renewed their faith. Thom would spend hours reading their letters, and often read them out loud to me, proud of his message and his impact on the world.

He also read articles in the business section of the major national newspapers and magazines, and saw the company's success validated over and over again. Even if the art establishment was dismissive, it couldn't dismiss millions of dollars in royalties, and going from being ranked in the top one hundred to the top fifty new companies. The more the accolades poured in, the more Thom felt gratified and grateful. And I was helping to put him in the game with our licensing business. He received his validation not from art critics, but from his licensees and collectors. When the books first became a success, he told me we were making history; that we were changing the way the art market worked. And, most of all, that we were changing lives.

Lightposts for Living went on to become an international bestseller. It was the first time he had ever published a book without pictures. It furthered his brand and his message, and it also forever cemented Thomas Kinkade as not just an artist, but as an icon who had a message the world was very interested in hearing. Thom was thrilled to be on the *New York Times* bestseller list. Given that he was such a voracious reader, it was a special accomplishment for him. And it was one of the highlights of his career to become known in the world as an author. Together we created over thirty books, but *Lightposts for Living* was his greatest success.

He pulled out the *New York Times*, which he always read from cover to cover, and said, "Look Eric! We made it to number twenty on the *New York Times* bestseller list! God does work in miraculous ways."

Lightposts for Living was so successful that we came out with a sequel, *Lightposts for Living II.* The yearly desk and wall calendars are still being printed.

<center>⚜</center>

Global licenses expanded our business into Japan and England, where Thomas Kinkade was also beginning to be well known. But it wasn't until I came up with a line of home furnishings that Thom became *really* excited. Thomas Kinkade throws, rugs, wallpaper, and furniture were the penultimate translation of his brand at the time. For Thom, a furniture line meant he had arrived at the pinnacle of an artist's success. His paintings had become an image-based brand by being replicated on mugs and calendars. His paintings were also a message-based brand, following the publication of his many books. Now he had transcended image by becoming a lifestyle brand.

The name, the brand—Thomas Kinkade—stood for a lifestyle that could be bought and experienced and owned with furniture and accessories. The furniture didn't contain any of his images; it merely bore his name. That's why he was particularly excited. In 1998, we signed a deal with Kincaid Furniture Company and Steve Kincaid (with his ironically similar last name) to create a full line of furniture and accessories products to be produced together with La-Z-Boy. He would release the furniture line and distribute it to furniture dealers around the country. The appeal for Steve Kincaid was that we also agreed to make art that would be exclusively available to the furniture dealers across America, to carry with the furniture line as their own edition of prints. In April of that year, the release of the Thomas Kinkade line of furniture signified the pinnacle of Thom's success as an artist. He had transcended his own images and had become a legend himself. In a sense, it would always be his highest moment of achievement.

❧

After the rebound of the company, with the money pouring in, I witnessed an extraordinary explosion of wealth. Thom, Rick, and Ken went on a spending spree that seemingly went on for years. There always seemed to be more vacations, more houses, more cars, and more boats to buy. Since the first founding of Lightpost Publishing, the three nobodies who had made it big beyond their wildest dreams had to

maintain their position on the rocket ship of success. And at times, the spending spree took on a decidedly competitive turn.

Ken's initial investment garnered him a top position that he firmly held on to. He was the largest shareholder, and felt he had a proprietary right over the decisions being made in the company. His vision dictated much of MAGI's formative business strategy. Part of that strategy, diversification, had left him with somewhat of a black eye.

Rick had much influence and power within the company, and in his own quiet way, he was a master at influencing decisions behind the scenes. He asserted his position by never having an office at the company. When the company was at Ten Almaden or at Charcot, Rick always maintained his office in Monterey. It was his subtle way of separating himself from the day-to-day operations, and perhaps from Ken. Everyone had their own fiefdoms and defended their positions protectively. Rick's way of challenging Ken's authority was to keep his own offices in Monterey, and rarely show up for meetings. When we had important meetings at the company, Rick was often sixty miles away in Monterey. It was the oddest thing at the time, but made sense in hindsight as the ongoing power struggle among the three company founders quietly escalated.

Rick also carefully maintained his position of trust with Thom. He was Thom's first partner; the first to believe in him, the first to make him a success. Rick seemed elusive and mysterious, but he was always very nice and charming to me. He was a disarming person; highly intelligent, handsome, suave, dashing even. He was superpolite whenever you met him, soft spoken, but with an impressive air. He was also a strong Christian.

Rick was a brilliant strategist. Everything he did had calculation behind it. Rick attended meetings, four or five a year, but he never said much when he came. Thom was also almost never there, but would often join by phone, staying at his studio to paint. But I would see Rick, sitting in his chair and tapping on his wristwatch—he wore a Casio watch with a calculator—a watch he never changed in all the years I knew him. He would tap and tap away on his calculator, while

others were doing the talking; always calculating, always figuring the numbers. At the end of many meetings, where important decisions were made and agreed upon by the various executives in the room, Rick would get up, smile, shake everyone's hands, and be on his way back to Monterey. However, it was widely thought Rick would meet with Thom privately after the meetings and advise him as to what he thought Thom should do. Oftentimes, decisions made in executive meetings on Monday would change on Tuesday, when Thom would call Ken or Dan Byrne and tell him he had reconsidered and now wanted to do things differently. We all suspected it had been Rick who had convinced Thom to change his mind.

The two men vying for control, with Thom caught in the middle, created a triangle. Ken had more control of the company on paper, but Rick had Thom's trust. And it was my impression that Ken had to work harder to hang on to his place in Thom's esteem.

A game of one-upmanship began that was at times comical to watch. New boats, new cars, new homes; there seemed to be no end to the three men's quest for owning the best, the most beautiful, and the most expensive things money could buy. If Ken bought a new Mercedes, then Thom bought a new Mercedes and an immaculate vintage Mercedes, and a pristinely restored 1960s vintage Chris Craft boat. Then Rick bought himself a luxury yacht. Thom and Ken owned a house together on Scenic Drive in Carmel-by-the-Sea, until Thom bought Ken's share to own it outright. After selling out of Carmel, Ken bought a property in the prestigious Incline Village on the north shore of Lake Tahoe, with neighbors like Mike Milken and David Duffield, the founder of PeopleSoft, who is steadily on the *Forbes* world's richest people list. Meanwhile, Rick bought a rambling hacienda estate in Carmel Valley. Then Thom bought a gorgeous restored classic home on the south shore of Lake Tahoe where the older money lived. And whereas Ken's property was across the street from the water, Thom's property was *on* the water.

I never discussed these things with Thom or Ken or Rick. I don't think they were ever aware of it. I suspect it all went back to the first

days when they became involved with each other in business. Rick was considered the one who had essentially discovered Thom on the sidewalk when he became his private art dealer and manager. On the other hand, Ken had made the initial investment that created Lightpost Publishing, which later became Media Arts, and Ken felt a foundational ownership as a result. And Thom, of course, was painting the pictures that actually fueled it all. Vying for position, recognition, and control was surely an unconscious but ongoing competition among the three.

This subtle but fierce rivalry was most intense between Thom and Ken, who were always very close friends, but seemed to need to position themselves in terms of the other all the time. The struggle reached an apex when Ken and his wife, Linda, decided to look for a bigger house than their property in Los Gatos on Redberry Drive. Their house was a beautiful home, well appointed and spacious, with a white stucco exterior and a sprawling garden and grounds. But Ken wanted to be in Monte Sereno, which is just a notch above Los Gatos in prestige. And one day, Ken and Linda found a large estate on Ridgecrest Avenue; a penultimate Monte Sereno classic.

It was immediately clear to them that this was their dream house. They called Thom and Nanette, wanting their friends to see the property before they bought it. Thom and Nanette toured the house with Ken and Linda, and approved of their choice. While Ken went back to work, Thom went home and got on the phone and called his realtor. He said he had found a house he wanted to buy. A house on Ridgecrest Avenue. He gave instructions to the realtor to make a significant offer on the house, and proceeded to buy Ken's dream house right out from under him.

The next day I sat with Ken at lunch. He was stunned by the seeming betrayal. Ken had trusted Thom, his best friend and business partner, and Thom had bought his dream home out from under him. Ken couldn't believe Thom would do that to him. I told him I was pretty shocked myself. Ken said he had only wanted to show Thom the house to get his opinion. That he had loved the house the moment he saw it, and Linda especially had loved it. They only wanted to bring their

friends in to get their final approval; they had been ready to buy it right then and there. Ken thought Thom must have gone right home and called his realtor.

I told Ken that I really didn't know what to say. I was pretty stunned, and couldn't imagine that Thom knew what he was doing. It wasn't like him to be duplicitous. He never hid anything. I asked Ken if he thought Thom had done it on purpose. Ken told me he knew Thom's nature. That he got excited and let himself get swept away. He knew it was just the way Thom was. Ken added that his wife Linda might never forgive Thom.

Ken and Linda kicked into high gear and went on a rebound house hunt. They finally found a huge estate on Forrester Road in Los Gatos, a house that had recently been built by Ken Gimelli, a wealthy waste magnate from Hollister, California, who had run out of money in the process of construction.

At that time Thom began a massive renovation of his new Monte Sereno estate, buying up several more properties around it to increase the property size to four acres. He created a massive compound with the main house at the core, a classic California cottage-style home from the 1920s. The main house was spacious and airy and much like a Thomas Kinkade painting: charming, cozy, inviting, warm, full of fabrics and textures and details. There were large French doors leading out into a lush garden, and large white windows with shutters and white open-beam ceilings. The grounds outside were verdant and blooming, with a gorgeous pool below. The surroundings were heavily wooded, and gave that same sheltering feel to the house that his cottages evoked in his paintings. The house itself was filled with all the originals he'd kept. If you looked around the living room, you might see eight paintings valued at $500,000 or more each, which meant you were looking at over $4 million in art.

Meanwhile, Ken and Linda had bought a virtual Hearst Castle of Los Gatos. The opposite of charming and cozy, it was grand and opulent. They renovated their eleven-acre estate with 10,000 square feet of living space, six bedrooms, and five and a half baths. They added

statues and carved friezes, doors, murals, pillars, and ornate fountains. It took stonemasons over a year to fit into place the flagstones of the driveway leading up to an eight-car garage. The entrance housed a grand stairway in heavy ornately carved wood, with a mural above it painted by Roberto Lupetti, an artist who had helped restore the Vatican's Sistine Chapel. The ceiling had hand-carved plaster scrollwork and appointments such as an exquisite marble mantle imported from Italy. In the bathrooms were marble statues from Pietrasanta, Italy, and there was sixteenth-century French brick tile flooring in the kitchen. Outside there were a tennis court, a pool, and an Italian garden. In that sense, Ken got his revenge. It quickly became known as one of the nicest houses in Silicon Valley.

We were happy to visit Ken and his family at his new estate, to spend Saturday afternoon in the garden, play a game of tennis, and let our kids swim in the pool. Ken seemed content with his new abode. He ended up with the biggest house of them all. Of all my memories and times spent in this grand home, there's one image indelibly etched in my mind: Linda standing in the kitchen with her checkbook, writing check after check to a literal army of landscapers, gardeners, pool guys, maintenance men, and housekeepers. The prize of one-upmanship, this stunning house, valued at one point at $30 million, became a full-time job for Linda while Ken toiled at the office.

❖

I straddled the line between the two friends for years. I had been very close to Ken from the beginning. He had hired me; I felt loyal to him and valued him as a person. He was a kind man with a good heart, who had supported me from the beginning, something I never forgot. But I also grew very close to Thom. Thom was comfortable around me as his buddy and as a confidante, and we spent a lot of time together, both with our families and just hanging out alone.

I'd sit for hours and watch him paint as he talked about his childhood. He loved to remember the past. Whenever he did, he always

twisted the negative into a positive. He told me that I didn't know "poor" until I had been in his shoes. That many nights they didn't have food, and he would wait longingly until his mother came home, praying she had groceries for them that night. That he had given his mother all of his paper route money to help support the family since he was twelve years old.

"We were poor, but we were happy. Those were the happiest times in my life," he said.

I asked him if that was really true, given all that he had now.

"Don't get me wrong. I don't ever want to be poor again. I think about that a lot. Once you've been poor, a part of you always fears going back. I don't ever want to go hungry again," he said.

"I can understand that," I replied.

"But that doesn't mean I'm not nostalgic for those times. It's not the hunger I remember; it's the beauty of that time. We lived in those beautiful El Dorado Hills, and my brother and I would go out and explore the abandoned mines and creeks and the old mills. We'd go fishing in the ponds and catch tadpoles. We ran through the green fields, chasing each other. So many days I would spend just lying in the grass, looking up at the sky, watching the clouds roll by."

It was his notion of simpler times. While he preached those messages to the people on his tours and visits, now he was speaking from the heart and from experience. He really believed and felt that the past was a simpler time, and that simpler times were happier times.

We also used to hang out in the local bars together, getting a drink after our work was done. We went to the Los Gatos Lodge Bar and Grill, or Thom's favorite haunt, the bar at the Hacienda Hotel. There was a dive bar called the Black Watch that Thom also loved to hang out in, and another called Carrie Nations. After hours of looking through my box of samples and ideas, talking about furniture or lamps or wall coverings, he said yes to everything and we went to have that drink. It was always fun hanging around with him. He was always upbeat in that period; never depressed. He was fueled by a relentless energy and enthusiasm. Over drinks he talked life, art, baseball, and our next plans.

On one particular day, with two Bud Lights in front of us and a baseball game on the TV above us, Thom told me how his schooling in fine art at Berkeley and Art Center of Pasadena encouraged him not to care whether anyone understood his art or even liked it; only to see his art as a vehicle for the expression of self. But he said that painting was always more than self-expression for him. That beginning with his discovery of the Hudson River School at Berkeley, he was fascinated with the tradition of the American monumental landscape painters as an expression of idealism and spiritual revelry. Long before the official critical art world questioned his validity and place in art history, he had rejected the idea that art was there to serve the artist. He said he passionately felt that art had to serve the people, not the artist; and that art wasn't about understanding, but about creating good feelings for the viewer.

Sitting at the bar that day, he told me he felt modern art had it all wrong. That artists had been fighting the wrong fight for a long time; fighting for self-expression while losing their cultural relevancy in the process. He felt the artist had forgotten his responsibility to have a positive impact on society. He believed in art's constructive values and principles. He said that artists used to be cultural leaders, the visionaries of their society, like the nineteenth-century American landscape painters who tried to point to a better world by depicting the beauty of the American West. Artists at that time had led the way to the expansion into the West.

Thom's feelings about the moral dimensions and inspirational importance of art coincided with his Christian beliefs, and his conviction that his art was a form of ministry and a responsibility to share his talent as a form of exaltation of Jesus Christ. He painted scripture in many of his images. For instance, he put John 3:16 next to his name: "For God so loved the world, that he gave his only begotten Son, that whosoever believeth in him should not perish, but have everlasting life." He called his paintings "beacons of hope" and "silent messengers." He added other scripture into his paintings, such as Matthew 5:16: "Let your light so shine before men, that they may see your good works, and glorify your Father which is in heaven."

He often talked about letters people wrote to him from all over the country, telling him God touched them through his art; that people had physical healings, and experienced salvation in front of his paintings; that the despairing found hope, that the stressed found new purpose, that the grieving felt reunited with their loved ones. According to these accounts, some suicides were even averted by the power of his images.

He believed that art was so powerful because it existed outside the constraints of time.

"Art is forever," he said, sitting in the bar that day.

Thom said he was fascinated by the way art transcended time, and he pointed out that music and books are limited by the way we take them in, in a temporal way. A piece of music ends. A book is read and put away. But paintings are permanent fixtures in your home and in your visual space. They imprint themselves on the viewer's heart, since the eye is the window to the soul.

"That's why I believe art should have a positive meaning. If an image conveys peace and serenity, then I am doing what God put me here on this earth to do."

Whenever Thom talked about his art, his message was always consistent. It was about his responsibility and his calling. He passionately believed in the power of his art, and he believed in his mission to do good with it. I saw him speak to crowds of gathered fans, to adoring followers at his galleries, to people on the street who recognized him, and to autograph seekers and acolytes. His message was one of faith and family, and the salvation of the light. He was the beacon and the messenger. He shone his light on the path, for the lost and the seeking, toward the glory of God. Kinkade's message, his ministry, and his passion were deeply felt. And the buying public responded.

He ordered another beer and looked up at the baseball game, thoughtfully.

He told me it had been miraculous for him to watch what God had done in his life. Using a kid from a broken home—his Dad was a World War II veteran who left the home to chase girlfriends, and

disappeared. His mother raised two boys. She met the Lord Jesus at a Billy Graham crusade. If all this could happen to him, then he felt it just went to show that God could use any ordinary person.

"You're more than an ordinary person," I said.

"I'm as flawed as the next guy. Maybe more," he replied.

I asked him how his mother was doing, and he told me Nanette and he were moving her into a house on their property. Since buying the original house, Thom had bought up three more adjoining properties to make it all one large compound. The little boy who gave up his pennies from his paper route to help support the family was now giving his mother a home. It brought tears to his eyes when he told me.

"It's the least I could do, after all she's done for me. Did I tell you my mother used to hang up all of my paintings in our house?" he asked.

He went on to describe how she had taken his sketches and paintings and hung them up on the wall of the trailer, next to dime-store reproductions of a Monet or a Rembrandt. Thom said she made a point to hang his work up on the wall next to the great masters in an act of encouragement and a validation of her belief in him. She also took Thom and Patrick to the Fine Arts Museum of San Francisco whenever they could go to the big city. Thom would linger in front of the paintings, enthralled, and see his future hanging on the wall.

"It's so important to encourage our children, like my mother encouraged me."

He asked me if any of my kids were into art, and I told him my youngest liked to draw.

"Make sure you encourage the gift. She could be the next Thomas Kinkade."

I smiled, "There will never be another Thomas Kinkade."

No matter how you looked at it, there was always a surprise in Thom. His actions spoke louder than words. He wanted to do right in his life, and he very often did, no matter how many times he fell into temptation. At his core, he deeply believed in the power of goodness, and he wanted to spread that good faith around.

Around this time, in 1996, Thom's father, Bill Kinkade, had also made an appearance. Absent from his life after he abandoned the family, he came back when Thom became famous and wealthy. Thom never talked about his father to me. I only learned through others that he had remarried and had two more children with his new wife, and that he was living in Medford, Oregon. Thom spent some time with his father and was able to reconcile with him. His father was eighty years old by then, and there was more joy at the reunion than resentment left over from the past. Thom perhaps shared some of the vices his father had, but unlike his father, Thom was a good provider, and a steadfast father and husband; and he was also wildly successful in his life. Perhaps that might have made him blind to the similarities to the ghost of his father inside himself. Thom also had his strong faith, no matter what was going on in his life. He forgave his father and he cared for his mother because they were the right things to do.

On that day, sitting at the lounge bar in the Hacienda Hotel, musing over life and art and his mother and father, we whiled away the afternoon, talking about it all. When he reached the end of his reverie, Thom ordered another drink and looked at me.

"So, Eric. How are we going to take over the world?"

We clicked our Bud Lights, back in the comfort zone. It was Thom's favorite subject: world domination. The excitement of planning, of dreaming, of bringing vision to life. And it wasn't because of the money. It was because he believed God had a special purpose for him, and that was to influence people through his paintings. He thought that with his paintings, he would change the world.

❦

It often struck me just how different Thom and Ken were, and yet I was close to both of them. While I enjoyed my boisterous buddy time with Thom at the bars after a day of brainstorming, spending time with Ken was always very different. Thom was exciting and surprising in person, and Ken was calm and mild. Thom was open and

jocular, and Ken was quiet and reserved. Ken liked things clean and new, and Thom liked things old and messy and lively. Thom was Bud Light and whiskey, and Ken was more of a crisp white wine guy. I enjoyed them both very much, and felt lucky to have such good relationships with the men I worked with. It was sometimes hard to imagine how these two polar opposites had become friends, but it might have been their very differences that attracted them to each other. They shared a sensitivity, and childhoods that were less than nurturing, both of them having been raised without a father in the home. Perhaps they shared a need to fill an emptiness stemming from that missing element in their early lives, which made them relate to each other. No matter how much they achieved, it seemed to me that they both craved validation. And the company and its success were major sources of validation.

On the surface, Thom and Ken were great friends and business partners. But there was always a sense of underlying competition between them; a hint of tension, and staking of claims over decisions and credit for what was happening with all the success. And I was the witness in the middle of a deep bond between the two men that was always straining at the edges.

One day we were invited for the first time to visit Thom at his house in Carmel-by-the-Sea (the one he had once shared with Ken and bought him out of). It was a beautiful, cliff-side home, perched along the meandering Scenic Road. Our children played together in the house, while Thom and I sat out on the porch looking over the sprawling white-sand beach of Carmel Bay, with its jagged limestone bluffs and arching, stalwart Monterey cypress trees, and the Carmel lighthouse in the distance—a view that Thom painted many times. Thom turned to me and said, "Come on, I want to show you my town."

We went to his driveway and he pulled up the garage door by hand, revealing a red and black fully restored 1921 Model T. It had a canvas convertible roof, gleaming brass details, mounted headlamps, wooden-spoke wheels, and thin rubber tires. It had no doors and no

windshield, and looked like a toy. We got in and drove into Carmel, Thom waving at everyone he saw. People waved back, aware of who he was. He pointed out different houses, and could name them all by his paintings.

"This is the *Hollyhock* house. You remember the painting I did?"

It was fascinating to see the real houses, familiar to me from his paintings. In comparison, one could see how he had turned up the volume on all the details: how a simple home became fanciful in his vision; how it went from being a place of ordinary appeal to becoming a place of magical beauty. He captured the spooky quality of the oak trees that hang over the town and give a feeling of being in another world when the fog rolls in. You might think you were in the Cotswolds or the moors of England.

We ended up on Dolores Street, parked the Model T, and walked to the Carmel Pipe Shop. Thom had a favorite cigar, a Punch Double Maduro Robusto. It had an extrastrong wrapper, was very thick, and was only a medium-length cigar. He bought a bag and we walked across the street to Sade's, a little dive bar, where we had a beer, chatting with the locals. Everyone in the bar knew him; everyone on the street knew him. We walked back out and poked our heads into a few galleries along Dolores Street, surprising the owners with his visit. As we walked, Thom talked about how much Carmel meant to him.

"Kuskey, Carmel is a special place. It's my real home after Placerville. I may live in Monte Sereno, but my heart is here. I have a certain spiritual connection to Carmel. There's probably no other place that inspires me more."

We went back to his house, where our wives had dinner waiting. The kids were running through the house playing tag, while the women were chatting in the kitchen about schools and play dates and diapers. When Thom entered the house, loud and boisterous, everyone knew the fun was about to begin. At dinner, the subject of children dominated the conversation. As we were having dessert, Thom looked up and saw the sun lowering through a layer of clouds over the ocean. He leapt up and said, "Look kids, can you see the light of

God?" His girls all ran and put their ice cream–sticky fingers on the windowpane, gazing out at the rays of sun over the glistening ocean, and exclaimed they all saw God's light.

Later Thom and I sat out on the porch and watched the last of the spectacular sunset, drank scotch, and smoked cigars.

Thom then started talking about all the plans we had and things he was thinking about. He thrived on new ideas, and I was the one guy he could think out of the box with. I wasn't part of the day-to-day pressure of the demands on his output in paintings, and I wasn't part of the noise of the business of selling prints. Thom and I could dream up new and more exciting ways to put his image on anything that made sense, and Thom never ran out of ideas.

I also fed off of him. Sometimes his ideas seemed crazy, and sometimes they clearly worked.

"How about a garden lantern with a cottage on it? Mission style." Thom asked.

"Yes," I said.

"What about an alarm clock?"

"Absolutely."

"A train set with landscaping," he exclaimed.

"Definitely."

"A wristwatch?"

"Why not?"

He wanted to put his images on nightlights, candles, umbrellas, cookie tins, storage jars, table runners, doggie blankets. From Thom's point of view, nothing was off-limits. It was fascinating and inspiring to hear him spin the ideas in his mind.

One time I joked, "Maybe we could make Thomas Kinkade houses."

His eyes lit up, "Kuskey, that's a great idea!"

At the time I thought he was crazy. Only a few years later, I would attend the ribbon-cutting ceremony.

<div align="center">❖</div>

In 1997 Thom painted another classic, *Bridge of Faith*, which became an enduring image. It was another of his themes, a series of bridges, which for Thom symbolized his walk with God. The low stone bridge, with a rickety wooden fence, reaches over a meandering stream cascading over river rocks, with the light of the sun searing rays through the dense trees and illuminating the distant path out of the shadows and darkness. Opulent grasses and flowers decorate the dense wooded setting. For Thom, it signified moments of revelation and joyous acceptance, and it became a big seller with his avid collectors.

<center>⚜</center>

Valley Fair Mall is an upscale, premier shopping destination for residents of Santa Clara and San Jose, and all of Silicon Valley. With nearly two hundred stores, seventeen food court locations, and nine restaurants, it is one of the largest malls in Northern California. In 1997 Media Arts first opened the Thomas Kinkade Gallery in the mall, believing it was better to sell Thom's artwork in a gallery dedicated wholly to his art, than trying to sell it in a multiartist gallery. This formula was such a success that they soon opened several more dedicated galleries in Carmel-by-the-Sea, Monterey, Hawaii, San Francisco's Fisherman's Wharf, and even Kansas City. The success of the new galleries kept Ken busy. And while sales of canvas transfer paintings increased significantly through these new venues, the need for more volume and more profit was always looming.

By far one of the most significant aspects of Thom's creative vision was when he came up with the idea to open licensed galleries to sell his replications. Until that time, it was the foundational business strategy to continue opening and managing company-owned dedicated Thomas Kinkade stores. But it was going to take too long and be far too expensive to build and operate them. Thom had taken quite an interesting tidbit away from our Hallmark visit to Kansas City. He had asked the executives how Hallmark could afford to open so many stores throughout the country, and they had explained that they didn't

own or operate these stores themselves; instead, they licensed stores under the Hallmark name. Proprietors could obtain these licenses and run the stores, with the agreement to buy and offer for sale a certain minimum amount of Hallmark products.

"Why don't we license galleries for people to own and run, and let them sell the canvas transfers for us?"

The idea immediately took hold. They would be called Thomas Kinkade Signature Galleries. It was a way to show Wall Street we could keep overhead down and increase profits. Rick suggested creating a training center in Monterey, where people could become familiarized with the galleries, learn how to run them, and sign on the dotted line. People could be preapproved and given a limited slot in a monthly training session, after which they had to commit to buying the license for a gallery. For Rick, whose sales techniques were formidable, it would be a natural.

While Thom was always the idea guy, the one to come up with the germ of a concept, he left it to the rest of us to put his visions into action. While he went back to his studio to paint, the rest of us had to do the actual legwork, develop the concepts, draw up contracts, and make the deals. The galleries became Rick Barnett's personal project. He shaped the concept and the details himself. The contracts, the terms of the licensing, the requirements for qualification were all hammered out in Monterey at Thomas Kinkade University. Thom wasn't involved in the details. He didn't want to know, and he didn't have the patience or the understanding for business and contracts. He trusted Rick implicitly and let him handle the business on his end. Rick hired a Harvard PhD financial whiz who helped shape the deals and draw up the contracts for him, and Rick had the final say in their execution.

Within two years, the signature galleries were a hit. Profits continued to climb and we all did very well. It was a great place to work then, and we felt like winners, although of course no one profited as much as Thom, Ken, and Rick. Between the three of them, they owned well over half the company stock, and on paper were probably

worth over $100 million. While the rest of us at the company went from doing well to doing great, they went from being rich to being superrich.

In 1998 Thom painted another one of his classic paintings, *Garden of Prayer*, the first of his most famous series of gazebo paintings. In it a classical gazebo, with six alabaster Ionic columns and a copper decorative scrollwork dome, stands beside the shore of an ambling river, which pools near the gazebo. A meandering path leads the way into the distant woods through an open green metal scrollwork gate. Flowers and leaves sprinkle the entire image with cascades of colors. Thom said it symbolized man's connection to the creator, by being in his creation, and that a visit to the gazebo would bring every viewer of the image closer to their God.

At this point, collectors were lining up to purchase the latest release in his series, which came out once a year. Thom painted about ten paintings a year; there would be a bridge painting, a gazebo painting, or a lighthouse painting. The seduction for the collector was that it became irresistible to have to have the latest incarnation in a series. Thom was hitting all the right notes with his audience, and the galleries and collectible shops were filled with patrons. When art professors asked their students to name a living artist, many times the only name that came to mind was Thomas Kinkade.

On November 2, 1998, *Forbes*'s cover story was "The 200 Best Small Companies," and Media Arts was named one of them. Ken did the interview for the magazine, as he usually did. The article featured a picture of him facing the camera with two Thomas Kinkade paintings behind him. The photo distorted his face through a wide-angle lens so that his head looked much too big. It was an odd editorial choice, but

perhaps, through its extreme perspective, it gave a sense of expansion and forward motion.

The article briefly described the success of Media Arts and pointed out the most pertinent details: that sales were expected to top $120 million in the upcoming year, and that Media Arts had been growing at the rate of 37 percent every year since 1995. It stated that the replicated artworks in the signature galleries sold for amounts ranging from $30 to $1,500, and that although Media Arts only owned 27 galleries outright, there were 140 galleries selling his work because of the increasing numbers of signature galleries. This unique cost structure meant that Media Arts kept its operating margins at 20 percent and its return equity at an impressive 57 percent. The article also mentioned that licensing revenue had jumped from $1.9 to $4.2 million that year.

Ken was quoted only twice in the article, but his brief statements were just enough to do some real damage, by touching on the subtle competition over who really ran Media Arts, and who really contributed to the success of the company. Ken summed up the nature of the company in one sentence: "We think of ourselves as an emerging consumer brand, a lifestyle company." He didn't directly refer to the massive appeal of the art or the popularity of the artist. In short, he didn't refer to Thom as the leader or the visionary he clearly was. By implication, it could be construed that Thom's contribution was certainly his significant skills as a trained artist, but that contribution might be perfunctory compared to the marketing genius exhibited by the company that supported his art. Ken framed the article and hung it in his office, and gave me a framed copy as a gift.

This was just another in a long line of articles that had built up frustration for Thom. He never felt he was given his due adequately when Ken gave interviews on behalf of the company. Thom always felt there was more to say about how the art was impacting people, and why they were responding the way they were. To Thom, it seemed like Ken was focusing more on the business model, which tended to weight the credit toward himself. When Thom confided in me, I could hear his palpable frustration.

"Where does everything in the company come from? It comes from me. From hundreds of hours I spend behind the canvas. I think people forget that sometimes. You know how I know that it all comes from me? Because I spend night and day painting. I'm tired sometimes, Eric, but I know I have to keep going. If I stopped, everything would stop."

This was also the first time I became consciously aware of Nanette's influence in Thom's affairs. Nanette generally kept a dignified distance from the business, surely consulting with Thom privately, but never appearing to interfere in business meetings. But in this case, her displeasure became known. From their perspective, as newlyweds Nanette and Thom had spent what little money they had to start manufacturing and selling lithographs of Thom's artwork, long before they met Ken. Thom acknowledged it was Ken's initial investment of $30,000 that made it possible to execute their vision on a larger scale, and allowed that vision to grow into something. They also acknowledged Ken's contribution. But for the article to imply that this company, begun by all of them, was merely a marketing machine, as opposed to the result of the toil and genius of the painter, was too much for them to bear.

Nanette was fiercely protective of Thom, and anything that hurt him or wasn't beneficial to him, she just didn't like. Thom was everything to her and the family. She knew how hard he worked and she was always supportive; stood by his side, smiled at him, was gentle with him. She touched his shoulder, and held his hand. She knew he needed the stable home environment she could provide, so he could work in peace. And she also wanted him to have the dignity of getting credit for all he did. It was her strength and her loving support behind the scenes that kept him going, while she never asked for any credit herself.

With the rumblings over the *Forbes* article and frequent contentious discussions in the executive meetings, it became clear to me that the cloud that had followed Ken since Black Monday had begun to darken. Although Ken was the largest shareholder, and had been CEO and was still chairman and president of Media Arts Group, some people thought there was a pattern that could be seen in retrospect. Some

openly said his penchant for diversification had resulted in monumental financial losses for the company.

With the growing mistrust over his past performance, and the *Forbes* article brewing even more trouble for Ken, a power void began to emerge. As if to fill this void, Rick Barnett stepped up and seemed to take a bigger and more important management role in the company. To his credit, Rick was always openly against diversification. He didn't care about other artists, and he said so. Anything having to do with new artists or new products, he was always vehemently opposed to. But outwardly he would only politely disagree.

Rick would concede that he could see people's point of view; that they felt to diversify was necessary to take the pressure off Thom. And then he would say that in Monterey he was seeing the overwhelming response to Thom's work and he just didn't see how diversification was necessary, and would end on, "I'm going to agree to disagree."

Then he sat in the rest of the meeting and tapped on his watch, always tapping, never telling anyone what he was calculating. If someone finally turned to him and said, "Rick, what do you think?" he would take a deep breath, very dramatically fold his hands, and lean back and say that he just didn't agree with diversification. Then he would get up at the end of the meeting, get back into his BMW, and drive back to Monterey, not to be seen for another couple of months.

We would pick up the phone and call Thom and tell him about the decisions we had just made in the meeting. He'd be on speaker talking to the group.

"That's fantastic! That's great news. We're just gonna conquer the world, aren't we? Good job," he would say and hang up the phone.

The next morning he would often call Ken and say, "I've changed my mind. I don't think this is a good idea. Here's what I want to do . . ."

We came to expect it. Thom was in a sense a weak person, easily influenced, especially by Rick. We all knew by the patterns that Rick would politely disagree in the meeting, get in his car, and stop by Thom's cottage on the way home and tell him what to say to management the next day.

The first era of the company could be called the Ken Raasch era, in which diversification (which later became known as the D-word) had failed to serve and ultimately understand the art business Thomas Kinkade created, and had almost cost the company its existence. Now the Rick Barnett era was about to begin, and the name of that game began with a capital *S*. As in *Sales*, without much of a watchful eye toward the perception and emotion of the buyer, and the typical art market management of scarcity.

For most of 1999, tensions and conflicts rose steadily. Although Ken was no longer fighting for diversification, he still exerted his decision-making power. Previously he had sent Dan Byrne to England for months at a time to try to fix what could not be fixed with the David Winter Cottages division. David Winter had once been a leader in the miniatures market, but the market had long collapsed. Dan did his best, but there just wasn't much to salvage. And the memory of the David Winter Cottages acquisition was etched in everyone's mind.

Thom began to withdraw more and more. He was never seen at the offices; he came in maybe once a year. If you wanted to meet with him, you had to go to him. And only if you could get past his secretary. Thom only liked meetings in which he could think forward, plan, and dream. He didn't like dealing with day-to-day business issues, and he didn't like conflict. In fact, Thom avoided confrontation at all costs. He wanted everyone to be happy, especially himself.

I had some mock-ups I needed Thom to approve, and had tried to get through to him for weeks, but his secretary kept telling me he wasn't available. I understood her job was to protect Thom; she guarded him like she was the Seventh Cavalry protecting the Black Hills. After she told me Thom would be out of his studio for the rest of the week, I decided to drop off the files I had for him at Ivy Gate Cottage so he could have a look at them over the weekend. When I got to the gate, Nanette answered the intercom.

"I'm just dropping something off for Thom," I said.

She told me to come in and head for the studio. I pulled up to the cottage and walked up to the door and was surprised to see Thom

sitting inside at his easel. He saw me through the window, smiled, and waved me in.

"I thought you were out of town," I said.

"She says that so I can have some peace and quiet."

I told him a lot of people at the company were waiting to talk to him. He said they would manage without him. After all, that was what a team was for.

"My job is to paint. The business will take care of itself."

I walked over to look at the painting he was working on. It was a thatched-roof cottage nestled in a lush woodsy garden full of bloom. I told him it was beautiful.

"It's *Everett's Cottage*. I'm painting it for her first birthday that's coming up," he said.

"She'll treasure it always," I said.

"A family is like a garden. Every child is a delicate flower that will bloom with the right nurturing," he said. Thom always talked in this way; the same way he wrote his books. It wasn't just on paper; Thom could hold forth on how to live one's life all day long.

The painting was truly stunning. A misty background connoted the mystery of a life still unfolding; the warm inviting light in the cottage, the germ of a young child's destiny just beginning, growing and developing inside, nestled within the harboring beauty of nature and the garden. Thom's images were always full of symbolism. I was most moved by his devotion to his four daughters, and his dedicating timeless cottage images in their name.

I placed the mock-ups on a nearby table and told him I would leave them for him to look at whenever he was ready.

"Stay. Keep me company," he said.

I began to understand more clearly that Thom wasn't busy; he was just hiding from the company. It wasn't in his nature to deal with business matters anyway. He was at his easel where he belonged. But I could also see how lonely he was. Thom's work required extraordinary attention to detail, which is why his paintings took him hundreds of hours to complete. He seemed happy for my company. I was the

kind of company that wouldn't pressure him or make demands he was uncomfortable with.

He finally turned to me and said, "Let me tell you something that might surprise you."

I said I was all ears.

He told me that when he traveled to England, to the Cotswolds to see the cottages there, he just found them so interesting and charming. He stayed at the old historic Lygon Arms in the quintessential Cotswold town of Broadway and walked the streets, looking at these small cottages all over town, which were originally built in the 1300s, and which had been added on to for over eight hundred years.

"Imagine how they looked, cobbled together through time," he said.

His brush kept dancing over the canvas as he spoke, and once in a while he would glance over at me. I was riveted, waiting for the secret.

He said he studied these cottages, one after another, trying to figure out what made them so charming. And then he saw that the windows and the doors and the rooflines were quite chaotic. They didn't make sense anymore from all of the additions over time. They all had crazy angles where one roofline would dive into another roofline or into a window. And there would be a door that led seemingly into nowhere. All of that chaos gave these cottages a mystery and charm.

I said that I could see what he meant.

He talked about the optic nerve, which we discussed a lot in our meetings, just as they do in advertising. The optic nerve takes in an image in a split second and tells the brain, before you can even think, if it likes what it's seeing or not. He told me that's how the Cotswold cottages were.

"They hit your eye and you just love them right away. That's what I try to capture," he said.

He looked at me and smiled. He could see I was amazed.

He then told me this was his pixie dust. It started with these Cotswold cottages and what he saw there. He decided to bring that charm of chaos and dissonance into his French country manors and his cot-

tages. He just made everything even more impossible and dramatic. He started painting windows in interesting places, and made them too small for an ordinary person. He jumbled up the rooflines, and added light that made people want to know where it was coming from. Like in a fairy tale, it drew you in. It was his secret. The charm of chaos was in all his paintings.

I was blown away. To hear the secret of the appeal stated outright was amazing to me. I felt like a sorcerer's apprentice gleaning the gift.

I stayed for a few hours listening to him tell more stories. And I showed him all my mock-ups. Before I left, I invited him to an upcoming event in San Francisco I had tickets to, and he gladly agreed to come. It was the annual Fine Wine and Cigar Expo, and as much as we both loved cigars, I figured he would be the perfect person to take along.

On the day of the expo, weeks later, I left work early and arrived at Monte Sereno by noon, where a black limousine stood waiting for us. Thom had a regular driver, a loyal and dependable man from the Philippines named Bo who took him everywhere, and was on call twenty-four hours a day.

As the limo pulled out of the estate, Thom showed me the stash of cold beers on ice and the bottle of Johnny Walker Black. He held up the bottle of whiskey.

"Eric, have a snort of whiskey with me."

It was his favorite phrase: a "snort" of whiskey.

I looked at my watch. It was barely one in the afternoon.

"No, thanks, I'm fine."

"No problem at all. I'm just gonna pour myself one."

On the drive to San Francisco I nursed a Coors Light from the icebox, while Thom had several shots of whiskey. Thom could put down liquor, and he often started in the middle of the day.

He pulled out his treasured humidor, which I had often seen in his studio. He had brought it in the car, and offered me a cigar. I told him how much I admired the humidor's burl walnut finish.

"They call it bird's-eye walnut. I'll get you one when we hit a million dollars in licensing."

He later did, and the humidor is still sitting in my office with a plaque that reads: ERIC KUSKEY. WITH APPRECIATION THOMAS KINKADE 1998.

On the drive, Thom asked me about friends of mine I had mentioned to him in the past who ran the National Museum of American Illustration in Newport, Rhode Island. He was very intrigued with the museum and its collection. Thom was a great fan of the American illustrators of the past; artists like Howard Chandler Christy, Howard Pyle, Maxfield Parrish, and Norman Rockwell. He talked about his dream to own a Norman Rockwell someday.

Thom loved Norman Rockwell more than any other painter. Rockwell personified the kind of images Thom believed in. Pictures that showed a quintessential American scene, with moments of connection and emotion, set within a deeply cultural context. His favorite painting was *Freedom from Want*, Norman Rockwell's famous image of a family gathered around a Thanksgiving meal, which he painted as part of a series entitled "The Four Freedoms." *Freedom from Want* must have touched Thom at his core. Here was the man who as a boy sat by his window, hoping for his mother to bring home food. He must have understood the need for that freedom most of all. He frequently talked to me about this series and how much it meant to him.

"Aren't these beautiful notions, Eric? *Freedom from Want, Freedom from Fear, Freedom of Speech*, and *Freedom of Worship*. That's my life right there, captured by Norman Rockwell. Everything I care about, everything I stand for, is in those paintings."

As we neared San Francisco, he asked me if I knew about *The Pied Piper*. I didn't know what he was talking about. He said it was the famous piece by Maxfield Parrish painted in 1909, and asked if I knew it was hanging in San Francisco. I told him I didn't know, and asked him to tell me more.

"We're going there," he said. "You won't believe it when you see it. There is a masterpiece hanging in the Palace Hotel. We'll go before the expo."

"Great," I said, nursing my warming beer.

I was not prepared for the turn-of-the-century grandeur of the art deco Palace Hotel in the financial district. We entered the Pied Piper Bar and Grill. I was stunned; Maxfield Parrish's masterpiece *The Pied Piper* hung above the bar.

We grabbed two stools and sat in front of the 6 x 16 foot painting, marveling at the vibrant colors in the image of the pied piper leading the children astray.

Thom ordered another whiskey and I had another beer. By this time Thom had already had three drinks in the limo, but I hadn't taken much note. We talked about the look on the face of the pied piper and the expression on the faces of the children, the exquisite detail, and how the painting transports you into another world. Thom told me that, in fact, the face of the Pied Piper was Maxfield Parrish himself, which had always fascinated him. We had a sense that the clock had stopped, just looking at it. We discussed the history of Maxfield Parrish and illustration in American art. I had been educated in the art that mattered to him, and he enjoyed talking to me about it.

Thom was in a reverie.

"Things mattered then. The human experience mattered then." He looked at me. "Things don't seem to matter as much anymore."

"It was another time, that's for sure," I said.

"Sometimes I think I belong to that time. I should have been a painter then. I would have been one of them."

"I think you *are* one of them."

He smiled. He thought so, too.

"I'm going to show them all one day. I'm going to show the world. I may not live to see the day, but when the book is written, I'm going to be known as the modern-day Norman Rockwell or Maxfield Parrish."

It made me feel a little sad, hearing him say it. There was something morbid, something foreboding about it that I couldn't put my finger on. Looking back, I think he knew the art world wouldn't accept him, and he already had a sense of his own mortality.

I told him there were plenty of people who respected him. That he was far more successful than Norman Rockwell was in his lifetime.

He said he knew he had the heart of the people, and that was what mattered most. But he felt he would probably have to die before he got respect for what he did.

"It's just how the world works. And that's all right. It isn't about me. But I do want to be remembered," he said.

I told him nobody could forget him, and clapped him on the back and got up from the bar stool. I said I would go run to the bank across the street and be right back. Thom picked up his drink and gazed at the Maxfield Parrish painting.

"Take your time."

I rushed across the street to get some cash. I wasn't gone for more than ten minutes. As soon I got back, I walked into the bar expecting to see him at the counter, but Thom was gone. I went outside. I looked in the lobby and didn't see him. I went out to the street. He was nowhere. Then I saw a dive bar across the street. I had a feeling he might be there, so I crossed over and stuck my head inside. There was Thom, sitting at the bar, knocking back another whiskey.

When we entered the expo, I had the sudden feeling that I was bringing a cat burglar into a diamond store. We started at the cigar section and stopped at booth after booth, where companies offer samples of their best cigars, and wine and port. Every booth you passed had a tray of plastic glasses filled with alcohol. I sampled a few here and there, but Thom was sampling the wine at every vendor. They were little glasses, but he would drink one or two and walk on to the next booth. After forty-five minutes he had probably consumed what seemed like twenty of those little glasses of wine. And he was beginning to swerve and sway.

I said, "Let's get out of here and get a breath of fresh air."

He said, "I gotta go take a leak," and promptly walked off, mistakenly walking into the ladies' room.

I was waiting nearby and hadn't seen him go in. Suddenly I heard a scream and commotion. I turned just in time to see Thom quickly coming out of the women's bathroom, drunk off his ass, his hand on his zipper, laughing hysterically.

"I was wondering why there was no urinal in sight! What kind of place is this?!"

We were both laughing hysterically by now. All I could think was, "Oh my God, the Painter of Light just went into the ladies' room at the wine and cigar expo."

Before I could stop him, he turned and went in again, on purpose. I was horrified.

"Thom!" I tried to call him back, but he disappeared inside.

I looked around and thought, "This cannot end well." I decided to go back into the expo to wait for Thom. I waited for ten minutes, but there was no sign of him.

I went back to the booths and looked everywhere. Finally I headed to the front entrance and stepped outside. There I saw two police officers standing with Thom sprawled out on the hood of their car, one arm behind his back, starting to put his hands in handcuffs. He was grinning, oblivious to the seriousness of the situation.

I rushed over to the policemen and introduced myself.

"I'm terribly sorry, officer. I was supposed to be with him. He might have had a little bit too much to drink."

"A little too much? This lady said he kept coming into the women's bathroom. Somebody called hotel security."

"I understand. But please, his car is right here," I pointed to the limo. "If you could release him into my custody, I will see that he gets home safely."

The officers looked at each other. They were smirking, too. They had no idea who he was. Here was this huge guy, clearly inebriated, laughing and slurring, sweat dripping down his face. They thought he was just another loopy drunk.

"Take him. Get him outta here."

They released his cuffs and I guided Thom to his limo. Once inside he laughed, falling back into the seat.

"You really saved my ass, Kuskey."

I closed the door as quickly as I could and told the driver to take us home. But Thom had another idea. He rapped on the driver's window.

"Take us to the Gold Club."

I didn't know what the Gold Club was, but it sounded like a strip club to me. The driver nodded and drove ahead as I watched Thom slowly slide down in his seat, his eyes closing. Within a few blocks he was fast asleep, snoring.

I tapped the driver. "Take us back to Monte Sereno."

I slept in the guest room of the cottage that night and woke up with a headache. I expected Thom to be out for the day, but when I dragged myself into the sunlight, I saw him sitting at his easel, his hair combed neatly, fresh as a daisy.

"Morning, Eric! How about some orange juice?" he asked, smiling as if nothing had ever happened.

When I told Ken about the experience, he said he was sorry I had to be subjected to that. But I really didn't mind. It was all part of the fun and boisterous and sometimes silly personality that Thom had. He was a guy with a bawdy sense of humor. He lit up a room, energizing everyone around him. And part of the fun was the drinking. Because of his jocular ways, it was hard to see it as a problem.

<div align="center">⚜</div>

Thom lived like there was no tomorrow. Everything was big and large and loud. He had an appetite for life, for food, for drink, for beautiful things and beautiful women. He consumed life as if there wasn't enough go around. I often had a sense there was urgency, and a sense of his mortality, in that appetite. He made frequent mentions of not expecting to live for long; of not being around to see this or that event. He often referred to things that would happen after he was gone. He would talk about the artists of the past, and would ask me why I thought so many great artists died young. I chalked it up to his romantic notion of the kind of painter he thought he was, and an overidentification with the likes of van Gogh or Toulouse-Lautrec. But looking back, these statements were consistently urgent.

When Thom ate a meal, he would sit, shoulders hunched, his up-

per body inclined over his plate, shoveling the food into his mouth as fast as he could. Watching Thom drink and eat was a bit like watching an Olympic sport in progress. It had the feel of a fierce competition against an unseen opponent. Perhaps it was an urgent need: the hard-to-quell childhood anxiety of not having enough. A whole beer was just a sip for Thom. If he drank iced tea, he would drink the whole glass in one gulp. When everyone ordered their dinner, Thom would sometimes order two entrées.

Thom was a great fan of the opposite sex. Like a child with no boundaries, he got carried away with everything that excited him. And to say that one particular thing really excited Thom would be a mis-statement, because absolutely *everything* excited Thom. He was the proverbial kid in a candy store, every day of his life. The hunger, the appetite, the voraciousness with which he took it all in—the beauty of nature, the thrill of a ride on his Harley, an all-night gambling spree, the transporting experience of spiritual rapture—always made it seem as if he felt it might be his last time to enjoy whatever he was experiencing. Thom read not just one but four books at the same time: history books, pulp fiction, spy novels, newspapers. He would devour them in a matter of days and move on to the next. He fed his mind, his body, and his spirit with a passion for life, and sometimes with indiscretion.

His accidental foray into the ladies' room at the Fine Wine and Cigar Expo was an accident that became a child's prank. There's no excusing it, but there might be some perspective to be gleaned that brings one closer to understanding what made Thom tick. He was unfiltered; he had no malice, no premeditation. You saw his thoughts in action as they were happening, and they came out unbridled and unexamined.

All the fun made it easy to overlook the deeper problems beneath. Ken had known Thom for a long time, and he was genuinely con-cerned that Thom was ill. And after seeing Thom nearly in handcuffs, for the first time I understood why Ken was worried.

As the tensions rose between Ken, Rick, Thom, and their respective teams, we began to hear rumors that Thom was going to bring his pastor into the company to help mediate and facilitate healthy communication.

And then one day he appeared: Pastor Mike Kiley, sporting a full white beard and glasses. He immediately went inside Ken's office and closed the door. An hour later, he came out again. Then he walked into the office of our CFO, Bud Peterson, and closed the door. Another hour passed. And so it went; we all received visits from Pastor Kiley. He introduced himself and said he wanted to be a neutral party in all discussions. With a soft demeanor, he stated that he would do whatever he could to build bridges and encourage friendly communication.

In the weeks and months to come, Pastor Kiley would be seen walking the halls, his hands clasped behind his back, smiling at everyone. On his arrival, it appeared to me that Pastor Kiley didn't know what a licensing agreement was, or how the canvas transfer system worked, but he sat in on all of our meetings. Within a year, Thom had given him the title of vice chairman of the board. Pastor Kiley began to be part of the decision making, and ultimately ended up making decisions himself. A period of chaos began that would never really abate.

We now sat in executive management meetings with Pastor Kiley praying over decisions, and listening to him sermonize on business practices. In board meetings, when tempers were running high and tension was thick, Pastor Kiley would raise his hands, looking around the room. He would ask us all to take a breath and remember who we were and what the company was.

Everyone would begrudgingly pause and breathe.

He asked us not to lose sight of who Thomas Kinkade was. He asked us all to remember the man we were talking about, and who we all supported with our hard work.

The executives would remain silent, as Pastor Kiley continued speaking in his measured pastoral voice, from his practiced spiritual counseling experience. He intoned that we were a mission-based com-

pany, and we all needed to remember that mission. Our mission was to change lives and to spread peace and love into the world. He would ask how we could do that if we didn't even have peace inside our own four walls.

He would look at everyone at the table. He said we had a historic opportunity to change the world. And he asked who else could say that out there. Not Coca-Cola. Not Chevrolet. We were changing the world from inside people's homes. We were entering into their lives and having a positive effect. And he reminded us it was Thom's wish that we all get along.

There was silence in the room. Everyone knew to let him speak his peace before we could get back to business. Then Pastor Kiley bowed his head and said a prayer.

I couldn't help but wonder what Wall Street would think if they knew about the churchman in the boardroom. Kiley was a trained counselor, but his training was in religious-based counseling and certainly not in business affairs. Kiley was also drawing a salary and now, as vice chairman of the board, the new title might have gone to his head. But he was a man with good intentions, and he kept Thom calm in the times when things were beginning to get heated between all factions. In that sense, I think he did his job.

But Pastor Mike Kiley wasn't the problem; he was just the tip of the iceberg. A revolution had slowly been brewing, and it was about to come to a head.

The art business is run by people who know the business of art. In order to be effective, you need to know what the art business means from a historical and practical sense. It's not merely about selling; it's about the mediums used to make the art, the history of the art and its precedents, and having a perspective about the art market, from the masters to contemporary artists. You should know what a stone lithograph is, or a serigraph, or why some painters use oils and others acrylic. You should know how Andy Warhol used multimedia, and how he created his famous Campbell soup cans series. You have to understand art's place in history.

Obviously, most vacuum cleaner salesmen are not trained in the business of art. Rick Barnett, however, had learned. A brilliant man, he had become an eloquent American art scholar. He knew the importance of being able to describe Thom's place in history. He was also Thom's biggest fan, perhaps only second to Ken. This struck me as right; that Ken and Rick were truly Thom's biggest supporters and his most avid fans. But when it came to talking about Thom, no one could talk about the art better than Rick.

He would say that Thom was America's most collected artist, and point out that Thom's works hung on twenty million walls in American homes. There was no artist whose images could be seen on more walls than Thomas Kinkade's. Not one artist in the history of the world came close. He said that probably not a day went by that the average person didn't see an image by Thomas Kinkade. No artist had been accepted by the public, collected, and was as beloved as Thomas Kinkade. His work was spiritual without being programmatic. It was rich with symbolism and metaphor. We weren't just talking about extraordinarily beautiful paintings of extraordinary craftsmanship, but meaning and message and purpose. Rick said that every one of Thom's paintings had something to say about the meaning of our lives.

As conflict over executive decisions, ownership and control, and the direction of the company was at its height in 1999, it was my impression that Rick was spending more and more time with Thom. No one had the kind of access to Thom that Rick did. Thom would close Ken out, but when Rick called, Thom always answered. At times Rick seemed to be the only one Thom trusted. And Rick steadily pointed out that the company was about sales, not diversification. That we needed to learn from the past, and we couldn't go back to what happened on Black Monday.

The power shift took its course. Rick's influence seemed to grow as Ken's diminished. Rick wanted sales, and with those sales, of course, came his commissions. To focus the agenda on selling, Rick suggested bringing in the best salesperson he knew: Greg Burgess, another former vacuum salesman and colleague of Rick's from the Kirby days.

Burgess didn't cut the figure of a senior executive in an art business. He had the demeanor of a former vacuum salesman, with studied body movements and smooth verbal cues. You wouldn't ever think of him as someone in a senior position at the biggest-selling art business in the world. Then Rick brought in Brad Walsh, another colleague from the Kirby days, to add to the executive sales team. Brad was a short and stocky character with a quick smile. Then Howard Walsh, Brad's father, joined the board of directors; a rotund graying man who was the retired CEO and chairman of the board of the Kirby Vacuum Company. All three Kirby guys had fast smiles and hardy handshakes, and they were killer salesmen. Driven by numbers, these guys could have just as easily sold sunglasses or staplers. With the new Kirby vacuum team taking over the direction of the company, numbers truly took over. It was all about the bottom line.

Rick even brought in an operational executive named John Lackner, and an attorney, Tim Guster, who became the general counsel for Media Arts. Both were also former Kirby employees. Sometimes it seemed like a coup from the inside by stacking the deck. With Kirby colleagues in the company, Rick gained a significant amount of control over the overall agenda. It began what could be called the second phase of the company: the era of Rick Barnett. No one knew it was the beginning of the end.

❖

Ken was a good person, but he was also a complex character; fiercely competitive, yet endearing to those who knew him. He was the kind of person who would beat you in a race and then come over and hug you. His life began modestly, similar to Thom's; Ken was raised by a single mother and a grandmother. And he always had an intense desire to be rich. In some ways it could be said that Ken had made all his money from the chance meeting with Thom at a wedding. Some people said they felt Ken's rapid success colored his perception of how hard or easy it was to make money. He never had the chance to learn the ropes,

or learn from mistakes, before he was already making millions. But even though Ken had had the idea of diversification, everyone else had jumped on board with it. When it failed, Ken was left holding the bag. He was the one everyone doubted; the one everyone blamed. When Greg Burgess and Brad Walsh came on board, there was no more tolerance for doubt. Within months the revolution took hold.

In this period of upheaval, I tried to focus on my own business and stay out of the corporate politics playing out among Ken, five Kirby vacuum salesmen, and a pastor whose lack of business experience was increasingly pushing him toward what seemed like a meltdown.

I was busy building the Thomas Kinkade Furniture line we had licensed and were about to reveal at the International Furniture Expo in High Point, North Carolina. We had rented a beautiful historic home, the Tomlinson House, in the country club enclave of High Point, to stage and feature the new line of furnishings.

The boardroom stress had also gotten to Thom, who was keeping more to himself, sequestered in his studio spending long days and nights painting. A trip to North Carolina would be a welcome reprieve for us all, and an excuse to celebrate. After all, the furniture line was one of Thom's most prized achievements. For Thom, furnishings were more substantial than collectibles; they were literal three-dimensional manifestations of his vision, turned into everyday objects of use.

We were staying at the Tomlinson House the night before the debut. The house was a creepy old Tudor-style historic home, built in the 1920s, and it was said to be haunted. It had a dark cellar and Thom had been taking people down there all night, turning lights on and off, having fun spooking them. Dan Byrne, Ken, Terry Sheppard, his videographer, and others from the company were there. Everyone was riding high on the success of the furniture line. Steve Kincaid's company had thrown a big party for everyone in attendance earlier that night. After the party cleared, only those of us who were staying at the house were left. And Thom was just getting started.

"Come on guys, let's have some fun. Let's play a game. Famous names game. Anybody who loses has to take a drink."

It was a little ironic. Thom advocated shutting off the television and playing a board game with your kids, to be together as a family. This was perhaps his way of interacting with the company family. And those who rarely got to see Thom outside of work situations were particularly tickled to observe him in rare form.

As we sat in a circle, someone began by naming a celebrity, and whatever letter that celebrity's name ended in, the next person had to name a celebrity whose first name began with that letter. If you couldn't think of a name, you lost and had to take a drink.

We threw out names from Kevin Bacon to Nat King Cole to Elle McPherson to Nick Nolte, after which Thom couldn't think of anybody and had to take a drink. We all got a little tipsy along the way, everyone in stitches, mainly over Thom's constant jokes and antics. Thom even tried to go to bed at one point and undressed down to his white skivvies, only to come down moments later and rally the troops again for another round of drinks and games. The evening ended up with him dancing around in his underwear; a 250-pound man running through the house half-naked. No one thought much of it or said much at the time. By three in the morning. he was charging around the house, half dressed, singing, playing the piano, and chugging vodka right out of the bottle. Everyone laughed hysterically until we heard that soft-spoken voice from upstairs. It was Nanette, asking Thom to come to bed.

We took it as our cue to exit. Only Thom remained in the living room, alone, drinking until six in the morning. He finally got about two hours of sleep before it was time to head out to the expo.

We took a stretch limousine to the High Point Market, and Thom made the driver stop at the famous, first-ever Krispy Kreme drive-through donut shop. He ordered a dozen glazed donuts and proceeded to eat them all during the ten-minute ride to the event.

As soon as we got to the Thomas Kinkade booth, where the furniture line was prominently displayed, Thom was met by a contingent of news reporters and cameras.

Thom stepped in front of the cameras, but couldn't get more than two sentences out before he passed out and collapsed on the floor with

the cameras rolling. He lay on the ground, out cold. Our staff quickly carried him into a back room, where EMTs were called to check his vitals. Bob Davis, Thom's event manager, told the press to return a little later; that the Painter of Light wasn't feeling well and needed rest. Thom slept in the back room for forty-five minutes and woke up raring to go, as if nothing ever happened. Then he set out to shake hands with the public, speaking his faith to those who had come to see him talk, signing autographs and taking pictures with his adoring fans.

<div align="center">⚜</div>

Six months after Thom and I had launched the Thomas Kinkade furniture line, sales were going through the roof. Hundreds of dealers across the country had jumped on board for the chance at selling the line and the exclusive prints along with it. Thom was immensely proud of his furniture line, and doing business with Steve Kincaid went off without a hitch. Steve was genuinely nice and a big supporter of Thom's. But as we were about to launch the second spring line, I got a call from Steve. He told me he was being inundated with calls from his dealers, receiving hundreds of complaints that no one was getting their art deliveries for the furniture lines.

I asked him if he had talked to anyone on the sales side, and he said he wasn't getting any of his calls returned. I told him this was the first I had heard about the problem, and vowed to set up a meeting with Brad Walsh and Greg Burgess at the upcoming International Furniture Expo to find out what was going on.

We all sat down in Steve Kincaid's office at the High Point Market, one year after our first successful launch of Thom's furniture line. The furniture was a great success and Kincaid had set up an enormous display encompassing close to ten thousand square feet of showroom. Entire home interiors were built for the show. There were four living rooms, four dining rooms, and four bedrooms providing living environments that displayed the lifestyle furniture brand of Thomas Kinkade. In the back of this massive showroom, Steve kept his office,

and this is where Brad Walsh, Greg Burgess, Ron Carpenter (Steve's associate), and I met with him. When we sat down, Steve got right down to business. He asked why he wasn't getting deliveries of the art for the furniture line.

Brad Walsh replied that he had decided to kill the program.

Steve looked incredulous. He asked what Brad meant, and reminded him that he had a contract.

Brad repeated that he had killed the art program and they weren't doing that anymore. Steve Kincaid, who was a polite, soft-spoken Southern gentleman, was turning beet red at this point. Barely able to comprehend, Steve asked him to repeat himself. And Brad reiterated that he had killed the art program for the furniture dealers.

I couldn't believe what I was seeing and hearing. I looked at Steve. He was livid. Steve asked Brad if he was reneging on the agreement with him. Brad said he was, and that it was his final decision.

Steve was incredulous. He said he couldn't believe that a guy like Thomas Kinkade, with everything he stood for, would go back on his word.

I tried to run damage control. I assured Steve that Thom was not aware this decision had been made. I looked at Greg and asked what he had to say about it.

Brad Walsh glared at me, now turning two shades of red himself. Greg Burgess had been silent for the entire meeting, and he didn't answer me now. Steve Kincaid looked around, threw his hands up and said we were done, we were finished. Then he stood and walked out of the room. I tried to call after Steve to stop him from leaving, but he was already down the hallway. As I watched Steve march off, Brad Walsh followed me and tapped me hard on the chest, getting in my face. He told me that if I ever went against him in a meeting again, there would be hell to pay.

I stood transfixed. I couldn't believe what I had just heard. Had he just threatened me? My mind was racing with a jumble of thoughts: "What do I do? Do I punch him first before he can punch me? Is this the moment I get into a fistfight with the senior vice president of sales

in the hallway at the furniture market? Can I let this guy destroy all my hard work of the last year? And what about Thom? He loved the furniture line. How could he do this to Thom?" I unclenched my fists and controlled myself. I told Brad that I didn't have to listen to his idle threats, and he responded that he didn't have to listen to me either, and he stormed away with Greg sheepishly scurrying after him.

Our contract with Steve Kincaid had been scuttled by Brad Walsh. It was shocking. They weren't interested in furniture. Thom's wishes and Thom's dream of having his own furniture line didn't seem to matter to them. Thom's reputation as an honorable person didn't seem to matter. Furniture didn't net them a commission. They seemed to be interested only in the sales that brought profit into their own pockets.

I called Thom and told him what had happened, and he was truly horrified. His beloved furniture line was most dear to his heart, and he was a man of honor. He respected Steve Kincaid as much as I did, and he immediately made some calls to see what he could do. He called Greg. He called Ron Carpenter, Steve Kincaid's right-hand man. But it was all too late. The damage was already done. Steve Kincaid had lost face with his dealers and there was no turning back.

I was a man of my word. I believed that your word was what made you who you were. But principles of loyalty and honor didn't seem to mean much to Greg Burgess or Brad Walsh. I had made a deal with Steve Kincaid myself, and it broke my heart when Steve finally cancelled his contract. Understandably, Kincaid and La-Z-Boy wanted nothing more to do with the Media Arts Group or Thomas Kinkade.

<p style="text-align:center">⚜</p>

In the spring of 1999, I had planned a trip to Taipei, Taiwan, to meet with Darwin Lim, who ran a huge distribution of myriad products imported from the United States. Ken, still desirous of finding a way out of the David Winter Cottages debacle, asked if he could tag along. He knew I was resourceful, and the trip to Taiwan seemed like an oppor-

tunity to engage with me over trying to find an international market for the remaining inventory of unsellable cottages.

We sent samples ahead to Taiwan and planned a trip that would also include Tokyo and Hong Kong. We flew first class, not uncommon for Ken, and I recall that the two first-class tickets for all our various destinations cost $20,000 each. We were met at the airport by a Rolls-Royce and taken to the Regent Hotel Taipei, where we stayed for several nights. We successfully set up a deal with Darwin Lim and continued our adventures, flying to Tokyo and then on to Hong Kong, traveling first class all the way. We stayed at the InterContinental Hong Kong and sat talking at the bar of the hotel, looking out at the stunning view of Kowloon Bay and the glittering bustle of the city beyond.

During the day we met with Art Collection House, a big art publishing company that specialized in famous painters of the day such as Christian Riesse Lassen, going out again at night to five-star restaurants, living high on the hog.

On the last night of our trip I was in my room, already packed for the next morning's return home, when there was a knock at the door. It was Ken. He looked dismayed. I let him into the room, concerned. It was clear that something bad had happened.

"What's wrong?"

Ken held up a paper in his hand.

"What is it? Was there an accident?"

I took the paper from Ken and read. It was a fax from Linda, his secretary. The fax read that he was to contact her immediately. It seemed to say there had been a *coup d'etat* back at home.

Ken had been removed by a majority vote from his remaining position as chairman of the board of Media Arts Group, the company he helped to found.

We ate dinner in the hotel that night and talked. Ken was alternately angry, afraid, and confused, trying to understand what had happened. I was shocked.

"They can't do this, right, Ken? They can't let you go from your own company," I asked.

Ken said he wasn't sure about anything right now.

I told him that he had founded the company with Thom; that he couldn't go on a business trip and suddenly be let go from his own company. Ken responded that he wasn't sure of anything until he could talk to his lawyer.

Ken felt deeply betrayed and embarrassed, although he wasn't necessarily surprised. Tensions had been running high back at the mother ship, and Thom had increasingly allied himself with Nanette against Ken. I will never forget how Ken appeared that evening; he looked deflated, like the wind had been taken out of his sails.

I was also concerned about what it meant for me. I had aligned myself with Ken politically at the company, and I couldn't help but think I would be next. Questions were swimming in my head. Was this the end of my ride with Thomas Kinkade?

A Man of Great Appetite

Success is a lousy teacher.
It seduces smart people into thinking they can't lose.
—BILL GATES

By 1999, Media Arts claimed Thomas Kinkade was the most collected living artist in the world. Two hundred forty-eight galleries sold his work across the country. His personally highlighted canvas transfers sold for $34,000 or more, and Media Arts posted $126 million in revenues and $84 million in profits for the fiscal year. Later in that year, *60 Minutes* aired a long piece in which Morley Safer said Thomas Kinkade was to art what Henry Ford was to automobiles. The world was taking note.

The modern art world was scratching its head. Whoever heard of a painter's atelier the size of a 100,000-square-foot warehouse? The avalanche of imagery coming out of Charcot Avenue was considered commercial kitsch, but no one could deny its pervasive appeal. And Thom was not apologetic about his status as a populist artist. He didn't want to be part of the rarified art world, creating the kind of art that was only for the elite few to enjoy. He didn't mind that his art was shipping out by the truckloads, because it meant he owned the heart of the people. As the art world looked on the phenomenon of the extensive replication of Thom's art with skepticism and mistrust,

Thom's success almost seemed to be mocking its veneration of the concept of the original art object. By producing the canvas transfers and adding dollops of paint, thereby making a copy unique and original again, it almost became a postmodern exercise in the semiotics of art.

While the art world scorned the notion that art should be used to quell people's anxieties, Thom was proud that his paintings provided inspiration and reassurance. He said, "High culture is paranoid about sentiment, but human beings are intensely sentimental. And if art doesn't speak language that's accessible to people, it relegates itself to obscurity." He tapped deeply into that sentimentality, and there was just no arguing with his success. Thom resigned himself to his outsider status in the world of fine art, and referred to himself and his work as the "Trojan horse in the enemy camp."

To me he would say, "They didn't appreciate Norman Rockwell when he was alive. Even Rockwell didn't think his art was worth anything. He gave paintings away to his neighbors and the milkman. And now they're worth a million dollars. Popular sentiment prevailed. I think it will be the same with me. I just don't know if I will live to see it myself."

At least Thom didn't have to wait for the monetary rewards of his work. The signature galleries were selling the multitiered editions like crazy, from his images in basic paper prints for a few hundred dollars, to the pricier canvas lithographs in multiple editions, with names like "standard numbered," "Renaissance edition," and "prestige collection." Collectors who paid $2,500 for a canvas transfer painting were content because the added special highlighting meant that, even if the next-door neighbor had the same image hanging on their wall, they were still different and unique works.

When the shipping bay at Charcot stacked the ready-to-ship paintings twenty feet high in the air, the sheer volume of sales posed one interesting dilemma. Thom could not physically sign the artworks, numbering in the hundreds, even thousands, that were leaving the warehouse every day. A machine was devised that would replicate his

signature on every work of art, and in order to comply with the industry standards of authentication and originality, a little bit of Thom's blood was mixed into the ink, which would make his signatures verifiable as authentic by providing Thom's actual DNA. It only took a drop of blood to mix enough paint for a thousand canvas transfer paintings, but it almost made him into a martyr, a Christ-like figure. Here he was giving his blood for his art. And the public ate it up.

<div style="text-align:center">⚜</div>

When Ken was voted out of the company, he was still its largest shareholder. After he returned from Hong Kong, he hired a lawyer whose first communication put Media Arts on notice that they had better be careful; that even though Ken accepted the company's decision, he still had compensation rights outside of his former salary. Ken not only had the power to potentially wreak havoc if he were ever to sell a large share of his stock as a now disinterested shareholder, but he also had the ability to sue the company for alleged mismanagement. Thom also knew that Ken knew his personal secrets. Things that might not be perceived as flattering: the many late nights spent drinking, and drinking too much in general. Ken was not the kind of person who would ever exploit that kind of advantage, but he also wasn't going to let the Kirby sales team run the company he had founded into the ground. In the first period after the separation, nerves of those on both sides of the fence were on edge in a standoff.

There was a bond between Thom and Ken that couldn't be denied, one that reached back to their common dream in founding the company. But something had gone wrong along the way. They had become subtle competitors rather than allies. Of course they owned a business together, but it seemed to have become about the chicken or the egg. Who was there first? Who was the germinator? Of course everything started with Thom, but Ken's original investment perhaps gave him a proprietary sense of his role in the company. This rivalry was slowly shifting Thom away from the person who was actually his

true and loyal friend. Their friendship represented the soul of the company; breaking that unspoken bond could disturb the balance of the spirit and heart of the company. With Ken gone, Rick was bound to gain more ground, and I wasn't sure if Rick was the same friend to Thom as Ken was. It was just who they both were. I felt they belonged together, and couldn't imagine how they would fare apart.

Ken confided in me in those days: how unappreciated he felt and how insulting, even devastating, it was to be scuttled from one's own company. But Ken was a loyal person. He felt that Thom truly was his friend, his best buddy for a lifetime. While he expressed that he was really hurt, he couldn't and wouldn't do any harm to anyone, or betray the love and friendship he had with Thom. So Ken accepted his fate, and he became determined to be successful as his own living proof of the adage that there is no better revenge than success. Silicon Valley and the Internet were booming at the time. Apple and Google were emerging and AOL was the hottest stock around. And Ken was drawn to their explosive growth potential.

We had lunch a week after his leaving the company, and he told me he was getting into the Internet business. It was 1999, and Silicon Valley was exploding; he wanted in on the action.

"You want in, Eric? Let's go," he said.

I had been thinking about my own future at the company. I was deeply loyal to Ken, and I was inclined to follow him. And despite the failure of diversification, I knew he had become the fall guy. Everything sticks to the CEO. It might have been his passion, but everyone at the company had also been on board with diversification. The blame just stuck to Ken in the end.

He told me that when I was ready, he wanted me to come and help him. He had been talking to some people and wanted to start a company called Familyroom.com that could bring like-minded faith-based families together in a safe place.

"That sounds like a good idea," I said.

There were many reasons why Ken's offer sounded good to me. It wasn't just that Ken had left; it was that with Ken's departure it seemed

as if the heart and soul of the company were gone. For all his ambitions and visions of expansion, ultimately Ken cared deeply about the company he had cofounded with Thom, and he shared their mutual vision of building the best art publishing business they could. And there was a spiritual dimension that Ken and Thom shared: a sense of destiny and spiritual mission. Ken also wanted to do good. I knew that with Ken being gone, the group of former Kirby salesmen who now held high positions in the company would shift its focus exclusively to sales, without the vision required to shape a market.

Granted, sales were going through the roof, and profits continued to rise. Rick Barnett had proven himself for a long time. Now he was opening more signature galleries, running Thomas Kinkade University, and bringing in numerous trained gallery owners. Ken had always been in the way of Rick's making the real decisions. Rick was never CEO; he couldn't tell anyone what to do and he didn't try. He gave his opinions, went back to Monterey, and exerted his influence behind the scenes with Thom, in private. With Ken gone, Rick was empowered. According to other executives still at the company, the first thing Rick did after Ken's dismissal was to negotiate a deal for himself by which he would receive a commission on every piece of art sold by the company.

But it wasn't Rick Barnett that was the problem; it was the aggregate trend. In the void left by Ken's departure, Greg Burgess and Brad Walsh rose to power. Greg and Brad were bold and brash and had waltzed in, acting like they owned the place. And besides my nearly coming to blows with Brad Walsh, tensions constantly ran high between the old guard and the new. Dan Byrne, Kevin Sacher, and the other original members of the executive team had been at the company for many years, and although the volume of sales kept increasing, we all felt there was no more soul in it.

Two days after Ken and I returned from Hong Kong, I received a call from Thom at my Charcot office.

"Eric, since Ken is gone, you need to know that I'm going to be doing some housecleaning at the company. We're getting rid of anything that was part of the Ken era."

"I understand," I said.

He told me I needed to know he had decided to install Greg Burgess as chairman of the board, and CEO and president of the company. I was stunned.

"Okay," I said hesitantly.

Thom said he knew I was obviously a big part of Ken's time at the company and normally I would be a candidate for this housecleaning he was planning to do.

"But I'm going to protect you," he said.

"I appreciate that, Thom."

"Just go and pledge your loyalty to Greg. He knows that you were close to Ken, and needs to know that you fully support him now."

I was torn. I had established the single biggest art-licensing program in the world. Thom was my good friend, as was Ken, and I didn't want to let either of them down. I was earning a lot of money at Media Arts, and I was expecting to earn a lot more in the coming years as my licensing contracts matured and I added even more licensees. I didn't know what I should do. Take Ken's offer? Pledge allegiance to a man I didn't respect? Give up my very lucrative position at the company?

I then understood that my blind faith in Ken had been just that: blind. I had been like a racehorse at Churchill Downs with the blinders on, focusing on the race in front of me, unable to see the developments on the sidelines. By placing all my trust and energy in Ken, I had sidelined myself along with him. I never entertained the thought that Thom, Nanette, and the board were right on some level, so I was stunned. I was naïve to the fact that the board of directors at Media Arts could do something like this, ousting Ken, an actual cofounder, from his own company. I hadn't seen it coming; no one had ever indicated this might happen. During all of my years in business, I'd never seen anything like it. Ken's world had collapsed around him. He had been toppled from his perch, and everything he'd built had been taken from him. My head was reeling. Where did I fit in?

Even though I understood what was happening and why, I wasn't sure I could go through with Thom's plan. I agreed to take the meet-

ing with Greg with a strong sense of foreboding. Until that time Greg and I had kept up a friendly and cordial relationship. He was a sharp sales guy. He would get on planes and establish more galleries so we could increase our sales and see our stock value rise. Hell, these new galleries were even selling my licensed products now. Suddenly, with Greg's support, there were a thousand new points of sale for my calendars and ornaments.

I appreciated Greg's sales ability, but I didn't think he was a CEO. He had never run a company of this size before; in fact, to my knowledge he had no experience as a CEO whatsoever, let alone CEO of the largest art company in the world. The anomaly of having Pastor Mike Kiley as a vice chairman was bad enough, and now the head sales executive was going to be our CEO? Like the captain of a ship, the position of CEO requires extensive management and leadership skills. It requires steering the ship and running the crew at the same time. Greg was like a navigator with his compass pointed north, but without a plan for how the company would ever travel in that direction. It made no sense to me. The company was at its peak, firing on all cylinders for the first time. I understood that Thom and the board looked at Ken as someone who would threaten this new prosperity and stability, but putting a sales guy in as chief executive officer, let alone chairman of the board, was counterintuitive. It felt like one step forward and two steps back.

I decided to go and see for myself what was happening and hear what Greg had to say. So I set a time to meet with him. I went into the new CEO's office, two weeks after returning from Hong Kong.

Greg sat behind the desk in what was formerly Ken's opulent office. Greg's family photographs were arranged behind him. It all felt surreal to me. We made small talk and shared uneasy laughs about the unexpected turn of events engineered by the board of directors. Greg asked me how Ken was doing.

"Not well, as you can imagine," I said.

Greg then ran through his speech about the new world order, telling me the Ken era was now firmly in the past and a new team was

being installed to take the company to new heights. Then he got to the point. He told me that although my affiliation with Ken made them all concerned, the company still wanted me to head up licensing and strategic relationships.

All this talk about a new day, new people, a new plan, and a new company made me uneasy. I understood that I was valuable, and that the company could use me. But did I really want to do this? Thoughts of Brad Walsh threatening me while Greg stood passively by flashed through my mind. I asked Greg what his plan for the company was.

Greg looked at me, then he seemed to fumble for words.

He simply said that Brad Walsh was now going to be senior vice president of sales.

I looked at him and asked if that was all.

He paused and added that he planned to make sales the focus of the company.

It seemed clear to me that he didn't really have a plan at all. His new plan was the old plan; his new job was the old job. The sales guy was not a CEO, and it hit me that I could never and would never pledge my loyalty to Greg; that I could never report to a man whom I felt didn't know what it took to run a company like ours. That this situation was a disaster waiting to happen. He had a limited vision for a company as large and complex as the multimillion-dollar giant Media Arts was. He knew sales—and sitting across from him that day, I sensed it was the only thing he knew.

I did the math in my head: six Kirby guys running the show and a pastor for vice chairman. It seemed like a terrible joke; a dangerous game, a theater of the absurd. I wondered what my wife would say. I thought of the cushy salary I was drawing. I thought of Ken alone at home, after all we had done together. I saw myself sitting in executive meetings and having to answer to Greg Burgess, a man for whom I had little respect. And it was too much for me to accept. At least I respected myself. Perhaps it was impetuous; I know I didn't think it through. Would I do it again? Maybe. But in that moment I was just furious. And I knew what I had to say.

"Greg, this isn't going to work for me. If you need to fire me, then fire me. I remain loyal to Ken; I cannot and will not report to you. Good luck."

I rose and walked out of the room, leaving a stunned Greg behind.

When I told my wife that night, she was happy to hear it. She knew how unhappy I had been since the Kirby crew came on board.

"At least you're not going to have to be around those phonies anymore," she said.

"What about the paycheck?" I asked her.

"You're the one with the licensing talent. They needed you more than you needed them. You'll make a living like you always have. But you'll do it on your terms next time," she said.

She was always so practical. And she was always right.

Ken and I got together some evenings later and talked about how everything at the company had become a circus. While Ken was distraught over being ejected from the company, he was also worried about Thom. I remember how that struck me as strange. Despite his own setbacks, Ken was still thinking of his friend. But that was the nature of their relationship; they were like competing siblings who ultimately always remained bonded. Ken felt that the board, and the heavy influences around Thom, had made him oust his own friend and partner. He felt Thom had been duped into a bill of goods introduced by Rick and the other board members. He knew Thom was not a leader, not a decisive person. He tended to avoid hard decisions and let others make them for him. And Ken also worried about Thom's increasing alcohol issues and how they affected his judgment and made him vulnerable to manipulation.

It impressed me that Ken would think of Thom over himself in that moment. It spoke volumes about him, and their relationship. Even though he had been spurned, Ken had an abiding love for Thom that was moving to witness. Despite his own woes, most of all he didn't want the Kirby crew to end up hurting Thom.

We sat in silence for a long moment, letting it all sink in, staring into our cocktails. Then Ken suddenly began to smirk. His smile was

strange for such a somber moment, but he just couldn't stop. It was infectious. I was smiling, too, by now. I asked him what he was smirking about.

Ken seemed to have realized that since he was the largest shareholder yet had no more executive or director obligations to the company, he still had a voice, but his responsibilities were significantly diminished. As the controlling shareholder, he had protected rights, and in a sense, he would be more powerful than ever. I had to laugh, too. I knew Ken wouldn't abuse his power by any means. But he at least had the ability to keep a watchful eye and prevent people like Brad Walsh and Greg Burgess from destroying the company.

I thought Ken was right. As the chairman of the board, the president, and the CEO of Media Arts, he was bound by very strict SEC rules and fiduciary responsibilities to the company. A senior executive must act in the company's best interests, first and foremost. But a shareholder is free of the restrictions of financial obligations to the company, and is instead guaranteed, under the law, a certain protection of their investment. As the largest shareholder, Ken still had implied influence, yet he was suddenly free for the first time in many years, from restrictions placed on him as a corporate executive at the company.

Days after he was removed, Ken's lawyers called Greg Burgess, and a letter to the board of directors was delivered. They were informed that Ken would, from now on, be scrutinizing every significant action the company planned to take; and that, if he was not in agreement with the company's decisions and policies, he would not hesitate to take action. Thom and Nanette thought they had finally removed Ken from the company, yet now as the largest shareholder, but no longer an executive, he was in a sense more involved than ever. Ken had won this round in the end.

Ken wasn't trying to get a little payback for his ousting. He was genuinely concerned for his investment. Not only had he been ousted from the company he cofounded, the company he had based his whole

life on, but by his own estimation, a man of questionable competence had been put at the helm. His newfound influence was a salve to the wound. From now on, he had the ability to influence the executive management team at Media Arts if they made any misstep that he felt put his investment at risk. And from that point on, as it turned out, Ken made more decisions and more money from the company than he ever had in the past.

I took my severance package from the company, vacated my office at Charcot Avenue, and joined Ken in his new Internet adventure.

It was a time of big changes at the company. By the end of that year, Dan Byrne, who had been named president after Ken was removed, left the company. James Lambert, the vice president of publishing, as well as the vice president of marketing, Kevin Sacher, also left. Bud Peterson resigned. Paul Barboza, senior vice president of sales, resigned. Jay Landrum, general counsel for Media Arts, made it clear that he would not support Greg Burgess in his new role, and refused to report to him. The board was firm in its decision, and Jay also resigned. All of the original senior executives, with only a couple of exceptions, were gone by the end of 1999.

❧

Silicon Valley was bustling with wealth and innovation. When I joined Ken for his first venture, Familyroom.com, he had hired several Internet consultants to help him build the business. Internet consultants were proliferating in Silicon Valley, eager to take the money of the aggressive get-rich-quick start-ups riding the Internet wave. Unfortunately, some of these consultants were not much more than scammers taking advantage of gullible investors. Ken was eager to forge ahead at the fastest possible speed with his Internet concepts, and was ready, able, and willing to write the checks needed to finance the venture. The cadre of consultants always had their hands out for another check.

Despite the heavy infusions of cash, Familyroom.com was a failure.

Ken started another company, OnVantage Inc., a desktop portal that a company could use to create a company hub and develop its brand. That, too, didn't work.

I watched Ken hire many people over the next two years who were more than willing to take the millions of dollars he was willing to invest; by some accounts, between two and three million in all. I did everything I could to support him. I worked for him for free for a year, trying my best to assist him in his Internet ventures. I was paid for another year, working with him toward launching his web concepts. But to no avail. The dream to become an Internet billionaire became more and more elusive. Ken's initial enthusiasm slowly gave way to discouragement.

In 2001 Ken and I were on a business trip in New York City, having lunch at the famous Café des Artistes on West 67 Street in upper Manhattan. We sat, surrounded by the stunning murals of forest scenes and wood nymphs by Howard Chandler Christy, talking about the state of things. He was particularly down; he looked defeated and demoralized.

Ken seemed depressed about the bad turn of events with his plans in the Internet business. His hopes of showing Thom he could be successful without him were dashed. I tried to cheer him up as best I could.

"Forget about the Internet thing. It's only money. But you still have lots of resources, you still have me, and you've got lots of talent. Let's get back into the licensing business. My phone rings off the hook all the time, and I tell them that the reason I haven't been licensing is because I've been working with you. But we can get back into the game together."

He looked moved, and asked if I would really do that. I assured him I would. That day, Ken seemed to rally again.

I didn't tell Ken that Thom had been calling, begging me to return to the company to head its licensing. I had spoken to Thom on a

number of occasions over the past several months, and he reminded me how well we worked together. He said there was still so much we could do with his brand. I always thanked him and said I was pretty settled right where I was.

"But we created so many licenses together! How many was it?"

"Over seventy-five."

"Let's make it a hundred. Let's make it two hundred. I have so many ideas!"

But I was loyal to Ken, and my family was back in Santa Barbara. I told Thom I liked working at home. Thom said I could commute the way I had before. I told him I would think about it.

But I didn't want to go back to what I had walked away from. I knew that what made me leave when I did was certainly not likely to have become any better. The day I left the company, I had told my wife to sell all our stock. I didn't have any faith that the Kirby crew could sustain this juggernaut of a company in the long run. But I did see the potential to continue to be effective with the licensing side of the business. I just knew it had to be on my own terms. When I pledged that I would never answer to Greg Burgess, I had meant it.

I finally floated it out to Ken that I had been thinking about getting back into the licensing business and thought of representing Thomas Kinkade again, this time as an independent contractor. And I told him I wanted us to do it together. Ken was torn. He didn't know if he had really recovered all his pride, or gotten over the hurt of Thom ousting him from their mutual labor of love. Wouldn't it be awkward to return after the shame of being removed? Ken didn't know I had been working hard behind the scenes to convince Thom it made sense to bring Ken back along with me. But ultimately he agreed, and we formed Creative Brands Group, a company specializing in the management and licensing of brands. As I knew them both well, I became somewhat of an ambassador between these two men, who clearly still had a deep emotional and spiritual connection to one another. When Ken said yes, I privately started negotiating our return with Thom.

I told Thom I had been working with Ken for two years now, and I thought he was a good person, and I just wouldn't feel right leaving him out of it. So I told Thom that if he wanted me to work with the company again, I would have to bring Ken along, since we were partners now.

Thom was hesitant. I reassured him that he knew me and could trust me; that I would be his guy and that we would do it the way we always did: together. Ken would certainly be involved, but I would be managing his licensing business. Finally, Thom said that if Nanette okayed it, then he was fine with it.

Days later, I met with Nanette in the kitchen of her house and told her all the same things I had told Thom. I half expected her to say "absolutely not" the moment I walked in. I knew she still blamed Ken for the company losing so much money. But she listened thoughtfully and finally agreed. I was exceedingly happy that I didn't have to talk her into it. The thing about Nanette was that she was always protective of Thom. She really cared about his welfare, his career, and how he was treated by others. She never spoke out against him, never let any seams show if there was trouble at home. Nanette was always that perfect, poised, supportive wife in her husband's corner, and I respected her for her dedication and her dignity. A few weeks later, we signed a deal stating we would represent Media Arts exclusively for all their licensed products.

<div align="center">⚜</div>

Thom was a down-to-earth man driven by his ebullient enthusiasm for life and an earnest desire to do good for others. Whenever the mention of his success came up, he credited his faith in God, and his desire to let God use him as a vehicle for good. He didn't want to build himself up, and he didn't want to be elitist. He preferred the corner dive bar, where he could talk to the regular guy sitting on the stool next to him, over any expensive dinner at the Four Seasons. He genuinely

Carmen Kennedy
Thom Kinkade

Mark
Gino

Thomas Kinkade at age 16 in "The Riffle" yearbook of El Dorado High School, Placerville, CA, 1974. Courtesy of Gold Country Girls

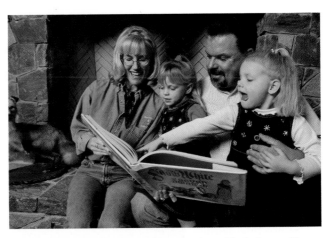

Thomas Kinkade with Nanette and their daughters. Monte Sereno, CA, 1995. Thomas Kinkade and Family © John Storey/Corbis

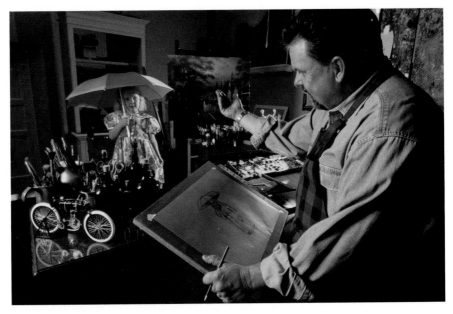

Kinkade in his studio with daughter, Winsor, 1995. © Getty Images

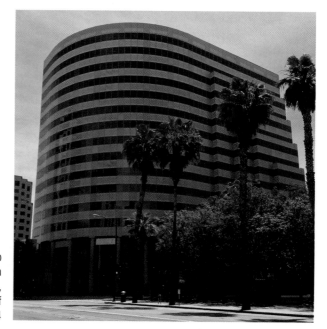

Media Arts Group headquarters at Ten Almaden Boulevard, San Jose, CA, 1995. Courtesy of G. Eric Kuskey, 2014

Bonus checks at Media Arts on Charcot Avenue, with Thomas Kinkade, Bud Peterson, and Ken Raasch, San Jose, CA, 1997. Courtesy of Bud Peterson

Media Arts Group goes public, December 7, 1998. From left: Jay Landrum, Brenda, Greg Nash, Richard Grasso, Ken Raasch, Bud Peterson, William R. Johnston. Courtesy of New York Stock Exchange Archives, NYSE Euronext

Steve Kincaid and Thomas Kinkade in High Point, NC, 1998. Courtesy of G. Eric Kuskey

Thomas Kinkade, Rick Barnett, and Terry Sheppard at a book signing event, 2000. Courtesy of Terry Sheppard

One of the many licensed products of Thomas Kinkade. Courtesy of G. Eric Kuskey

A gambling trip to South Lake Tahoe, CA, 2002. From left: Jay Landrum, Ken Raasch, Eric Kuskey. Courtesy of G. Eric Kuskey

A night on the town with the boys. From left: Jay Landrum, Thomas Kinkade, Dan Byrne, Kevin Sacher; San Jose, CA, 2002. Courtesy of G. Eric Kuskey

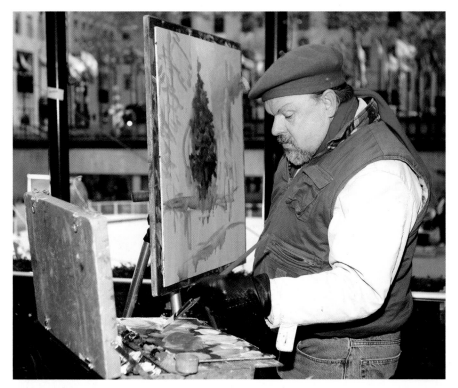

Thomas Kinkade painting the Christmas tree at Rockefeller Center, New York City, 2007. Copyright © Bennett Raglin, Wire Image, Thomas Kinkade Paints the 2007 Christmas Tree Rockefeller Center, Getty Images 2007

The Pied Piper of Hamelin by Maxfield Parrish (1909) was commissioned by the Palace Hotel of San Francisco for $6,000. It has been hanging in the art deco bar of the Palace Hotel in San Francisco since 1909, and garnered a recent estimated value of $3 to $5 million. Courtesy of the Palace Hotel of San Francisco

Thomas Kinkade's mug shot after his DUI. Carmel-by-the-Sea, CA, 2010. Courtesy of Salinas County Superior Court

Kinkade at the 137th Kentucky Derby, 2011. Copyright © Joey Foley, Film Magic, 137th Kentucky Derby Arrivals, Getty Images 2011

"I, Thomas Kinkade, being of sound mind and body do hereby bequeath to Amy Pinto Walsh $10,000,000 in cash from my corporate policy and I give her the house at 16324 and 16342 Ridgecrest Avenue for her security."

Thomas Kinkade handwritten will (#1), 2012. Courtesy of Santa Clara County Superior Court

"I, Thomas Kinkade, hereby bequeath my house at 16324 Ridgecrest Avenue, Monte Sereno, CA to Amy Pinto in the event of my death. I also give the sum of $10,000,000 to Amy Pinto to be used for the establishment of the Thomas Kinkade Museum at 16324 Ridgecrest Avenue, Monte Sereno, CA, for the public display in perpetuity of original art. This statement is null and void if my relationship with Ms. Pinto ends as it is defined by me in a future letter."

Thomas Kinkade handwritten will (#2), 2012. Courtesy of Santa Clara County Superior Court

loved the regular people, the fans, the devoted collectors, the support-ers. Despite his millions, he was always that country boy at heart. And his connection to Ken ran as deep as his roots in Placerville. After all, they had done it together, back in Thom's garage, printing and pack-ing, and selling their wares out of Thom's pickup truck. Nothing runs deeper than a shared dream.

Money changes things and people can lose their way, but Thom and Ken were still the same two men inside. They both came from broken homes and a single mother. They knew these things about each other, and it seemed to make their connection stronger. It always seemed to me that Ken would have done anything for Thom and, misguided or not, he always did his best for Thom.

Thom's connection with Rick didn't seem to me to be as personal as it was with Ken. Rick was good at establishing confidence; perhaps that was what made him so successful in sales. He could establish trust, but he hadn't risked anything with Thom the way Ken had. He had simply delivered. He had taken Thom and sold him to the world, just like he had promised on the very first day they met at the Carmel-by-the-Sea art fair. Rick wasn't sentimental; he was an enigma, carefully keeping to himself, playing things close to the vest.

I found myself caught in the triangle among the three friends. It had all the makings of a romance, without the actual love affair. I ob-served the ebb and flow of shifting sands of allegiance that continually vacillated among Thom, Ken, and Rick. Rick made Thom feel good, but beneath his smooth ways he himself was elusive, unreachable. Ken was the devoted friend who was always there. No matter what Thom dealt out to Ken, Ken would remain true. Thom went to Rick for business matters, but he went to Ken for matters of life.

Ken was Thom's conscience, his reasonable older brother, the one who could talk him down from a ledge or stop him from doing some-thing crazy when he'd had too much to drink. Once Ken was missing from Thom's life, stories in the vein of "you won't believe what Thom did now" began to hit the rumor mill.

There was the story that made its way to me of Thom's trip to Las Vegas sometime in the year 2000. He had gone for a weekend of cards and roulette with Nanette and his mother in tow. His mother was still living in one of the houses on his property. Thom had certainly taken care of her after their early struggles together.

They went to the Mirage Hotel one night to catch the Siegfried and Roy show, with a nice table near the stage where they could see the tigers up close. For his mother it was a special treat to go to a Vegas show. Such luxuries were a dream when she lived in that trailer home with her kids, working three jobs to get by.

From what I heard, Thom had been drinking heavily in the evening and was already past the point where he had his faculties about him. A couple at an adjacent table had already gotten up and asked the waitress to relocate them because of Thom's boisterous antics.

When Siegfried and Roy appeared out of the dry-ice fog on stage, the tigers were roaring and pawing from the platforms, music playing as the light show danced over them. The duo strode forward to the cheering and applause of the crowd, their arms outstretched. As they neared the edge of the stage, they came close to Thom's table. Thom caught sight of Roy, dressed in leotards and tights, wearing a protective codpiece. At that moment, Thom leapt up from his chair and pointed at him.

"Codpiece! Codpiece!" he yelled, laughing hysterically.

Thom's mother and Nanette reached out to him, looking embarrassed, grabbing his arm desperately, both of them pulling on him, trying to get him to sit down and be quiet.

"Codpiece!" Thom yelled again, laughing.

Nanette and his mother insisted that he sit down. Thom briefly focused his eyes on his mother and saw the look of concern in her face. Finally he came to his senses and sat back down in his chair, still chuckling to himself.

Thom voraciously took in all of life, consuming the world as though it was going out of style, which included his increasing consumption of alcohol. Ken had tried to hide Thom's addictive nature from me in the beginning. I think he didn't want me to think less of Thom when

I first worked for the company. He wanted me to like Thom and be comfortable being friends with him. I think Ken wanted it for Thom's sake and for the sake of our business.

By the time Ken and I returned to work with Media Arts, Nanette seemed to have given up trying to change Thom. She kept herself separate from the inevitable late-night drinking tours that went on when he left the house. Ken covered for Thom in our business, and went out of his way to avoid scheduling meetings after a certain hour in the evening. Thom would sometimes become visibly uncomfortable at signature gallery events at which there were only a few people present, or those that were held at someone's home, perhaps because it meant he couldn't drink. He would become visibly agitated and do everything he could to end the evening early. It was the unspoken secret that wasn't a secret; it simply wasn't discussed. When the drinking became impossible for me to overlook, seeing Thom drunk and drooling at the end of a night, Ken said, "I don't know what's wrong with him. He's just a man of great appetite."

There were more incidents such as this in the two years when I wasn't part of the company and not directly in Thom's life. I heard about them from James Lambert, who heard it through Terry Sheppard. Terry's job was to chronicle Thom's life through photography and film, and hang out with him late into the night. Terry was actually a talented filmmaker and a willing accomplice to whatever whim Thom was pursuing at the moment. He followed Thom around with a camera and made video after video, documenting every part of his life. It was meant to preserve Thom's legacy, creating a video record of the events of his life and the many things he accomplished.

Inevitably the days of shooting would turn into nights of carousing and drinking, and Terry would go off the clock, turn his camera off, and, along with other members of the posse, simply join Thom as a drinking buddy. Thom had promised Terry a place in the company for his loyalty and devotion, but Nanette felt less favorably about Terry as an enabler of Thom's late-night ventures. Terry became a witness to the goings-on, and one felt that he had plenty of stories to tell.

It was Terry who was present when Thom took a trip to Southern California for a meeting with Roy Disney. He was also making an appearance on the *Hour of Power*, a religious television show shot at the Crystal Cathedral in Garden Grove with Pastor Robert Schuller. After his appearance on the television broadcast, Thom and Terry hit the town and went drinking into the night. According to Terry, they teetered back to the Disneyland Hotel early in the morning, Thom completely inebriated. As they approached the hotel, Thom caught sight of a large statue of Winnie-the-Pooh. Thom zigzagged to the statue, zipped down his pants, and urinated on the statue.

"This one's for you, Walt!" he laughed as he relieved himself on the unsuspecting Disney figure.

Terry was also present when Thom was visiting Las Vegas and the opulent European-style Bellagio Hotel, where some of his artwork was hanging in the hotel's restaurant galleries. As they were riding the elevator up to their suites after a late night, Thom drunkenly unzipped his pants and urinated into the corner of the elevator.

There is another incident I heard about through the grapevine. Thom had gotten so drunk one night while out with John Dandois, an executive at Media Arts, his wife, Mary Louise, and others from the company that he fell down and couldn't get up again. Mary Louise reached out to help him off the floor, but Thom was so inebriated and ornery that he flipped her the finger, repeatedly saying, "F— you."

Hearing these stories wasn't a surprise, but always left me with a sense of unease and worry for Thom. The excessive drinking was a part of his life we all wished wasn't happening. And there was always that apprehension, what will happen this time? Will he hurt himself this time? Will someone find out? Keeping the two sides of Thom straight was a challenge in life and in one's mind.

I felt it was high time to get back into Thom's life, and for Ken to be back and involved with Thom. At least we might be a positive influence. It sounded to me as if the soul of the company had left with Ken, and Thom had become a little lost in the process.

✤

Morgan Hill is an upscale bedroom community to Silicon Valley, sprawling over hills and ridges carpeted with grasses and wildflowers, with lush vegetation in its creeks and valley bottoms. Buttressed by the Santa Cruz Mountains and the Diablo Range, Morgan Hill's natural beauty and small-town charm made it a natural location for Thomas Kinkade's new company headquarters.

Several changes had taken place during Ken's and my two-year absence from the company. Sales had continued to increase to such an extent that the 100,000-square-foot warehouse at Charcot Avenue was no longer sufficient to handle the volume of output and demand. A business park location in Morgan Hill was chosen for its proximity to San Jose and Los Gatos, and its convenient shipping position on the 101 South Valley Freeway.

Inside the Madrone Business Park complex the company built a campus that housed a 61,000-square-foot headquarters, an adjacent 155,000-square-foot production facility, and another 56,000-square-foot production and distribution building. A 127,000-square-foot distribution facility was located nearby, directly on Madrone Parkway. Nearly half a million square feet were devoted to servicing the business of one painter.

Canvases were pumping out by the truckload. The focus on art sales and the push for profit had built the house. But in the art market, in which value is built on scarcity and the exclusivity of limited editions, I wondered if that focus on sales, in such prolific volume, could continue in the long run.

Ken and I had negotiated a ten-year contract with Media Arts Group to exclusively represent its licensing contracts. We opened an office with a small staff in downtown San Jose. Thomas Kinkade was our primary client, but as an independent agency, Creative Brands Group represented many other clients during that time. The business was divided into two distinct areas. The first, the core business of licensing, was left to me to manage. I managed all the Thomas Kinkade licensing

and increased the total licensing agreements to over one hundred contracts. In addition, I managed several other brands, including that of New Zealand photographer Rachael Hale, which I ultimately built to almost a hundred licensing agreements. The other focus of our company, run by Ken, was to find and execute investments in new opportunities. Our goal was to take our income from the agency and pay each other very well, along with our staff, but to invest the money we had left over into new ventures. However, because of the extremely successful licensing business, focusing on anything else almost proved to be nothing more than a distraction. Ken also became deeply involved in the Thomas Kinkade art business again, albeit now as an outside advisor to Thom and the revolving door of CEOs.

Unlike the art market side of the company, the licensing side had the opposite mandate. Where scarcity protects art market value, licensing is all built on volume. The more sales the better. You couldn't overexpose a cottage on a Christmas ornament. The very sales volume supported its popularity and salability. No one worried about the resale value of an ornament or a calendar. It was just a way to get a piece of the artist otherwise not within reach. And Thom's artwork provided so many images and a never-ending wealth of licensing opportunities that we were guaranteed to do well in the upcoming years. It felt good to go back in as an independent company, with a built-in buffer between us and the everyday ongoing politics.

When we arrived at the Morgan Hill headquarters, Ken and I were astonished. We weren't prepared for the massive size of the facility and the extent of its elaborate landscape design, including gazebos from Thom's paintings, flower-lined walkways, and streets with names like Thomas Kinkade Lane. They called the headquarters simply Morgan Hill, with the address 900 Lightpost Way. It felt a little like Disneyland.

The money it must have taken to build Morgan Hill, and the apparent money being made, was staggering. The entire campus was the size of two Wal-Marts. I couldn't help but think back to my first days at Media Arts when the company was ensconced in the luxurious Ten Almaden address, just days away from disaster. Now it seemed as though

Black Monday had never happened. The history of the layoffs, and the memory of nearly losing it all, seemed to have been completely erased. It looked like another big gamble to me.

Like a 500,000-square-foot temple built to the artist Thomas Kinkade.

CHAPTER 5

Reversals of Fortunes

God is my art agent.
—THOMAS KINKADE

Thomas Kinkade University was situated along Wave Avenue, just steps from Cannery Row, in Monterey, California. It was the training ground for prospective Thomas Kinkade Signature Gallery owners, who had already gone through an extensive vetting process and considered themselves among the lucky few to be considered for the opportunity to invest in a signature gallery.

I spent many days sitting in on the sessions at Thomas Kinkade University and met scores of couples who came for the opportunity. Middle Americans, good earnest people: couples who were ready for a new adventure in their lives. They were mostly Christians who wanted an opportunity to spread the light of God through Thomas Kinkade's paintings, and become prosperous doing so.

By the time the prospective gallery owners arrived in Monterey, they had already been through a rigorous process of prequalifying for the privilege of attending the "university." Their finances had been scrutinized for their ability to pay the costs of designing, building, and stocking inventory for a gallery, which in most cases would cost well over $100,000. Seminars were held twice a month on average, and space was limited; every single attendee felt extremely fortunate to have been accepted into the program.

The seminars educated the candidates about the Thomas Kinkade art business in all of its facets. Attendees learned how the paintings were made, from the fact that it took Thom an average of over three hundred hours to paint one of his masterpieces, to learning about the canvas transfer system, and the materials and machinery involved. They learned the logistics and physical process it took to manufacture canvas transfers, from the clean rooms to the drying and stretching of the canvases, the different sizes and editions of the paintings, and the various colors and wood and quality of frames available. They learned how to display the art, how lighting worked with paintings, and the optimal room temperatures and humidity needed in the galleries. They were taught how art was sold, how commissions worked, what the profit margins were. They were shown graphs of Thomas Kinkade sales, the rising numbers of the stock value on Wall Street, the millions being made by the company because of the success of the art; a success they, too, could be a part of.

Dwayne and Sue Young from Des Moines, Iowa, were the typical kind of couple who would qualify to open a signature gallery. Their kids were grown, they had money saved up, and they owned a family business they were willing to sell. For them, like all the couples who made the trip, coming to Monterey was just the beginning of the adventure of a lifetime.

On the morning after their arrival, Dwayne and Sue woke up in the Monterey Holiday Inn, enjoyed a complimentary continental breakfast, and left the motel early to be the first to arrive at Thomas Kinkade University. Since they had a little extra time, they stopped along the wharf to take in the moist salty air. There was surely nothing in Des Moines that came close to that fresh smell of fish and sea.

Like so many other hopeful couples before them, Dwayne and Sue sat on one of the benches along the pier and watched the seagulls flutter and squawk, fighting over some discarded crumb wedged in the weathered boards of the wharf. Buoys clanged in the distance, and the sound of the waves hitting the buttressing boulders along the shore-

line was rhythmic and soothing. They held hands as they both felt the excitement that had been building for weeks. They didn't have to talk about it; they always knew what the other was thinking. They were quiet types with an adventurous streak, and they both felt they were about to embark on the biggest adventure of their lives.

Dwayne and Sue prayed over their decision to open a Thomas Kinkade Signature Gallery. Every time they had asked for a sign to tell them whether they should sell their longstanding and lucrative plumbing business, the answer always seemed to be yes. There was no pressing reason for them to open a gallery, other than the call of the adventurous spirit inside them and their strong devotion to their faith, which had set their hearts on fire when they heard about this business opportunity. For so many devoted Christian collectors of Thom's art, this opportunity was a dream come true. Dwayne, like the other gallery licensors who were schoolteachers and dentists, electricians and civil servants, had cashed out of everything he owned—his life savings, his real estate, his family business—and bought two round-trip tickets to Monterey. Now here they were, the money burning a hole in their pockets.

The Thomas Kinkade University office complex was located in a stunning modern glass building overlooking the ocean and the pier at Cannery Row. The view alone impressed everyone who attended, as it spoke of wealth and success. When they entered the building, Dwayne and Sue were led through the well-appointed offices toward the conference room where they were about to meet the legendary Rick Barnett. Everyone in attendance knew he was the man who discovered Thomas Kinkade painting on the sidewalk in Carmel-by-the-Sea, and became his first and only dealer. That he was Thomas Kinkade's most trusted associate. He probably talked to the Painter of Light every day. He might as well have been John the Baptist to the Savior. Dwayne and Sue couldn't wait to meet him.

As candidates walked through the company's opulent halls, they were impressed by everything: the stunning architecture, the million-dollar

view, the many assistants who bustled about the offices. Everything spoke of good taste and prosperity. A perky young woman led them through the halls, pointing into the deep recesses of the offices.

"Mr. Barnett's office is over there. That's the Thomas Kinkade Museum. If you ask nicely, you'll get a tour at the end of the day. It's by appointment only for a few select people. And here's where it all happens. Looks like you're the first ones."

Dwayne and Sue smiled as they were led into a large conference room with floor-to-ceiling windows. Forty chairs were set up in rows facing a podium. Audiovisual equipment towered on one side of the room. A long counter along the wall was covered in muffins and donuts, pitchers of orange juice, and a steaming coffee percolator.

Dwayne and Sue went over and poured themselves some coffee.

"Look at this spread. We could have eaten here and saved money," Dwayne chuckled.

"The hotel was still free, honey." Sue squeezed his hand.

"Look at that view," Dwayne mused.

Sue turned to look. "I could pinch myself. Are we really here?"

Lovingly Dwayne looked her in the eyes. "Yes, we are, sweetheart. We made it."

At seven-thirty, Dwayne and Sue took two seats in the front row right up against the podium, to hear every word and to be as close to Rick Barnett as they possibly could. Dwayne and Sue nodded and smiled to prospective gallery owners as they trickled in, mostly couples from all over the country. There was a celebratory feeling in the air, as everyone shook hands and introduced themselves by name and origin.

"Frank and Leslie. Allentown, New Jersey."

"Chuck and Wendy. Edina, Minnesota."

"Dave and Tanya. Prescott, Arizona."

"Dwayne and Sue. Des Moines, Iowa."

Soon there was an increasingly excited buzz in the room as the chairs filled up and the sugar and coffee took effect. Everyone seemed eager as the hour neared. 7:55. Only five more minutes, and the mo-

ment they had been dreaming of for weeks and months would finally come to be.

There was a studied choreography to the event, as carefully planned as any performance. I always entered the room at 8:00 sharp, and a hushed expectant silence would fall over the room. I quickly moved to my seat in the front row, at the very edge of the podium, prepared to give my presentation at the end. Disappointed looks followed me as I sat down, as the expectant crowd realized I was not Rick Barnett. Then the attention returned to the open door.

Every sound coming from the hallway could mean the arrival of Rick Barnett. Over and over again, sounds teased the nerves of the waiting future gallery owners, but the door remained shut and no one came. You could hear a pin drop as the minutes passed and everyone sat, wringing hands, checking watches, the tension and anticipation in the room building to an uncomfortable level. Dwayne and Sue exchanged a few silent glances and held sweaty hands, their nerves getting the better of them.

Then it happened. The door opened at 8:05 and Rick breezed in, dressed immaculately, hair perfect, his six-foot-three frame seeming all the more imposing to those seated before him. He looked like a movie star who had taken the podium to receive his Oscar; he could have won on looks alone.

In one hand he held a clipboard, in the other a Bible.

He paused dramatically at the microphone and leaned in, scanning their faces, his right hand raising the Bible high into the air, and invited the group to pray with him.

"Let us pray," he said.

You could almost feel the goose bumps rise in the room, as Rick thanked the heavenly father for their presence, prayed for a productive two days, and asked that the glory of God be upon their endeavors and bless them all to do his works and glorify his name with the opening of the new signature galleries.

Rick was a brilliant speaker. His demeanor instilled confidence and security in people, and he had a way of making everyone at the

seminar feel special and welcome. The exclusivity and privilege of their attendance, and the chance to own a gallery of their very own, was never lost on them. And he wouldn't let them forget it either. Throughout the weekend, he reminded them that they were lucky to have made it this far and to have qualified for such an incredible opportunity.

The training sessions were held over several days and went from morning to evening, with lunch provided. The long hours, the close quarters, and the volume of information often had the feeling of revival meetings. After all, the whole idea of owning a gallery, besides making money, was doing the work of God. The intense shared religious vision often made me feel as if they were indoctrination sessions rather than merely informational seminars. With emotions running high, and sales pitches mixed with religious overtones, the two-day experience was intense and demanding.

The second day was as long as the first, as information overload set in. Within less than forty-eight hours, everyone there knew everything about the Thomas Kinkade gallery business. On the second evening, the seminar culminated in the highlight of the entire experience: a dinner with Thom. For everyone in attendance, it was worth the price of admission. He appeared like the Dalai Lama himself. If there was anything that could make the prospective gallery owners feel special, it was breaking bread with the Painter of Light. For two intensive days they had been allowed into the inner sanctum and listened to an aggregate twenty hours or more of information about Thomas Kinkade the man, his art, and his business. To meet him in person was an overwhelming and transporting experience.

Thom made the rounds, stopping at every table, clasping hands and talking with every single person in the room. He asked people how they liked their meals, and if they were having a good time. He thanked them for being part of the Kinkade family. He introduced Nanette to the couples, and joked about their better halves. People glowed, shaking his hand, telling him how much they admired him as an artist, how honored they were to be part of the work he was doing

in spreading light in the world through his art. They talked about how long they had been collectors, and what crossroads in their lives led them to decide it was time to open a signature gallery.

Here he was, the legendary painter they idolized and had collected for years, whose paintings hung on their walls at home and touched them every day; the painter who shared their deep abiding faith in God, and whose images validated that faith. Here they were safe from a secular world that didn't share their values, among fellow believers who dedicated their lives to doing good in the name of Jesus Christ. Here was Thomas Kinkade in the flesh, speaking to them as though they were old friends, witnessing his own faith to them. The emotional impact couldn't have been greater. The religious experience couldn't have been stronger. And on top of that, the financial rewards seemed limitless.

Dwayne and Sue went back to their hotel that night, their heads in the clouds, their hearts forever touched, and their minds made up.

<center>⚜</center>

When I was invited, my role at these seminars was to give a presentation about the licensing aspect of the gallery business. I told people about the licensed products available for sale in the galleries. I demonstrated how they could offer calendars, books, and other Thomas Kinkade collectibles for sale, and how these small licensed items would bring a first-time buyer in to buy a trinket, who would later return to buy the actual art; once a customer was inside, the magic could take effect.

Over time, I looked into countless faces of prospective gallery owners and saw their rapturous looks; I saw the joyous expressions that told me they had been utterly won over by the magic of the experience. I was one of them. After watching many of Rick's presentations, touting the virtues and profit potential of owning a Thomas Kinkade Signature Gallery, I went home with starry eyes and explained to my wife how we really needed to think about opening a signature gallery of our own. That we just couldn't lose with the numbers being what

they were, and the potential of earning into the millions. My wife looked at me, a hand on her hip, a smirk on her face. She said, "Eric, you've been drinking the Kool-Aid."

The morning after the seminars were completed, the final and most important event of the weekend came: a meeting in which a contract to open a gallery of their own was offered to each couple. It was time to sign on the dotted line and make a full commitment; an investment that in some cases exceeded $150,000.

The requirements set out by the contract to run a licensed gallery were extensive—so extensive that the contract was over a hundred pages long. A minimum inventory had to be purchased, oftentimes totaling over $100,000. The gallery had to be built in approved venues, malls, or storefronts, and furnished and built with approved materials and approved construction companies. It had to be designed to replicate the Thomas Kinkade Corporate Owned Galleries, with specific prescribed floor plans and layouts. Gallery owners also had to agree to the pricing policies of the company, offer the works at prescribed prices, and agree that if they were to deviate and discount any of the works separately, they would automatically lose their license and were expected to burn their entire inventory.

The opportunity to license a gallery was so exclusive that if the candidates for a signature gallery didn't sign a contract right then and there in the offices of the Thomas Kinkade University, they could forever lose their chance to buy into this miraculous business. It was made clear that scores of people were applying for the same privilege. There were wait lists, and people were being turned back. Only a limited number of galleries were to be opened; it was now or never. The signature gallery candidates were each interviewed. They were told the process was very selective, and not everyone was considered. In fact, many more candidates were turned down than were allowed in. It was made crystal clear what kind of opportunity this was. As much as Media Arts wanted them to sign on the dotted line, they had to pass the last hurdle. If they didn't qualify or sign, they were taken off the list and someone else got a chance. The pressure was on.

Prospective buyers were also advised to use the services of a financial consulting firm, Pebble Beach Financial, owned by a Harvard PhD economist hand picked by Rick Barnett. As would later be alleged, because of the competition of others waiting in line to open a gallery, there was really very little time for buyers to call their attorney, to review the finances, to talk it over, sleep on it, or do the due diligence anyone might normally conduct in the process of making an investment that would take all that they had worked for their entire lives and put it into a business venture they had learned about for an entirety of two days.

While Thom had had the initial idea of opening signature galleries, much like Hallmark's licensed stores, he wasn't involved in their managerial planning or their execution. He left the signature gallery program in Rick's hands, as well as in the hands of the executives who supported Rick, who were based in Morgan Hill. Thom didn't get involved in the details of most of the business. He was rarely seen at Morgan Hill headquarters, mainly ensconced in his studio, painting; leaving the day-to-day business to those he trusted, and perhaps trusted to a fault. Thom only came in as a closer for the dinners. He was brought out as a sales tool, doing what he did best: interact with the public, shake hands, spread his light to those who admired him.

The weekend's pitch at Thomas Kinkade University was so effective that the preapproved signature gallery licensees signed up in droves. Hundreds of galleries were opened. This meant that not only would the company potentially receive from $100,000 to $200,000 per couple who signed up, but it would also generate income through the sales each of these galleries would bring in, which in turn helped feed the hungry Wall Street machine.

❧

The signature galleries became the vehicle by which the company rocketed from sales in the tens of millions to sales in the hundreds of

millions. From the success of the first Thomas Kinkade gallery in the Valley Fair Mall, to the highly profitable corporate galleries dedicated to selling Thomas Kinkade, to the expansion of the Thomas Kinkade Signature Galleries—once the company figured out they could control the environment in which the art was sold, there was nothing stopping them. They had hit the sales jackpot.

It was all about the staging of the event. As did the Thomas Kinkade University seminars, so the galleries created the perfect sales environment and staging to sell the art to the public.

Thomas Kinkade Signature Galleries were designed from top to bottom, from layout to lighting, from doorknobs to the placement of the fireplace. Every new dealer had to sign a lease on an appropriate space and extensively remodel the location. In addition, Media Arts Group required that each signature gallery utilize a single company-approved architectural design firm to render and design the space for them. If their proposed gallery was going to be 40 × 18 feet of space in a mall, the design company would draw out the plans, calculate how much carpeting was required for the space and what color it should be, where to buy the pulls for the drawers and cupboards, and where to purchase the fireplace and the desk for the front entrance where the receptionist would sit with a computer and a phone.

The construction of every gallery required specific materials and colors, from the kind of wood for the paneling, to the browns and burgundies and greens of the walls and wainscoting, to the Thomas Kinkade furniture and accessories in the viewing rooms and offices. The preapproved Thomas Kinkade lampposts and store signs over the front door had to be purchased. The easels that displayed the art for sale in the windows, and the hardware of not only the front door, but also drawer handles and light switches, were all predesigned and selected.

Signature gallery owners had little control over any part of the layout of the gallery, and had to commit to purchasing and installing every last element the company prescribed. The required fireplace had to be positioned so that when a customer entered the gallery, they

would first see the flickering hearth and its warming fire beckoning to them. It was a fantasy environment, an interactive experiential space, much like a ride at Disneyland.

The customers' senses were tantalized. They felt the warmth of the hearth, and heard the soft music playing inside the soundproofed environment. They smelled the scent of the perpetually cooking apple cider and cinnamon wafting through the gallery. Every one of their senses was stimulated to remind them of home, of their childhood, of happy and comforting times. Thom's art covered the walls from floor to ceiling in multiple gallery rooms and throughout the hallways, in a veritable maze of his imagery. The hallways were designed to be narrow, so that the viewer was never far from the paintings, which beckoned from all sides, as the recessed lighting cast a warm glow. It was an overwhelming physical experience to be inside a Thomas Kinkade signature gallery; an alluring trap for the senses.

The final sale was made in a dedicated room, in which the work of art that the buyer was interested in was displayed as though hanging on a wall in their own living room. The prospective buyers were led to comfortable chairs facing the wall where the canvas transfer painting had been hung, and would sit looking directly at the art. Then the gallery owner, trained in the sales techniques taught by the seminar sessions, would actually lock the door so no one could barge in and interrupt the mood. At that point, they performed the clincher of the entire experience: the light show. The lights in the gallery were all on dimmers and so, with the customer locked inside, the gallery owner would slowly lower the lights until the painting began to glow. The effect was pure magic.

Prospective buyers would exclaim in astonishment as they witnessed the paintings beginning to glow in the dark. I saw it demonstrated many times, and the effect was truly magical. In fact, I brought many a painting home and demonstrated it to my kids, who squealed in delight. Children and grown-ups alike loved the glowing lights of Thom's paintings. If the gallery owner could just keep the buyer in the

gallery long enough to witness the glowing effect, the deal was almost always sealed.

If there was some hesitation, with the door still locked to prevent interruptions, further incentives were offered. The limited availability and the high desirability of any piece of art were pointed out. The prospective buyer would hear about how the painting was sure to sell out due to its limited edition. They would have to understand that the current low price would rise soon. That the art would gain in value and prove to be a great investment. That the prospective buyer couldn't afford to let this one get away. And finally, layaway no-money-down installment and financing options were offered, which, once caught in the web of the Thomas Kinkade experience, made it impossible to walk away.

⚜

In 2001, Media Arts Group quietly crossed the billion-dollar threshold in total retail sales.

⚜

When Dwayne and Sue opened their gallery in Des Moines in 2001, they were entered onto a list of galleries that Thomas Kinkade would visit. The company, as part of their VIP assistance with merchandising, marketing events, and sales programs, supported every gallery with a formal planned event in which a new canvas transfer painting would be released, and Thom would come to be on hand to give a talk and sign autographs and books.

I came along on some of these tours, and they all unfolded in the same way. The signature gallery hosted what was known as a "collector event." Thom was invited to come and give a speech at the gallery, and the evening ended in a dinner with the artist. These events were often planned as whistle-stop tours for Thom. He would board a private jet and hit five stops in five days, touring like a politician: Chicago, St. Louis, Pittsburgh, Cleveland, and Paramus. He attended the collec-

tor events in one intensive week, and then retreated to his studio for six months to return to painting.

The pressure on Thom to create new works of art was great. The company needed between twelve and fifteen originals a year. Each painting took Thom over a month, and hundreds of hours to paint. Every masterpiece often had over fifty layers of paint on it, and required time to dry in between layers, so that he worked on several paintings at a time. All those layers gave the paintings their dimension and luminescence. So when a tour came up, it was often a welcome reprieve for Thom to get out of the studio and take a little break.

When I had the opportunity to tag along to a collector event with Thom and the ever-present Nanette, Bob Davis, Thom's event coordinator, and Terry Sheppard, his videographer, we would take a limo from the airport and head right to the gallery. As we approached, we'd see the gallery up ahead, decorated festively, lights beaming to the outside. An "events team" would already be on hand helping to coordinate the evening, making sure everything was just right.

It struck me that these events resembled a political rally. People were lined up along the sidewalk outside the gallery, already waiting for hours. A collector event was always open to the best collectors first, so that the waiting crowd could see the privileged few milling inside, sipping wine and eating cheese and crackers.

The new painting was first revealed to these select few collectors, before the general crowd was allowed inside. The gallery advertised in the local newspaper, so that not only collectors but also anyone curious could come to meet the Painter of Light. The new painting was never the original, which would have been sold by Rick in his gallery in Monterey for between $500,000 and $1 million. It was a copy, another canvas transfer, released in a limited edition, which was often about 2,750 copies.

The fact that the painting being revealed was a copy didn't bother anyone present. It was part of the phenomenon. People who collected canvas transfers, and those who just came to see the new image, were there for other reasons than we usually associate with a typical art

collector. The admiring public of Thomas Kinkade was there for the new *image*, the newest incarnation in a series of images, like an audience lining up for a sequel to a blockbuster movie. They were not there for the original object that depicted the image. It was the content and not the object that was important. Singularity of object was irrelevant to them, unlike a true art collector in the speculative art market. It was the addiction to the series. The newest lighthouse, the newest bridge, the newest cottage. It worked much like advertising, where once you have a consumer base loyal to a brand, they will come back for the new and improved version of the same product.

The brilliance of the entire sales technique was that there was still an exclusivity and factor that seemed to be legitimate. There were 350 signature galleries around the country by then, and there were only a limited number of canvas transfer paintings of each image to go around. Each gallery would be allotted only a few to sell, so that collectors had to buy them while they could. Of course, each canvas transfer was also still unique because of the hand-retouched highlighting, and the fact that DNA from Thom's blood mingled with the ink was in the signature. The chosen signature gallery would send out a notice that a new painting by Thomas Kinkade was coming; that Thom would personally sign paintings and books and any collectibles; and that everyone could come to hear him speak.

When the time came, everyone gathered before an easel covered by a white sheet. Then Thom emerged to applause, everyone smiling, the proud gallery owners standing nearby. There was an overflow of people, and many never made it inside, relegated to peering in through the windowpanes. The gallery owner would step up to the microphone.

"We are proud to be presenting to you tonight, a new work by our wonderful artist and friend, Thomas Kinkade."

The crowd applauded enthusiastically. Then the painting was revealed. The sheet was pulled aside, and a collective sigh rippled through the crowd.

Thom was led outside the gallery to a small stage that held a podium with a Painter of Light seal, which rather closely resembled the

presidential seal. Thom climbed onto the stage as Nanette stood to the side, the way she always did. He faced a crowd of a hundred people or more and delivered his address. It was awe inspiring to witness the throngs of people gathered in the street just to get a glimpse of Thom and to hear him speak. The crowd reacted with so much adoration that I was overtaken with the feeling that something important was happening; that we were all in the presence of greatness.

"Art is a universal language. When you use words to spread a message, it might be in German or in French and we would need an interpreter. But painting is a universal language. Painting is forever. It's a message unto itself."

The crowd nodded in affirmation. Thom looked from side to side, making eye contact with the audience, gesturing smoothly.

"You know, the fact that God could use an artist like myself to spread his message of hope is evidence that God has a sense of humor." Everyone laughed.

"I have been blessed to see God use me in spite of myself. If he can use an artist, he can use anybody. As my preacher said to me as a young boy in the country church in Placerville, California, when I was growing up, 'When you see a turtle on a fence post, you know he didn't get there by himself.' Well, I didn't get here by myself, either."

Thom held his audience in the palm of his hand. He was funny and had the crowd laughing in all the right parts. His jokes were always on him, and usually about his humble beginnings. Then he talked about Nanette; about their courtship, about their lifelong friendship, their wonderfully fulfilled family life, and how much she meant to him. She stood by his side, her hands clasped, smiling as she listened. She sometimes nodded to the audience to punctuate one of his points, and laughed in all the right places. She let him be the star. People loved seeing her interact with him, although she remained on the side, supporting him quietly. She was the proof; the witness to his witnessing. He explained how he owed everything to her patience and her devotion; how she was his better half. He recounted the story of how he first put her initials into a lithograph for fun, which grew into a tradition of

adding her initials numerous times into every single picture he painted. He told anecdotes of picking daisies in the field and swimming in the creeks with her, and how he fell in love with her at first sight. He spoke about their marriage and how solid it was, and how meaningful that was in a time when half of all marriages failed.

Then he spoke about his philosophy of life, and the many tenets in *Lightposts for Living*. He spoke about finding that which will bring a brushstroke of joy to your heart, and choosing the color you want your life to be. He spoke about painting your life the way you want it to be, and living in the light of thankfulness and simplicity. The audience listened, enraptured. Then he demonstrated how the paintings would bring these principles into everyone's life, and how strongly he felt about his life's mission to spread that joy and peace through his art.

When he finished his speech, he stepped off the podium and shook hands with his fans, took photos with babies, made small talk with the good folks, and signed autographs for a good hour or two. He could have run for governor with so many followers supporting him. The crowd thought of him as a great man; even as a prophet walking on earth.

When the event was over, he thanked the elated gallery owners. More often than not, he got back into the limousine and drove to the hotel, where Nanette was unceremoniously dropped off. The remaining posse of men would head out for a night on the town. If Thom poured his heart and soul into his speeches and into changing people's lives through his art, then he threw the rest of himself into the experience of living life at its fullest that he advocated for his followers.

It was this duality in Thom that I first witnessed in the bar in Kansas City, on our first Hallmark trip. Over time I had come to accept it as part of him. He was a man of contradictions. After giving inspired speeches in which he brought heaven down to an adoring crowd, he was ready to raise hell into the midnight hour. Maybe it was just the effect of the drink. The contradictions inside of him, his weaknesses and his foibles, made him more human to me; more approachable. He was an icon, but he was also just a man; fallible and imperfect, but with a good heart and good intentions. And he always kept us in stitches

with his one-liners and his late-night jokes. One time after an event, we ended up in a bar. A buxom waitress came up, and he said, "Well, well, well, it's very nice to meet you!" then looked at her ill-disguised cleavage and added, "Both of you!"

<center>❖</center>

The days of late 2001 were filled with success and prosperity. Media Arts was making hundreds of millions. Our books were million-dollar sellers. The licensing business skyrocketed further. And the signature galleries were driving cash by the barrelful to the shiny new Morgan Hill corporate headquarters.

When Thom wasn't locked away in his studio, painting for hours and days without rest, he was out at night letting off steam, having fun. Thom was a gambler, and we had many poker nights at Ivy Gate Cottage that went into the wee hours of the morning. Thom also liked to invite guys from the company to head out to Lake Tahoe, to stay at his house on the water, and spend the night gambling at one of the casinos in town. And even though Dan, Kevin, and Jay had left the company, they still loved Thom, and we often found time to get together.

On one such occasion, I was with Thom in his studio and we were strategizing about new projects and concepts. Suddenly he exclaimed, "I think it's time for a Tahoe trip. You remember the last one?"

"No, Thom. I've never been."

"I can't believe it! Let's rally the troops and make it a weekend! We'll get a private plane and gamble in Tahoe."

"Sounds like a great idea. Who do you want to have come along?"

"Call Dan Byrne. Kevin Sacher. Jay Landrum and Ken."

It was raining that night and I worried there would be snow up in the mountains, but Thom laughed at my concern and told me to tell the guys to be ready.

The next morning we met at San Jose International Airport and boarded a private plane like rock stars. There we were, executives in

<center>143</center>

our suits and ties and sunglasses, feeling on top of the world, riding high on the VIP treatment: no lines, no baggage claim, no waiting.

The plane was well stocked with alcohol and cigars, and we enjoyed every bit of the indulgences as we climbed the western slope of the Sierras, flying over Thom's childhood home, Placerville. We leaned into the windows and looked out as Thom excitedly pointed it out.

"There it is! My hometown!"

Over the Sierras the weather started to turn, and the rest of the flight, climbing the mountains to South Lake Tahoe, was one of the bumpiest I had ever taken. Being in a small plane was unnerving; you could feel every bump and shake. I couldn't help but think of my wife and four kids and wonder if a gambling trip to Tahoe was a responsible risk to take. I exchanged glances with the other guys. As the plane bumped up and down, shaking and rattling, Dan Byrne looked particularly concerned, and we tried to reassure each other with brave grim smiles. Thom, on the other hand, was unfazed. He was sipping a Bud Light and had a cigar firmly wedged in his mouth, wishing he could light it.

"What's wrong, Kuskey? You look a little green."

"Just want to make it one piece, Thom."

"Oh, we'll make it. This happens all the time."

I dared a glance out the window at the snow-capped mountains and the ominous billowing dark gray sky above. It looked like we were heading into a major storm. Then the lake came into view and we headed into a bumpy descent. As the winds buffeted the small plane, we landed at the South Lake Tahoe airport and disembarked just a little the worse for wear. As we stepped onto the tarmac, walking to the waiting stretch limousine, we overheard the crew talking about how the airport had been closed to commercial traffic because of hazardous conditions.

"Interesting start to the weekend," I thought. We took the limo to Thom's house, which was quite amazing: a beautifully restored 1940s lake house with a private dock and a gorgeous boathouse. His fully

restored 25-foot Chris Craft boat swayed by the dock, undulating in the lapping ripples of water. It was snowing up in the mountains, and I was sorry not to have a chance to ride in the boat this time. The boat, like the lake house, like his Model T and his Harley, were all unique items with history and character; one of a kind, just like him.

We went to grab a steak dinner at Harvey's Casino, where Thom told us about something he had developed with the roulette tables. He called it the "system." As we dug into our huge slabs of prime rib, wine, whiskey, and beer were flowing; he swore his system was fool-proof. We hatched a plan to use the system at Harvey's roulette tables that night.

The system was simple: wait for the roulette tables to run either four blacks in a row or four reds in a row, and then bet on the opposite color. Statistically the system was a joke, but that night, just as Thom had promised, it worked and worked. By the end of the night we were splitting up the tables, betting for each other, finding the run, betting on all even or all odds. Like an *Ocean's Eleven*, we were the gang that couldn't be stopped. We made thousands of dollars by the end of the night and stumbled out of the casino, after many more drinks and cigars, our pockets loaded with chips. When we cashed them in, Kevin had $2,000, I had $3,000, Dan had $2,000, Thom made $3,000, and Ken $4,000.

We slept like logs that night, having vowed to return to the casino the next day and do it again. The system was magic, intoxicating, and we all wanted more. It was the feeling we had whenever we were with Thom. There was a sense of invincibility about him that we all shared in his presence. Nothing could stop him; everything he touched was magic. He saw the world as miraculous, and it opened itself up miraculously before him. There was always more to be had, more to take in, more to consume, more to want, and more to own.

The weekend struck me as a symbol of our life with Thom. We boarded this wild ride with him, which took a perilous turn over Placerville, and we nearly crashed before landing. But Thom was invincible. We gambled and won at Harvey's Casino; the system worked, even though it shouldn't have. In fact, it worked until it didn't.

In the morning I received a phone call letting me know I had to return for a family affair. I regretted not being able to join the guys for another greedy round. But as I headed home with $3,000 in my pocket, the rest of the guys lost all their winnings back at the casino. I was the only lucky one to get out in time and keep my money.

From that weekend on, the system was revered as a symbol of our luck in the world, and our one night of winning was turned into lore.

<center>⚜</center>

On December 6, 2001, William "Bill" Kinkade passed away at the age of eighty-three. He was buried at Memory Gardens Memorial Park in Medford, Oregon, in a veterans' gravesite marked WILLIAM T KINKADE, CPL US ARMY, WORLD WAR II. He left behind two ex-wives and a current wife, four children, three stepchildren, and seventeen grandkids. His obituary discreetly named Thom as "W. T." from Monte Sereno.

By this time Thom's brother, Patrick, was living in Fort Worth, Texas. He had earned his bachelor of arts from the University of California Berkeley in psychology and anthropology, a masters from California State University in Los Angeles in counseling psychology, and his PhD from the University of California at Irvine in social ecology and research methodology. He was teaching criminal justice at Texas Christian University and publishing in the field. But despite his academic achievements, his life was a paltry one in comparison to Thom's, and Thom tried to help him out financially by giving him projects with the company, such as writing children's books.

In the wake of his father's passing, I had to admire Thom. For his ability to forgive, and for the fact that ever since his father's abandonment, Thom, the oldest boy, had ultimately become the man of the house, the responsible one. Ever since his paper route, he had taken care of the family that once struggled to survive in a trailer home in Placerville. Thom's sister, Kate Johnson, was now living in Vallejo, California, in a house in Thom's Hiddenbrooke gated community, while Thom's mother was still living in the house he built for her on his property.

Terry Sheppard was one of many people present at a South Bend, Indiana, book signing at the end of 2002, which later became the stuff of legend. Thom was on a book signing tour, traveling the country and speaking at signature galleries, shaking hands and signing autographs. To watch him at these events was always extraordinary for the way the crowd gathered around him, and the effect he had on people when he spoke. I had seen the way he commanded an audience; how he made them laugh and cry. He held them in the palm of his hand. He knew how to turn it on before a crowd. But when he let down his guard, the impulsive, immature part of him came out and his appetite often got the better of him.

On this particular evening Thom was in the heart of his constituency. If you plucked a woman off the street in South Bend, you would most likely grab a Thomas Kinkade collector. South Bend was also the home of the collectibles industry trade show, the Collectibles Expo, where the Bradford Exchange was prominently featured and where Thom had gotten his start. Thom couldn't have been in a place more meaningful and more central to his career than South Bend. After the book signing, long after the crowds had gone home, Thom and a few of his posse were still in the gallery, as well as the owners and their employees. There were six people in all, two of them women. It was late, and everyone was drinking and cleaning up. Thom started up a conversation with the men about a woman's anatomy. He began polling them.

"What do you think a woman's best assets are? Are you a butt man, a leg man, or a breast man?"

It must have been shocking for everyone to hear Thom strike up this conversation in front of the women. And these were Christian women. They idolized Thom, and they were in business with him. It was a terrible lapse of judgment, surely fueled by alcohol.

The Thom I knew wouldn't hurt a flea. But sometimes, especially once the drink took over, he didn't have a clue as to what he was doing. He would think things were hilarious that were shocking to others.

All the more shocking must have been the moment when Thom approached the well-endowed female employee of the signature gallery and palmed her breasts.

"These are great tits!" he exclaimed.

Thom would later claim it never happened, but many witnessed it.

The billion-dollar painter's appetite was great and often unrestrained, and one day it would come to get the better of him.

---➢› CHAPTER 6 ‹⬅---

Snakes in the Garden

Nobody ever lost a dollar by underestimating the taste
of the American public.

—P. T. BARNUM

By 2002, the 500,000-square-foot facility at Morgan Hill was pumping
out five hundred paintings a day. The perfected assembly line pushed
the canvas transfers through the high-tech facility, humming like a
well-oiled machine, creating the clones at an average of one per min-
ute. Even though replicated nearly three thousand times, these copies
would go on to sell for between $1200 and $10,000 apiece, which could
mean $500,000 per day. In part, the justification for the value of these
products lay in the hand highlighting added at the end. With the touch
of the human hand in the machine-printed canvas, every copy became
an original again; a concept never before explored in the history of art.
For some editions, in order to increase the value, Thom sometimes
drew an additional original sketch on the back of the painting, and
also sometimes added highlights himself, all of which brought added
value by the touch of his hand. And for those collectors, the ordinary
people for whom $2,000 and up was a lot of money, Media Arts had a
helpful financing program available.

The phrase *Painter of Light* was trademarked, and the small TM sym-
bol was added to every mention of Thom's name in print. The phrase

Sharing the Light also received a trademark. At the height of Thom's success, it had become obvious that his art was more than art—it was an idea. And the idea in the art was at its most powerful when you combined the image with words. That way, the image didn't just have to imply the idea; it could state it overtly. Thom's paintings always included a small scriptural reference as part of his signature line. Much to the delight of his collectors, Thom also added in Nanette's initial, *N*, cleverly hidden throughout various aspects of his paintings. It soon became obvious to everyone at the company that when you took an image of Thom's and put it on the page of a book and added a quote beneath, the image and words worked powerfully together to capture what he was saying and created a new product, a new brand. The images became more than images; they were moments of inspiration capturing an existential state. The words completed who he was as an artist, a writer, and a prophet.

Quotes taken from the scriptures, and from important figures in history and religion, were added to our prints as well as to our licensed products. Soon some of Thom's art calendars also contained biblical quotations. Instead of just reproducing a bucolic summery image of a lush garden enveloping a cozy cottage, we would include a quote from his *New York Times* bestseller *Lightposts for Living,* such as "Pursue your passion—or put passion into your pursuit" or "My life shines with God's radiant blessings when my heart is the color of joy." Words were added to many of Thom's core art products as well, and the message component became a big part of the business and greatly expanded the buyer base. Not everyone could afford a canvas transfer painting, but they could buy small, beautifully framed gift prints with Thom's quotes and sayings added. These could be sold for $60, or $99, or $120, based on size. With Thom's wisdom added, they nearly became their own market.

It was the task of my licensing division to approve the products our licensees planned to produce. A licensor like Hallmark would plan a new run of Christmas cards with one of Thom's images, and send us a mock-up with the image and a suggested quote included in the card. My team would analyze the image and approve it, based on our guidelines and Thom's wishes.

Mostly we were looking for quotes that were "inspirational," a marketing concept similar to motivational material; quotes had to entail messages that motivated and inspired the reader in a positive way. We were also looking for messages that contained the notion of light. Thom often brought everything back to the idea of light, as a core concept to his own brand as the Painter of Light. An image of a sunrise over a wintry cottage in the mountains became doubly powerful with a scriptural quotation beneath it, such as this one from the Book of Ecclesiastes: "Truly the light is sweet, and a pleasant thing it is for the eyes to behold the sun" (King James Bible).

Thom's images combined with inspirational messages were so powerful that customers just kept buying and fans kept coming for more. The Thomas Kinkade Collectors Society offered guided tours in Placerville, for which collectors traveled from far and wide to see his childhood home, his first studio, and the church where he and Nanette were married. They toured the houses he painted and walked the Main Street he immortalized.

The signature galleries provided inside access to the magical kingdom of Thomas Kinkade, and many collectors became obsessed. They could go to their local mall and enter the world of Thomas Kinkade like a ride at Disneyland. Some couples, prosperous hard-working people who had saved their money, some who prospered by owning their own businesses, or those who were willing to go into debt, spent up to $150,000 collecting hundreds of his canvas transfer paintings, and ultimately had to rotate them on a weekly basis to see them all. Collectors described experiencing withdrawal after more than a couple of weeks of staying away from the galleries. Another collector owned forty-four paintings and had them all hanging on his walls, with nine in his breakfast nook alone. This humble man from a small town in Texas spent $80,000, probably his life savings, on his canvas transfer collection. When asked which was his favorite Thomas Kinkade painting, he replied, "The one I don't have yet."

Media Arts advertised Thomas Kinkade as the most collected artist ever. This was calculated by the number of times an image was

reproduced and sold in its various editions, which numbered in the thousands for every image. No artist painting an original, and printing a limited edition of a hundred prints, could ever come close to the number of times a Kinkade painting was reproduced and published. In sales meetings and interviews, the high edition numbers were turned into a positive talking point: "Thomas Kinkade has sold more art than Monet, Picasso, Pissarro, and Manet." If someone inevitably asked, "All of them?" the answer would be, "Combined." In fact, it was true. No other artist came close to edition sizes as large as Thom's, or reproducing paintings and prints in the volume that he did.

Thom became such a star that he was a regular fixture at the White House. He was invited several times, not only as a personal guest of Bill and Hillary Clinton, but later of George W. Bush. For the Clintons, Thom was chosen to present a painting of the National Christmas Tree for the 2000 Christmas Pageant of Peace, which was also used on the cover of the pageant's program.

I had seen Thom in his studio back then, weeks before his departure, and he was buzzing around like a bee. He could hardly contain his excitement. He told me he was going to the White House as the Painter of Christmas, something he had always wanted to be. He showed me the program for the Pageant of Peace with his image on the cover.

"William Jefferson Clinton. What do you think he's like?"

I told him I thought he had his fair share of personal issues, but he was one of the greatest presidents this country had ever had.

"I think so, too." He grinned and added, "At least now I do!"

Thom and Nanette went to Washington, DC, to be on hand for the lighting of the tree ceremony, and Thom presented his painting to the president. Thom and Nanette even joined Bill and Hillary Clinton in the presidential box for the occasion. The painting was offered for sale at Thomas Kinkade galleries throughout the country, all of the proceeds going to the Pageant of Peace to support future National Christmas Tree lighting ceremonies. Thom had certainly achieved what he set out to be; he was finally the Painter of Christmas.

After his White House visit, Thom was very enthusiastic about Bill Clinton. He kept saying that he was a "hoot," and referred to him as "Captain Bill" from then on.

In the wake of his success, Thom had also become a sought-after guest speaker for pastors and religious leaders. Even bigger than Bill Clinton, in Thom's mind, was Billy Graham. Thom revered him. He was truly humbled when he was first invited to speak at a Billy Graham event. Speaking for Graham didn't hold the excitement of being at the White House and being recognized as an artist, when the art establishment was trying its best to pretend he didn't exist. Instead Billy Graham meant validation of his mission and his faith, and that was of paramount importance to Thom.

Thom later spoke at many Billy Graham events, and was even invited to place a large mural painting entitled *The Cross* in the Billy Graham Library. The painting shows a promontory jutting out above a vast and distant land, intersected by a cascading river far below. Clouds billow in from left and right, and atop the jutting rocks stands a cross, partially silhouetted against the sun setting on the horizon. The landscape is verdant and lush, and the sun casts a strong pink, orange, and yellow glow over the clouds. Intense rays project from the sun, inexorably drawing the eye, with the cross standing in opposition as though in a kind of duet or dialogue.

The biggest highlight of them all, surprisingly, came from Rome, the haven of that "fringe" religion called Catholicism. Pope John Paul II personally invited Thom to come to the Vatican to present him with a painting. When the news hit Media Arts headquarters, the whole company was aflutter. Of course Thom knew I had been raised a Catholic; he used to rib me about it.

"What's up with this whole thing about the pope, Eric?"

"I don't know what's up, Thom. He's the head of the Catholic church."

"How can one man be the head of a church? Only God is the head of everything. What's with that whole Catholic thing, anyway, praying to statues and buildings?"

"Thom, we don't pray to buildings, and we certainly don't pray to statues. The statues are there to inspire prayer."

I was tolerated, but it was clear that Thom and his born-again compatriots at the company barely thought of Catholics as Christians at all. Even Ken would introduce me as, "This is Eric, our VP of licensing. He's a Catholic Christian."

It didn't bother me. I thought it was kind of amusing, how being Catholic was considered fringe in Thom's born-again circles.

Then out of nowhere, when Thom received an invitation for an audience with the pope, his entire tune changed overnight. Suddenly Thom was all about the pope. He was going to travel to the Vatican and present him with a painting titled *Sunrise*. It, too, was an epic image showing a massive cross, placed on a hill, overlooking a far and distant land of hills and mountains touched by hanging mist and clouds, and the rays of the rising sun.

On the day Thom arrived at the Vatican, he nearly missed his audience, his flight having been delayed. Terry Sheppard was trailing along, capturing every moment of Thom's visit on tape. They raced through the streets of Rome and, by the glory of God, made it to see Pope John Paul II on time. They presented him with the painting in front of a crowd of thousands of people looking on in St. Peter's Square. From then on, I never heard the end of it.

"That pope is a great man, Eric," Thom would say.

"I'm glad you think so, Thom."

"Yeah. He's a holy man," he said reverently.

I was never referred to as a Catholic Christian again.

⚜

Thom's outreach was the most meaningful and important part of his work to him. Besides the long laborious hours he spent painting in the studio, Thom was happiest when he was out speaking to his fans. I saw people on their knees, praying, in tears. He elicited a devotion and fervor from his collectors and followers like I had never seen. It

was moving to see the effect he had on people. It was exactly what he wanted; to touch people in a positive way. I met people who had read every one of his books. I encountered collectors who had turned their homes into shrines to Thom. They saw Thom, as he saw himself, as a messenger of God who was here to shine a light on the path of the Christian people, his faithful followers.

He made a strong impression up on stage, dressed in a nice dark suit with a button-up white shirt, his mustache neatly trimmed, his hair perfectly combed. He gestured openly with his hands to punctuate a point, and held the microphone with ease and confidence, pacing as he spoke, and measuring his pauses perfectly.

He spoke to his Christian followers, hitting at the hearts of their lives. He would caution them to stop and smell the roses. To slow things down. To embrace simpler times. I think he spoke from the heart. He always talked privately about his memories of the past and his own nostalgia for simpler times. I often felt that all the wealth and acquisitions he had weren't making him as happy as when he was a boy in Placerville, running through the fields with nothing to his name except a connection to his creator.

"Look at you," he said to the crowd. "There you are, buying that new car. You've got a new computer. You're taking another vacation. But do you ever stop to wonder if you're really in control? Are you running the things you're pursuing, or are they running you? Do you really need these things?"

He made eye contact with everyone in the audience.

"Do you know what you need? You need to turn down the volume of life. The noise level is killing you, isn't it?"

People in the audience would nod.

"You've got to turn it down. Start with your television. Do you really need to have it on every day? Why don't you read a book instead? Read the Bible. Go outside. Listen to the birds singing. Gather your kids around you. Talk about memories. My paintings are there to remind you that you need to do that. You need to simplify, or you will get run over by the train of life."

There would be more murmurs and nods, and a few tears in the audience by now.

"When is the last time you said 'I love you' to your wife? When is the last time you tucked a love letter under her pillow? Or surprised her with a gift when it wasn't her birthday?"

By now everyone in the audience was feeling guilty for neglecting their significant other. Then Thom would move to the subject of the light.

"Here's how easy it is. Come into the light. Step into the light in your life."

Some people raised their hands to God. Some had tears in their eyes, overcome with emotion. Some bowed their heads in prayer. These moments often had the feel of a revival meeting.

"My paintings will be a reminder that you are called to a simpler life in which you appreciate all the wonderful things you have around you. God has designed a life for you that is simple and meaningful. He wants you to have a close relationship with him and with your family. Just look at me; that's how easy it is. It's what I've got, and what I wanted all along."

It might seem there was irony in the fact that Thom was advocating simpler times for others, and living with less, while he himself lived a life full of luxury. But Thom didn't see it that way at all. He always believed in what he was saying; it was the nostalgia he had for his own early life. He really believed that living simpler was better, and often told me that his life was happiest when he had nothing. However, he was also playing a certain role very convincingly, the role assigned to him by the company as the representative of the brand. He was a personality, a lifestyle, and a message. And whether he lived it himself or not, the message had to get out, and people loved to hear it.

Thom was completely separate from the process of selling the artwork. Even when he showed up at a collector event or a signature gallery, he came as the personality. He never hawked anything; the company was very careful to keep him away from the sales side. He was the Wizard of Oz. He stayed at home and painted the simpler times he

advocated, and went out and met his adoring public, and talked about the messages in his paintings.

Perhaps that's why it was hard to reconcile the duality of Thom's personality. In those moments when I saw him speak, I saw Thom the brand, the personality, the legend. But somewhere inside was Thom the real flawed person. I know he believed the things he said. I think he dealt with the contradictions, and the pressures to live up to a legend and a perception of perfection, by compartmentalizing his mind, and by escape and denial. These habits are common among alcoholics. They are coping mechanisms. Instead of facing the contradictions, his fears and his shame, he had to project the best side of himself out to the world, and numb his unconscious shame and conflict with alcohol. And I believe both of these actions were justified in his mind as long as he was doing God's work. It was a life of perpetual sin and atonement. But I have never doubted his conviction. There was nothing cynical in his belief that he had a special task given to him as the painter with a higher purpose. This ultimately exonerated him in his mind. It was all justified, all in a day's work for someone who was a messenger from God.

Thom was really no different than any great artist you've read about in the history books. They were all tortured, driven by demons, and haunted by vices that often took them too young. He was obsessed with the idea. He often talked about Vincent van Gogh, and all the artists who died young, with a sense of identification and inevitability. Thom was sensitive, he was obsessed, and he had no choice in life but to paint. It was his lifeline and his destruction. Perhaps a certain suffering is necessary for any artist to be great. It's the question of what comes first, which might never be answered. Are you an artist because you suffer, or do you suffer because you are an artist? Perhaps both are true.

Thom's fervent following meant the company was practically minting money. Thom was an icon, and with his message, he had become a way of life. There were corporate discussions about how the brand had become larger than Martha Stewart or even Disney in its broadness of appeal. Thom would say that Disney would never sell

its own furnishings the way he had done, and Martha Stewart would never open a theme park, but he was the kind of brand capable of pulling off both those possibilities. There were discussions of a Thomas Kinkade fragrance and Thomas Kinkade Sunday morning children's TV programming. The only limit seemed to be what the imagination could hold—and Thom's imagination was endless.

At one point early on Thom and I were brainstorming new ideas for licensing products, and I had jokingly mentioned making Thomas Kinkade–branded houses. Thom jumped right on the idea. At the time I didn't think he was serious, but he brought up the idea years later when I had returned to work with the company.

"Eric, do you remember when you suggested that we license Thomas Kinkade houses for a development?"

"Thom, I was kidding."

"I paint paintings of houses. Why can't we do the whole house?"

"Okay," I said slowly. "I think I can come up with a way to do it."

Soon enough, we were contacting developers, architects, and city planners. We ended up signing a licensing deal with the Taylor Woodrow Company, a British company with an outpost in Los Angeles that was willing to build a development in Thom's name in a tract-housing grid of suburban Vallejo, California. Thom wanted an English name and a rustic feel to it, just like his paintings. We settled on a name: The Village at Hiddenbrooke, a Painter of Light™ Community. When we looked at the plans drawn up by the architects, there were roads and houses that bore the titles of his paintings and names of locations in them. It was as close to designing a theme park as I could imagine. Later that year, his dream became a reality.

As the money poured in, Thom, Ken, and Rick never stopped spending. While I traded my Volvo in for a slightly used convertible Porsche, the three founders of the company were buying cars, cars, and more cars, and more houses and more boats. Thom bought a vintage Harley-Davidson and rode around town like a hardcore biker. He added a 1969 Mercedes SE convertible to his growing car collection, and a 1960s Porsche.

Thom also bought a historic 660-acre ranch, making a longtime dream come true. It was a working cattle ranch near Gilroy, California, nestled in the Diablo mountain range of San Benito County, just an hour away from Los Gatos. It was called the Doc Bar Ranch and had a history of quarter-horse breeding. The famed racehorse Doc Bar was buried on its grounds, with the headstone long lost and the location of the grave forgotten. Thom loved to head up to his ranch, get on a horse, and go on long cattle drives. He'd step out into the sunshine and paint the mountains, enjoying his whiskey and cigar on the veranda. Some days he read his favorite books in the hammock under the tall oak tree: James Michener novels, pulp fiction detective novels from the forties and fifties, history tomes. Other days he went off to shoot deer in the hills with pieces from his collection of guns and rifles. The house was the kind he always preferred: an old, historic adobe structure from the turn of the century, written into the Spanish land grants.

If he wasn't on a horse, Thom was on his Harley cruising the Central Valley's winding roads. He would take part in the annual Hollister Rally Harley Ride, famous for the motorcycle riot in 1947 that struck terror into the hearts of Americans. The story made it into *Life* magazine, a copy of which Thom owned. He even rode along on the weeklong Sturgis Rally in South Dakota, one of the largest motorcycle rallies in the world. Thom was always up for an adventure. You wouldn't catch Ken or Rick dead on a Harley, much less in a crowd of bikers, but Thom wanted to taste as much of life as he could. In his quest, he was down to earth, nonjudgmental, unpretentious, and open to all flavors and strata of life.

Thom was a sentimental man. He loved the past and he loved remembering, because things were always better in memory than they were in the present. Having old things kept him in touch with the past, even if it was just his rumbling vintage Harley. He wasn't a tough guy, but he would walk through town with his cigar, wearing his biker boots, his bike parked on the side of the road. He'd go into the nearest dive bar, the grittiest place he could find, where he'd chat up the guy on the next bar stool to find out what he was thinking about.

On one of many of these occasions I witnessed, Thom plunked himself down in a dark and dingy biker bar in San Jose and looked at that one old grizzled biker nursing his Wild Turkey on the rocks, sitting on a red vinyl bar stool. Thom turned to me and said quietly, "Look at him. Can you imagine the stories he has to tell?"

He then looked at the old biker again, and nodded to him. Thom was secure that no one knew him or recognized him in these places, so it was safe to simply strike up a conversation and begin to investigate someone's life, which he loved to do.

"How are you today, sir?"

The biker would glower and try to ignore Thom. But Thom was too persistent and charismatic to ignore.

"What are you drinking there?"

"Wild Turkey," the man would say.

"Mind if I buy you another?"

The biker glanced at him suspiciously. Then he shrugged and nodded; no one ever turned down free alcohol.

"Bartender! Bring us what he's having. Three of them."

The bartender poured our drinks, and Thom would start his questioning.

"So where are you from? How long have you been coming to this place? This is the most amazing bar. I've driven by a hundred times, but never came in."

As the bartender and I watched, amused, Thom would delve into the man's life and buy him several more rounds. Finally he'd leave with the story of another life; another connection made.

Thom talked to everyone, and everyone talked to him. He dressed up as Santa Claus at Christmastime and handed out presents to friends. He socialized with his Monte Sereno neighbors in their mansions, and he also knew the homeless in town personally. He had a spirit that wouldn't quit; an appetite to know people, and to experience as much as possible.

The building validation by his business and his fans and followers had a significant impact on Thom as well. He actively sought to do

good in the world, getting more involved in charities and philanthropy, giving his time to the Make-A-Wish Foundation, donating his art to charity auctions, and speaking to people whenever he could. I saw him speak to thousands at a time, and I saw how they really wanted to hear what he had to say. In those special moments, the nights of partying and drinking were forgotten. These were the moments that meant the most to Thom, and represented the peak of his happiness. Giving people hope was what he was really all about. The money was a game, and the toys were just that—toys.

<div align="center">❦</div>

At the peak of his success, never in the history of the world had an artist developed a brand like Thomas Kinkade. Never had a painter sold his work in the hundreds of millions. Thom was far more than art; he had become a brand. Popular artists like Peter Max and Leroy Neiman barely came close to the recognition Thom's work garnered. Only Andy Warhol might be as recognizable as Thom had become. And Thom used to say, "Andy Warhol is my hero, and I'm his heir apparent."

The critics such as *San Francisco Chronicle*'s Kenneth Baker and the *Los Angeles Times*'s Christopher Knight disagreed, and many had nothing but harsh things to say. Critics called his work mechanized, saccharine, and schlocky, and said it belonged in the trash. They called his paintings facsimiles of something inherently dead, and said that escapism is not art; and that Thom might as well be selling hamburgers. Essayist Joan Didion called his imagery creepy in that the cottages had such "insistent coziness as to seem actually sinister, suggestive of a trap designed to attract Hansel and Gretel." She added that "every window was lit, to lurid effect, as if the house might be on fire." University of Missouri art professor Brooke Cameron predicted that no one would remember Thomas Kinkade as an artistic innovator. He said there was no poetry in his work and it was kitsch, and that Thom was a male Martha Stewart.

I always felt these criticisms were much too harsh. I knew Thom's art didn't appeal to the modern art market, but I felt he was a considerable talent. When I watched him at work, I was amazed at what he would create in his long hours of painting. I felt he was a genius, whether one liked his imagery or not. For me, there was no discounting his immense talent.

Of course, Martha Stewart was music to everyone's ears at the company. The comparison was hardly a problem for Thom. That was the point: to reach as many people as possible. Because of Thom's belief that his art was also his ministry, and because he felt there was a higher calling to his selling and distributing as many images into the world as possible, he saw no reason to worry about its legitimacy in the art world. Thom was serving a higher god. He had no need to apologize for success. Success only meant that his silent messengers, his paintings, were spreading more peace and light in the world. Defending his place in the pantheon of art, he would declare, "Twenty million people can't be wrong." Indeed, tens of millions of people owned something published by Thomas Kinkade, which made up an estimated 10 percent of all Americans. Thom would opine, "David Hockney can't say that!"

He didn't endear himself to the art critics with such statements, but he wasn't trying to. Thom would openly claim that in time Picasso would not be "regarded as the titan that he is now." He characterized him as a man of great talent who hadn't used his talent "in any relevant way," and that he could create "three Picassos before breakfast because he could get ten thousand dollars each for them." He saw no irony in criticizing Picasso for wanting to make money with his art, while he himself was selling his art "by the carload," as the *New York Times* expressed it. He told the *Times* his art was populist and "wildly embraced by our own culture," and that while he might not be endorsed by the critics, his heart belonged to the people. In another interview, he took on the foundation of the art world, the sanctity of the original: "Lots of artists have the opinion that publishing your work is selling out. They're hung up on the one-of-a-kind thing. I'm a messenger. You can't be one of a kind when you're a messenger."

To me Thom once said, "Eric, just imagine if I was Tom Clancy and I had just finished my fifteenth novel. And I spent nine months writing it. And then I decide to publish only one book. What good would that do? Money aside, how is that spreading or sharing the work? Tom Clancy sold forty-five million books. There's a reason he doesn't just print a hundred books. I'm the same way. I am going to print as many prints as people want to see." Thom saw his prints as a novel. That was his way of sharing, of touching people's lives.

Thom simply saw his art as ministry. Spreading his message to the world without restraint; a message of family, faith, and simpler times. He was anachronistic in that sense, living in another era in his mind. Reconciling the contradiction between the Thomas Kinkade who spoke about his values to thousands, and the Thom I saw heading out into the night was sometimes a challenge. But he was the first to acknowledge it himself. He managed his own contradictions by constant confession and humility.

"I don't know why God chose someone like me."

"I give credit to God. Everything I do is God working through me."

"I'm a fallible human. I try my best, but I fall short."

"Thank God we are forgiven."

He never took credit for his painting. If someone paid him a compliment, he wouldn't jump in and agree. His answer was always the same: a simple "thank you." If someone pointed out how well things were going, he would always praise God. It was how he managed his own conflict, and how he appealed to his audience. They saw the humble man, the contrite man, the man seeking God's light, striving for a better life. Whether or not he lived them all the time, I know Thom deeply believed in the values he preached.

At Media Arts, Thom's values were selling tools. They were the brand. In executive meetings, the value of Thom's message was good business. Once the Kirby salesmen had invaded the executive stratum of the company, anything that created a sale was fair game, and religion in Thom's art, like sex in modern advertising, seemed to be the hottest sales tool they had. Thomas Kinkade University certainly

incorporated religion as part of the mosaic of the business. Images were sold with religion by the inclusion of Bible quotes and biblical images. The "light" concept helped to develop consistency in the brand, and the Painter of Light trademark provided crucial brand-name recognition. Contrary to Thom's being all about his ministry, Media Arts evolved into a company that seemed to be all about the sale.

Thom earnestly believed he was a chosen messenger of God, that his life's purpose was to paint images that would not only touch people's hearts, but literally change the world. He had a gift inside of himself, a gift he took no credit for. He had been blessed with this gift for a reason, and he was always focused on how he could use it to do God's work in the world. He wasn't cynical or calculating about it. The company used his gift as a sales tool, but for Thom it was his purpose in life.

Ken's departure from the board, and from his position as CEO, had signaled a detrimental shift in the company's values. Sales became the main driving motivation for everything Media Arts did. It wasn't about the long term. It wasn't about having a broader perspective, or about building and honing the image and the message for the long view. Scarcity drives value in the art market. The perception of scarcity of Thom's images needed to be managed by the company, but it was undercut and ignored by the desire for sales at all costs.

Internally we analyzed the market all the time. Greg Burgess, Rick's former Kirby sales associate who was acting CEO, famously told CNN that there were over forty walls in the average American home, and their job as a company was to figure out how to populate "every single wall in every single home and every single business throughout the world with his paintings." We created spreadsheets of sales, counted the galleries, the products, the venues, the licenses and licensees, and calculated them against the American population. How much could be sold to how many people? Was there a risk of overexposure?

We called it the "brick wall." It was always a baseline discussion in the company. We were always asking ourselves, "How much is too much? What is the right edition size? When do we hit the brick wall?" We would joke about it nervously, in a kind of gallows humor. If a

truck with a shipment was delayed, we'd look at each other and say, "Must have hit the brick wall." If sales dipped slightly after Christmas, an annual phenomenon, we'd kid, "It's the brick wall." But there was nothing funny about the thought.

It turned into a kind of game of hocus-pocus. It was brought up in meetings, when we would say, "It's out there. The wall is lurking out there somewhere." It was spoken about with a sense of apprehension. Like a monster we felt was lurking in the bushes, but one we just couldn't see. Over and over again, we were convinced we had finally hit the brick wall.

Years ago, Kevin Sacher, former senior vice president of marketing, had come up with a crude method of calculating the market saturation potential, which he shared with management at a time when the signature galleries were just exploding. He added the number of planned yearly editions and the number of editions already sold, multiplied all the images over the current lifetime of the sales, and then divided this number into the population of the United States. At the time, he determined that a hundred million Americans owned some form of a Thomas Kinkade painting. He pointed out that if you included all the licensed products, that number would double. His final conclusion, which he wrote up in a memo, was that we had already reached the brick wall in the late nineties; that a limit had been reached, and the market demand could no longer sustain the output.

There was concern over his memo for a few days, and I sat in on a few meetings to discuss the issue. As the senior vice president of licensing, the sale of the art was not my area of expertise. I deferred to the sales team's feelings about Kevin Sacher's projections. In these meetings I had to let them be the experts. The "brick wall" sounded like an ominous thing, and something I didn't want the company to hit. But if they said things were under control, I had to believe them. Licensing is the opposite of the art market; you want to sell as much as you can. There was no brick wall for licensed products.

These harbingers were quickly forgotten, and more editions were printed and more galleries were opened. Kevin Sacher was the only

one who spoke out now and then, reminding us of his report. He'd warn us all: "I'm just saying, guys. I did the math. It doesn't look good." Then Thom would shatter another record, sell more prints, more calendars, more plates, and the idea of a brick wall seemed absurd. We never saw the monster coming. Instead all we saw was an endless demand.

Ultimately we had no blueprint to go by—no one in the history of the world of art had ever done what Thomas Kinkade and Media Arts were doing. The company was in unknown territory. It was anyone's guess what would happen.

At the height of his success, there truly seemed to be no limit to Thom's sales appeal and marketability. The licensed product possibilities were also endless: puzzles, rugs, bookmarks, wallpaper, and wrapping paper. The opportunities for invention and reinvention seemed infinite, and the public's hunger for the newest Kinkade product appeared to be inexhaustible. I was doing my job, and my job was to sell as much as possible and create as many products as possible. That's the beauty in licensing; the more reinventions of products in the market, the better for sales.

The sense of invincibility that pervaded Thom's consciousness and the company's sales strategy meant there was no calculation for oversaturation. It just didn't seem to be a factor; the plan was no plan. Signature galleries continued to be opened—over four hundred of them by 2002—and paintings continued to be released into the market. Expansion was the name of the game, and it wasn't questioned by management. We all believed it; I certainly did. The arguments for it were very sound on paper. It was what we needed to do as a public company. As mentioned earlier, even Thom welcomed the idea of taking some of the load off his shoulders. Expansion marched on. As long as there seemed to be demand, that demand was going to be met.

Starbucks Company saw growth similar to the signature galleries' growth, with multiple locations opening so close to one another. The crush of competition began to diminish the exclusivity and the appeal of the brand. Supply and demand is a dance that must be well choreo-

graphed; too many dancers onstage make for a lousy performance. Too much growth, too fast, can lead to a forced contraction, as we saw with Starbucks closing over five hundred stores in 2008. But as long as there was room on that increasingly crowded stage, the company kept expanding.

Adding to the expansion of the sales tool for selling Thom's art was the QVC network. QVC first aired Thomas Kinkade sales as early as 1998, and by 2002 they aired a regular broadcast from the Morgan Hill company headquarters. At the time, Thomas Kinkade was the only brand QVC allowed to sell off-site from their headquarters in West Chester, Pennsylvania. Media Arts spent millions to build a living room in Morgan Hill, from which remote shows were broadcast on the QVC channel, featuring Thom and his art. Thom went on camera to speak to the audience about his art. He described his symbolism in the different prints, and the number of Ns he embedded; he gave his messages of hope and simpler times. He would smile into the camera and speak to every viewer as though they were sitting together in their living room.

"This is one of my favorite pieces. It's a house I drive by every day when I'm at my home in Carmel-by-the-Sea. I just love the light when it first comes up from the east and touches the oaks of the shore, and the houses perched about the ocean, like this one."

Media Arts never wanted Thom to appear as though he was selling his own artwork. Thom was always kept far away from sales, and entirely on message. So on the QVC show, he was simply speaking as the celebrity artist. He left the actual selling to Dan Wheeler, a frequent host of the show.

Dan would step in and ask questions and guide the conversation.

"You are, of course, called the master of light. What is it about the light that interests you?"

"I see light as more than just a physical dimension; I see it also as a spiritual dimension. Something that I think gives hope to people. I've always had the goal, through my artwork, to inspire people's hearts, give them a little hope. Remind them that every day the sun comes up and it's a brand new day."

"That's right, your art does inspire hope and many good feelings. We hear from our viewers all the time, how happy they are that they purchased one of your images."

Then Dan Wheeler would turn to the camera and make his final push.

"And folks, for only fifty-nine ninety-nine, this beautiful, inspiring print can be yours. We're going to make it especially interesting by offering a twenty percent discount to the first one hundred callers. Pick up that phone and give us a call, so that you can have this beautiful Thomas Kinkade print for your own, before they all sell out. And folks—they always do."

And the art sold in the millions of dollars every hour.

A fine line was being trod, but this time it was overlooked. The name Thomas Kinkade stood for many things. The name was message, it was lifestyle brand, and it was art. But could all of these be reconciled? Unlike a Martha Stewart product, Thom's art was very specific and didn't change. He had his program, and he followed it to a tee. He painted cottages, gardens, lighthouses, bridges, gates. Every year he would paint a new bridge, a new gate, a new cottage. This created a desire in collectors to have the next lighthouse and collect his work along themes. But it also created somewhat stagnant imagery over time.

The necessity to nurture the market as an art market was crucial to the product. This wasn't house paint. Or a Mickey Mouse trinket. These were paintings—art—that purported to have a market value as well as a spiritual value. There is something intangible about how an art market sustains itself and its product; a certain sleight-of-hand that keeps any given artist at the top of the heap. If every collector were to decide that a certain artist's work had no appeal, then that artist's value would instantly plummet. An artist like Keith Haring, once highly valued in the eighties art boom, suddenly dropped with the perception of his commercialism, only to start climbing again twenty years after his death. The sale by influential collector Charles Saatchi of his entire collection of Sandro Chia, a highly valued artist in the eighties, caused

Chia's market value to plummet. It is, in a sense, a perpetual bubble kept intact by those with a stake in its continuation.

This is why the sales-at-all-cost approach to selling art, in an art market based on limited editions and scarcity, was a dangerous game to play. Licensing was based on the idea that more was certainly merrier. But the art market, even Thom's less sophisticated art market, had a mind of its own. However, it seemed to me that little thought was given to the careful development and cultivation of his core market by the people at MAGI, who appeared to be ultimately uninformed and possibly unqualified.

Not everyone was unaware of the saturation problem. Those watching from the outside voiced concern. In an interview with *USA Today*, a business and marketing expert, Peter Sealey, is quoted saying, "I think he's got too much stuff out there, and as supply exceeds demand, you'll see a decline in interest."

In the end, it often came down to Rick Barnett and his opinion. Everyone in the meetings always turned to him.

"What do you think, Rick? Are we hitting a wall?"

Rick pulled out his briefcase, put on his reading glasses, contemplatively shuffled his papers, and read deliberately as the rest of us watched with bated breath. He put on and took off his glasses several times, then tapped on his calculator watch, tap-tapping as the twelve executives in the room looked on. He finally flung his glasses down, looked around the table, and said that we now had 180 people on our waiting list.

Holding up the list for emphasis, he added that he was opening galleries as fast as he could, and saw no end to the demand. The idea of hitting the wall anytime soon was quickly dismissed, and more and more galleries were opened.

But the signs were there. By 2000, fifteen galleries had closed. They hadn't been able to keep up with the mandatory inventory purchases from the company, and hadn't been able to generate the sales needed to sustain the day-to-day operation of the galleries. By that time, Ken and I had left the company, and if anyone had concerns over the closing of

the first galleries, they were not discussed with us at that time. From the outside, it looked like business as usual.

In a sense, there was never much incentive in taking too close a look. The company was raking in huge amounts of money, everyone was profiting, everyone owned stock, and everyone got their Christmas bonuses. No one wanted to rock the boat, and the boat was the stock price. As long as that remained healthy, hovering around the $30 a share price, everyone was content not to fix what wasn't broken.

<p style="text-align:center">❦</p>

It was always about Wall Street. The stock value and quarterly earnings were pressures that loomed continuously. Since Media Arts was a public company in which people owned stock, investors cared about its financial health and its valuation on Wall Street. Media Arts employees monitored the chat rooms and financial blog sites on which investors posted, to keep abreast of the word on Wall Street. One day it came to the attention of Tim Guster, general counsel at Media Arts, that an anonymous Yahoo! Finance chat room contributor with the name "Eyes Nose" was regularly posting about Media Arts and Thomas Kinkade. Using expletives and insults, Eyes Nose was badmouthing the company to an extreme, claiming calamities and mismanagement, and predicting imminent doom. And worst of all, he was tearing into Thom's character and the company's Christian ethos with extremely disparaging, obscenity-laden attacks that were shocking to anyone who read them. Copies of the transcripts made the rounds at the company, everyone puzzling over this apparent "agitator" taking such brutal aim at Thom and the company. People wondered what could possibly be the reason. Was he trying to drive the value of the stock down with his negative rants, in order to short the stock?

Then one day, the anonymous agitator crossed the line. He started hinting at information only senior executives at the company could have known. And he threatened to disclose Thom's home address.

Tim Guster decided to take matters into his own hands. He filed a lawsuit against Yahoo! to force them to disclose the identity of Eyes Nose, as he was posing a potential threat to Thom's security. The suit dragged on, and during the discovery period Guster subpoenaed the information on Eyes Nose from Yahoo! On the last day of compliance, Yahoo! reluctantly gave up the name of the Internet service provider for Eyes Nose. Guster filed another subpoena asking the Internet service provider to disclose the identity of Eyes Nose. Before the last day of the mandated compliance, Guster heard a knock on his door and Eyes Nose entered his office. It was someone inside the company; in fact, someone on the Kirby crew.

Guster reported the incident to Thom, and then to senior management and the board that day. Action was taken immediately. The culprit was soon gone from the company, and Eyes Nose stopped posting in the Yahoo! Finance chat room.

Soon Greg Burgess ended up paying the price for the incident, since it happened on his watch, and there was a general feeling on the board that he should have seen it and prevented it. The board called a meeting at Thom's beach house in Carmel-by-the-Sea. Greg knew he was going to be fired. He was being given one last opportunity to talk to the board about the incident and his future at the company. As a formal board meeting, there was a roomful of people: Thom, Ken Raasch, board member Tony Thomopoulos, and others. Of course Ken was there in his position as the largest shareholder. He had as much concern and say in the matter as anyone did, and probably a healthy dose of silent "I told you so."

I heard later about what had happened. Greg Burgess arrived an hour late, which irritated everyone. According to Thom, Greg finally stumbled inside with a bloody bandage wrapped around his head, saying he had been in a terrible car accident. Someone asked if they should call 911. But Greg exclaimed, "No!" Then he slowly began to unwrap the bloody bandage from his head and added that he was just kidding. There was no head wound; there was no accident. Greg said the bandage was just a metaphor for the condition of the company,

and that he was trying to show his passion for the job by showing he would go to any lengths to fix things. He said he had a plan. Everyone in the room was dumbfounded. Their CEO seemed to have lost control of his faculties.

Greg pulled out a sheaf of papers and told the group that he had a "new plan" for the company. He was immediately dismissed from the room and from his job, and asked never to return.

The board had a problem on their hands now: they needed a CEO. In that very meeting, after Greg was gone, they turned to Tony Thomopoulos and asked him if he would be willing to come out of retirement and come on board as interim CEO until a suitable replacement could be found. Tony didn't need the money or the headache, but he agreed to help out.

As a founding member and Thom's closest confidante, Rick was, of course, the last man standing. But the Kirby era of sales at all costs had finally come to an end—at least for the time being.

✦

Tony Thomopoulos was the former president of ABC Television and former chairman of United Artists. He was not only a member of the board, but also a friend of Ken's and mine. He had acted as a consultant during many of the early years, when Ken was developing CinemaClips and he and Thom had a vision of getting the Thomas Kinkade business into Hollywood.

When Greg Burgess was fired, Tony agreed to take on the job for six months. Tony was married to Cristina Ferrare, a former supermodel, and they brought a Hollywood touch to the company that was glamorous on paper. He would have just as gladly spent his days enjoying his well-earned retirement instead of taking over the helm of the juggernaut that Media Arts was, but he did it as a favor to Thom. Tony had become friendly with everyone over the years he consulted for the company, and he liked Thom personally. Tony was also a Christian, and thus fit in with the company's sensibilities. He was competent, re-

sponsible, and conscientious, just what the company needed after the turmoil experienced under the leadership of the former CEO.

Tony was the Hollywood elite, handsome and dashing, with long gray hair and aviator sunglasses; always well dressed. He and Cristina were a Bel Air couple, raising their beautiful children, and Christina was busy starting several businesses with Tony's help. Every week Tony got into his powder-blue Mercedes-Benz 350 CLK convertible with the white leather interior and the shiny chrome wheels. He would leave his perfect life and drive the three hundred miles to San Jose to the chaotic and dysfunctional Media Arts.

On one of his first days there, I was present with others to greet him and show him the workings of the company. Tony looked around and said the company was in serious disarray. He ended up dutifully overseeing the company for the next two years, after he had agreed to only six months, jetting back and forth between his home in Los Angeles and San Jose, without ever having planned to do so. He held things together well enough for the machine to keep churning; he was a well-spoken representative for the company and made many important contributions.

Early in Tony's tenure as CEO, a senior-level sales executive recommended the company participate in a one-time sale of Thomas Kinkade prints at the discount outlet Tuesday Morning. The company needed extra capital since sales had been down with galleries closing, and Wall Street pressures had only increased. Tony had the unenviable task of helping to decide whether the sale of very dated inventory would anger or alienate the existing customer base of the signature galleries. Because the items offered would be paper prints and not the highly sought after canvas transfers, Tony's team recommended the sale be approved. There was much discussion at the time about whether the sale should proceed. The discussion even made it over to my office, where Tony asked Ken and me what we thought. My response was that I was not close enough to the details, and suggested that maybe the signature gallery owners should be polled. I'm not sure what exactly happened after our discussion, but the sale went through,

and it created a firestorm of controversy. If the discount sale didn't send the company into further oversaturation of the market, to some it gave the appearance of desperation.

⚜

Vallejo, California, is a suburban outskirt of the San Francisco Bay, the tenth most populous city in the area, and the home to the Six Flags Discovery Kingdom theme park (formerly Marine World Africa USA). Mainly a tract housing grid, it became the home for the Thomas Kinkade Village inside the Village at Hiddenbrooke, a planned development of ten related communities, all inspired by the Painter of Light.

Beside a Smorga Bob restaurant and a Rite Aid stood a billboard by the freeway advertising GET AWAY, EVERY DAY. THE VILLAGE AT HIDDENBROOKE, with images of golf greens, leisurely dressed golfers, and steak dinners. The village itself abutted the edge of Vallejo, beyond which the land emptied into brushy hills and farmland. The Hiddenbrooke development spread over thirteen hundred acres, with a golf course at its center.

On March 16, 2002, the day of the ribbon-cutting ceremony, I rode out to Vallejo with Thom and his family, to be on hand for the occasion. He wanted me to come, since the spark of the entire endeavor had begun in one of our brainstorming sessions. Nanette sat beside him as Thom looked out the window at Vallejo speeding past.

"Isn't this just a glorious day?" he exclaimed. "Did you ever think we would do it?"

"I knew we would," I answered.

"Well, you are really the one who did it, Eric. You pulled this whole thing off. I can't wait to see it all in person."

"I'm sure you're gonna love it," I said.

He turned to Nanette and squeezed her hand.

"Remember, honey, when we first met? I barely had a roof over my head back then. Now I'm building houses for people!"

When we arrived, a huge crowd had gathered, eager to catch a

glimpse of the Painter of Light, and to have a view into one of the model homes.

We had marketed the village with all of Thom's branding. Our brochure touted the village as a vision of "simpler times," and called it a "neighborhood of extraordinary design and detail." Thom had wanted to create cottage-style homes "filled with warmth and personality," and a "garden-style landscaping with meandering pathways, benches, water features and secret places." The cover of the brochure featured one of Thom's paintings, which showed a rain-drenched village with a church steeple and a family out on a walk with their dalmatian, spring flowers cascading all around them.

Thom's vision was that this village would bring to life the quaint cottages and gazebos and the lush garden landscapes right out of his paintings. On closer look, the area looked much like any generic development of tract houses, with concrete patios and bare lawns. No church steeple in sight and no town square; just the developer's square-foot planning. The 101 nearly identical tract homes were squeezed fairly close together, were bordered by a stone wall and gate. The Kinkade village was neighbored by other communities with names like St. Andrews, The Heights, and The Masters.

Four model homes were open to the public, with the names Everett, Winsor, Chandler, and Merritt, after Thom's four daughters. Each home was designed in a particular architectural style, such as Tudor or Victorian, but it was just that: with architectural detail in terms of the style, but not in design. And certainly nothing like the thatched-roof cottages of Thom's paintings.

Thom and the company did not design or construct the houses. The Taylor Woodrow Company had designed the houses and submitted plans to my department and to Thom for approval. There was a financial reality to the strictures inherent in that process. A price point had to be met to be able to offer the houses at $400,000 each, and that meant certain limitations were unavoidable. To approximate the Thomas Kinkade look, the firm focused mainly on adding gabled roofs, dormers, and white picket fences. The patios were very small,

and the fireplaces were only gas. Landscaping was too expensive for the company to maintain without having sold any of the individual spec houses so, save for a few daisies, there were dirt lots instead of the lush blooming gardens of his paintings.

There was a ribbon-cutting ceremony with the mayor of Vallejo, who handed Thom the big oversized scissors. A stage and podium had been set up for Thom, at which he spoke to a rapt audience of about a thousand. Terry Sheppard was also there to document the momentous event with his video camera. Thom's four daughters and his mother, Mary Ann, stood with him as well, the girls lined up in a row by height and age.

Thom stood in front of the crowd and looked over the distant mountains and the California brush that led toward Placerville, and his voice echoed through the microphone.

"Being here today with you all means an awful lot to me. This development is a lifelong dream come true. To make my paintings and my vision come to life in these beautiful homes is like God painting me a miracle. Who would have thought that that scrappy boy from Placerville would one day come here to cut the ribbon on his very own housing development in the beautiful Vallejo Hills."

Thom was visibly emotional as he spoke, the crowd nodding and smiling and with him all the way, as Thom gestured into the distance.

"This is my backyard. This is like home to me. If you look closely, you can see Placerville up there, toward that ridge. All of that is El Dorado County, where I grew up fishing and running around with my brother doing boy things. And picking flowers and courting my future wife, who is still right beside me today."

The crowd applauded for Nanette as she waved and smiled into the audience.

"And my four beautiful daughters and my mother are here, too."

The crowd cheered even more. Thom gave his mother a squeeze around the shoulders.

"I wouldn't be here without this woman," he exclaimed.

Mary Ann smiled modestly, clearly so proud of her son. Then Thom leaned in to the microphone and continued his speech.

"I must have looked over these desert shrubs many times and thought they were nothing but dry land. If somebody had told me then I'd have my own village built here one day, I would have laughed them right out of town."

He grabbed the podium and looked around the houses, fashioned after his paintings. His eyes glowed and his voice quivered.

"This is home. This is really home. It's going to be home for a lot of good people; a lot of loving families. There's nothing that could make me happier right now." Then he raised his arms to the crowd excitedly. "My paintings have come to life!"

There was a big cheer, and Thom stood taking it all in, dabbing at the corners of his eyes, Nanette patting him on the back.

After the ceremony, Thom posed for photographs with Nanette and his four beautiful daughters and mother. Three news crews and their vans were on hand to cover the event. Thom was elated. He beamed for the cameras, his arms around Nanette and his girls. He joked with the newspeople and cameramen.

"Have you signed up for a house of your own yet?" he asked jokingly.

People would grin and shake their heads. "We hope to one day, Mr. Kinkade."

"Well, you keep hoping, all right? Never lose hope."

His enthusiasm was infectious. He waved as he walked on.

"Don't you leave here before you get yourself a house, all right? Tell 'em Thom sent you!" And he was off again.

He toured the entire village and talked to people about the sources of the names of the cottages and the streets with names like Wisteria Circle and Rose Arbor Way. He couldn't believe he was seeing his paintings brought to life; houses that bore the names he had once given his imaginary cottages, such as Lilac Cottage, Stillwater Cottage, and Gingerbread Cottage.

Thom had tears in his eyes as he paced the streets with me, exclaiming at every detail and every nod to his legacy.

"Look at that. They got it down, didn't they, Eric? Looks just like the painting. Now isn't that something?"

I had seen him at many functions, openings, and special events, but I had never seen him as emotional as he was with the opening of his village.

The model homes were decorated with Thomas Kinkade furniture that was not included in the purchase. Framed photos of generic happy-looking families sat on the mantels, and chintz and florals covered the sofas and drapes. Thom's prints covered the walls of the houses, with as many as fourteen pieces in each. The children's rooms were decorated in horse and golf themes, and the libraries had books on the shelves. Ironically there wasn't a Bible in sight. Perhaps it was just an oversight, but a big one, given Thom's Christian following.

I will never forget that day, nor Thom's reaction to the event. It was moving to see him walk through a construction of his vision, the manifestation of his dreams made real. This was his own Disneyland, with the dream and hope for simpler times and the family togetherness his paintings promised, and which his collectors deeply yearned for.

I watched Nanette stand lovingly at Thom's side and smile as he held in his tears. Nanette might not have approved of his late-night carousing, but she must have understood his weaknesses and forgiven him, knowing the grandeur and magnitude of the man's achievements, as well as the boy inside.

If there was a peak, a height of heights for Thom's happiness, then I saw it on that day. Perhaps the sheer scope of his achievements struck him all at once. Perhaps the emotions of a young boy who once had only a dilapidated trailer to live in, and no food in the house, overwhelmed him. Perhaps it was the ultimate manifestation of his vision; something no other artist had ever done. And perhaps he sensed this was a turn in his fortunes, the beginning of the end. It was nothing Thom would articulate at that time, but I've always thought back to

his nostalgia that day with the feeling there was more to it than met the eye; a premonition perhaps. I would never see him quite so happy again.

The writing was on the wall.

By the end of that year, Media Arts had posted four straight quarters of losses.

Lessons in Supply and Demand

The sea rises, the light fails, lovers cling to each other . . .
The moment we cease to hold each other,
the moment we break faith with one another,
the sea engulfs us and the light goes out.
—JAMES BALDWIN

When Dwayne and Sue Young heard about the Thomas Kinkade Signature Gallery that was opening only a few streets away from their downtown Des Moines, Iowa, location they were concerned. Their own gallery had been open for a year, and business had steadily declined. Luckily for them, Dwayne still had a significant nest egg left over from the sale of his family business, so he could afford to cover the monthly allotment of paintings they were obligated to buy in order to meet their contractual purchase quota. After Thom had visited the gallery for their grand opening, business had been brisk for a while, and every family member and friend had come in to purchase a canvas transfer to get in on the good investment and support Dwayne and Sue. They had held special events, holiday happenings, hired a Santa Claus for Christmastime in the gallery, and staged an egg hunt in the gallery on Easter.

At some point, by the end of their first exciting year—a year filled with pride of ownership, mastery of the art market and art handling,

hiring and training gallery staff, and the planning and hosting of the gallery's special events—they had to admit to themselves they weren't making it. And with another gallery opening several streets away, things weren't going to get any better. It was hard for Dwayne not to feel personally responsible for the lack of business, although Sue always reassured him they had gone above and beyond the requirements and had invested not just money, but loving care into the gallery.

It had been a joy for them to spend every day among the thatched-roof cottages and gardens and gazebos of the paintings hanging on the walls. There were days it didn't feel like a job at all; it was a privilege and a blessing. When they spoke to collectors, they spoke with genuine affection and enthusiasm for the latest release, or their classic favorites. It seemed wrong to doubt that all would be well—it seemed a little like doubting God. Their faith was inextricably linked to the endeavor, and they never questioned that they were doing the work God wanted them to do.

Even with the strong sense of calling that had led them to sign on the dotted line in Monterey, California, after their weekend intensive at Thomas Kinkade University, they had also considered the matter carefully as far as the money went. After all, they were told by the team in Monterey that they were practically guaranteed to be netting nearly $200,000 a year with their business. They had been reassured about the solidity of the businesses with graphs and statistics. They had been shown business plans and projections. It was all so encouraging, and the numbers were obviously so strong. They felt as if they couldn't go wrong.

A year later, however, the financial reality was becoming all too clear for them to ignore. After much prayer and agony, Dwayne got on the phone and called representatives at Media Arts to ask for an extension on the next required allotment, and to inquire whether there was any financial support possible from the company, since the numbers were just not measuring up to what they had been promised. He wasn't looking to make trouble; he simply wanted a little help to make it over a rough patch. He also wanted to inquire politely why there

was another gallery opening several streets over, when they weren't making ends meet with their own.

Dwayne was given an answer in very simple terms: he had signed a contract and there was nothing the company could do. The contract stated that if he were in arrears there would be penalties; and if he couldn't pay he would be sued.

Dwayne hung up the phone in shock. Neither he nor Sue could believe this was possible from the Painter of Light's company. Their worldview, and their image of Thomas Kinkade, were shattered.

Dwayne and Sue were not alone. By 2003 a significant number of galleries were failing. Contrary to what prospective signature gallery owners had been promised, the business was not certain to succeed. And they had been promised many things at Thomas Kinkade University. They had been reassured no galleries had ever failed, except two. And in both cases, those failures were only due to sickness in the family.

Good people, like Dwayne and Sue, saw their life savings disappear because they couldn't move the merchandise and the customers weren't coming. There were too many galleries for them to compete with; often several in the same town, in the same neighborhood, or even on the same street. Thomas Kinkade paintings were being offered on the QVC network at greatly discounted prices, and people preferred to buy the art at a reduced price. Dwayne and Sue watched with dismay as the Painter of Light broadcast from the Morgan Hill headquarters of Media Arts, four times a year, from his own specially built studio, selling prints at discounted rates. This was the same company that was threatening to sue them if they didn't pay their contractual allotment. And still they were contractually obligated to sell their stock at the predetermined full price.

Then Media Arts made a deal with Tuesday Morning, the off-price, deep-discount retailer that specializes in name-brand closeout merchandise. Dwayne and Sue were alarmed. With over eight hundred stores across the country, Tuesday Morning was powerful competition. The fact that the Tuesday Morning sale of Kinkade's artwork took place in

December, just in time for Christmas, made it all the worse. Thomas Kinkade was the Painter of Christmas, and the holiday was the most important retail time of the year for any signature gallery.

But Tuesday Morning was selling Thomas Kinkade paintings by the stacks; next to rugs, lamps, china, luggage, toys, Christmas wrap, and garden furniture, all in their casual self-serve, no-frills environment. There was no need for cinnamon and spice, dimmed lighting and hearth fires, when the discount was so attractive. Customers began asking Dwayne and Sue if they were jacking up their prices, when the paintings they were contractually obligated to sell for $479 were being sold at Tuesday Morning as prints for $59.95. They were a different edition altogether with different attributes, but prospective customers found the distinguishing characteristics difficult to discern.

But the fact that any Thomas Kinkade works were selling for $59.95 at all was the real problem. Media Arts was only looking to unload some old inventory, open editions that were not signed or numbered, and which had never been sold. They were more like posters than limited edition prints. Tens of thousands were taking up room in the warehouse, and rather than burn them, they thought it would make sense to frame them and sell them to Tuesday Morning. They had no idea it would cause a firestorm of controversy.

By 2003 ten galleries were suing Media Arts, claiming Thomas Kinkade and his company had defrauded them by creating unfair competition. The lawsuit said Media Arts had saturated the market with other signature galleries, and by selling the canvas transfer inventory through discount chains, which drove the prices down and made the art impossible to sell. Media Arts fought every one of the lawsuits, often with a countersuit. Interim CEO Tony Thomopoulos was the unlucky recipient of the debacle that had been brewing for years as a result of the previous management team's sales-at-all-cost policy. Its sales philosophy had not taken into account the nature of the art market; a market experienced dealers know they have to protect by carefully cultivating the release of an artist's work, in order to avoid a loss of faith in the art or a loss of faith in its market viability.

The casualties began to grow. The stories were heartbreaking. When Dwayne and Sue attended a fine arts dealers convention, they happened to meet other Thomas Kinkade Signature Gallery owners, and saw many of these people in tears. Some gallery owners had lost their homes. Others could no longer afford to pay for their children's education. Dwayne and Sue themselves were facing bankruptcy. These couples were once well off, but now they had not only lost their nest eggs and their retirements, but also their businesses and professions. Some were forced to leave their homes and the states in which they lived in order to find work elsewhere.

The faces of the failing signature gallery owners were varied and yet the same. Once well-to-do business owners were reduced to becoming supermarket managers; interior designers became clerks for box companies. One gallery owner had once been an entrepreneur worth upward of $3 million. He and his wife had just remodeled their 6,000-square-foot dream home in Michigan. Then their gallery failed, leaving them with a $500,000 debt. The couple ended up divorcing. By the end of it all, the husband found himself living in a small apartment with his dog, having lost everything.

By June 2003 Media Arts posted a net loss of over $3 million; $0.27 per share. A year earlier the loss had been a little over $500,000, or a loss of $0.50 per share. The trend was alarming. The sluggish sales and the galleries closing in droves were a clear indication that Thomas Kinkade's art had reached market saturation. Two years later, there seemed to be no more empty walls left to fill in the homes of America. *Was it the brick wall?*

Dwayne and Sue mortgaged their house, liquidated their stock, and countersued when Media Arts sued them for unpaid fees.

✤

There were two kinds of people affected by Media Art's policy of sales and saturation. The signature gallery owners who invested in a gallery and ended up losing their investments, and the collectors who

bought paintings they thought would not only hold their value but become more valuable over time. Collectors bought prints on canvas of an image replicated in the many thousands, signed by a signature machine and retouched by the brush strokes of studio assistants, with the promise that they were making a good investment. They had all been swayed by the cinnamon scents and enveloping, warming hearth of the signature galleries. Their imaginations had been set on fire, and their deep yearnings sparked for simplicity and peace in an increasingly complicated and uncertain world. It was as though they could, with a moment's glance, enter the realm of a Thomas Kinkade painting with the promise of a life away from the bustle of modern-day existence.

But did the artwork make for a good investment? Most Thomas Kinkade collectors were not savvy about the art market. Thomas Kinkade spokespersons even boasted that gallery employees were not knowledgeable about the art world, but rather friendly and welcoming. The lack of "culture" supposedly was a plus. The collectors were often trusting and uninformed individuals, interested in the art for emotional reasons, without a pragmatic knowledge of the larger picture. Many perhaps didn't understand that, while they bought a canvas transfer painting in a limited edition of 2,750, a limited edition of a popular artist like Peter Max might only reach perhaps 100. And furthermore it's safe to assume that many collectors didn't realize that the same image was replicated on canvas and paper, in so many different sizes and versions that the total edition size was sometimes over 200,000.

<center>⚜</center>

Terry Sheppard had been promised the keys to the kingdom by Thom. He was the one guy who was always there for Thom, and who had an insight into his life like almost no one else had. Terry was the staple in his posse; he chronicled every minute of Thom's life for posterity. There was a time when Thom didn't go anywhere without Terry. It seemed like he wouldn't go to the grocery store without Terry there with his ubiquitous camera, capturing the Painter of Light in his or-

dinary and extraordinary moments. In that sense, he was the most important person in Thom's life. And for his loyalty he was promised a significant role in the company one day.

One day in 2003, much to our surprise, we heard around the company that Terry had been fired by Thom. I'm certain Terry never imagined this would happen, as close as he was to Thom. Rick Barnett was the most influential, Ken was the most devoted, but Terry was his pal—the beloved Labrador retriever at his master's side, faithful, never straying.

Terry must have asked him, "Where are the things you promised?" Thom's tendency to avoid conflict and be unavailable most likely didn't help Terry's shock and feeling of having been betrayed. Thom was a gregarious, easygoing spirit. It was hard for anyone who knew of their arrangement to imagine what brought Thom to the point of firing Terry. Perhaps there was pressure from the company. Perhaps people thought Terry was not a good influence. Nobody knows for sure. Terry was Thom's biggest follower; he idolized him and would have done anything for him. And he knew where all the bodies were buried. It was as though he had been cut out of the will. In the end we never knew what happened, but I understand that Terry wrote a manuscript, soon after being let go, detailing his experiences with Thom entitled *Thomas Kinkade: Painting by Numbers*.

<div align="center">❀</div>

By June 2003, Media Arts had posted yet another quarter's losses. Tony Thomopoulos, who to his credit stayed far beyond his desired tenure to continue to support the company in its distress, was trying his best to assuage the increasing concern on Wall Street, as well as of collectors, over the quarterly losses, and to reassure them about the soundness of the business and the value of the art. Tony explained that with the recent invasion of Iraq earlier in the year, the economic environment had been made much more difficult, and that in these times it was not unusual for discretionary spending to shrink as consumers were more

cautious about their spending. He tried to reassure an ailing market-place, and a skittish Wall Street, that Media Arts was implementing a comprehensive strategy to continue to build the lifestyle brand. The company planned to expand to a broader consumer audience by broadening the base of the licensing partners, and at the same time exert better control over the distribution of limited canvas transfer and paper reproductions of the art.

Six months into Tony's tenure, the company had actually hired his replacement. Chuck Vita, an executive at an Atlanta broadcast company, was to be the permanent CEO of Media Arts. He was a devout Christian, and his reputation was excellent. Tony was a big fan of Chuck's, and had started packing up his office, happy that a replacement had been found, allowing him to return to retirement.

However, Ken Raasch told me that something very strange had happened in his first meeting with Chuck, and that he thought Chuck might be a problem. No one believed Ken at the time. But soon, interesting stories were swirling around about him, and it wasn't long before he was gone. Tony Thomopoulos, who would just as happily have stayed retired, was called back in, and would serve for two more years before the next replacement was found. This was part of a ten-year pattern of "revolving door" CEOs, only adding to the company's chaos and woes. Tony was among the best and the most conscientious.

Several key factors might have doomed Media Arts and, ultimately, Thomas Kinkade. The first was the decision to go public. The art publishing business had been successful on its own, and would have continued to be. But with the pressures of Wall Street bearing down, the need for quarterly profits first drove the decision making at the top toward expansion and diversification, which nearly cost the company its life. The subsequent removal of Ken, and what seemed to be Media Arts's ensuing policies of sales at all costs, further fed the Wall Street machine, but ended up creating a market bound to collapse due to saturation. Thom's friends and cofounders of the company, Ken Raasch and Rick Barnett, helped create success in the short term, but might have contributed to its problems in the long term.

Thom wasn't a businessman at heart, and he left the management of the company in the hands of those he trusted. He was a visionary and an artist. He avoided conflict and strife, and tried to let others handle the dirty work. He wanted to do good with his talent, he wanted to be liked, and he wanted to enjoy himself. He trusted his friends to make the right and the tough decisions. He didn't want to hear about the lawsuits when they began to hit Media Arts in 2003. He didn't want to know his company was suing the very gallery owners he had once visited and clinked champagne glasses with. Thom couldn't easily separate his relationships and feelings for people from the needs of the business, rather choosing to avoid having to deal with things altogether.

Thom's ultimate coping mechanism was twofold: avoidance and drinking. If he wasn't comfortable in a situation, he disappeared. Didn't answer his phone. Wasn't available for meetings. Holed up in his studio and painted for days and weeks. If you finally caught him at a lucky moment, he avoided serious discussion by changing the subject, or suggesting heading out to a bar. Thom didn't reveal his feelings if they were negative. I never saw him depressed; I never saw him down. He was so positive and upbeat all the time that it was as if he didn't even know how to express himself if there was something bothering him. As if he had a *need* to be upbeat and positive all the time. And when you feel that you have a connection to God, you tend to see things in terms of blessings and gratitude. A deep faith doesn't really allow for complaining. I believe that's part of the reason why Thom avoided negativity; he felt it would just be wrong. If something negative had to be stated, Thom spun it into a positive.

"What do you think about those lawsuits, Thom?" I asked.

"I've got a lot of faith in Ken and that new lawyer he hired. Don't we have a great team?"

Then we ordered another round of beers and talked about licensing some more. Anything to avoid the uncomfortable subjects.

Nanette began to come to executive meetings, taking a more active role as spokesperson for her husband's interests. She began to rise in

influence and importance, showing strength where Thom was becoming weaker.

We started to have our licensing meetings in the dining room of Thom's house so Nanette could participate and also keep an eye on the kids. We sat at the big table and I brought out the mock-ups and samples, and we all looked at them together. Nanette looked at everything carefully, conscientiously. I admit that it felt a little weird to me at first after all those years of Thom and me meeting alone, but she showed herself to be very smart, very adept at the moving parts of the business, and very visionary, too. She asked if we could put the Christmas image on cookie containers, and I said that was a good idea. She also mentioned the idea of glow-in-the-dark puzzles, another concept I loved.

❧

In October of 2003, with Nanette's firm support, Thom took his company private. The stock had plummeted to a little over $2 a share, down from its high of $30. Thom and Nanette decided together that it was time to take the company back, and out from under the pressures of Wall Street. Thom had already negotiated with Ken for the largest stock share prior to this time, and Ken had finally, after many years of holding out as the largest shareholder, agreed to sell Thom just enough of his shares, which allowed Thom ultimate control over the company. Ken earned a huge windfall payment from Thom, and would still receive significant ongoing income including royalties on certain editions, just as he always had.

It had been a never-ending struggle between Thom and Ken; a battle over ultimate assertion of the original ownership and control of the company. Since their first days in the garage, they had begun competing for their respective positions. Even when Ken was removed, he continued to hold on to his control by remaining the controlling shareholder. By allowing Thom to now become the largest shareholder, finally he could no longer hold the sword of Damocles over Thom's

head. Conversely, Thom had held what Ken called "the power of the paintbrush" over Ken and the company. If things came to a head in business, or didn't go in a direction Thom was happy with, then Thom would threaten to stop painting, which meant that everything would come to a grinding halt. It was the ultimate assertion of his being the source of all things the company achieved and profited from.

The settlement between Ken and Thom over the largest stock ownership brought a new peace between them. Thom's taking the company private was the next step in his taking back what he felt was really always his. Enough time had passed since the sting of the *Forbes* article, the disaster of the David Winter Cottages losses, and Ken being forced out of the company. The constant vying for control and validation over who was most important to the company was finally implicitly laid to rest. Time had told; everything came from the paintbrush in the hand of Thomas Kinkade. The company existed, thrived, and succeeded only because of him.

Thom negotiated a deal with the stockholders to buy them out at $4 per share in cash, which represented a premium of over 60 percent above the $2.37 value at the time. Thom paid over $32 million of his own money in order to own the company outright and free himself from Wall Street. By the following month, Media Arts reported an income jump from its previous quarter. By January 14, Eric Halvorson, the former president of Media Arts, was named CEO, finally relieving Tony Thomopoulos and sending him back into retirement. Six months later, Eric Halvorson was removed and Dan Byrne was rehired after five years to become the new CEO.

In January of 2004, Thom also removed the name Media Arts from the company; a name which for so long had stood for diversification and had promoted the publishing side of the business over the importance of the artist who made it all possible. Thom renamed it the Thomas Kinkade Company.

By gaining the largest share of stock, taking the company private again, and putting his own name on the company, Thom had settled the score and ended the longstanding unspoken rivalry; he had won.

Thom and Ken were finally able to relax with each other and return to the friendship they'd had in the early days. Thom kept on painting and Ken lent his support in the ongoing lawsuits, which the company was fighting at the time. Ultimately Ken was still happiest when he was involved in Thom's life, whether owner of the company or not.

The lawsuits were being settled in arbitration. A new CEO had taken the helm. And Thom had a company that finally bore his name. For the first time in a long while, there seemed to be light at the end of the tunnel.

<div align="center">❦</div>

In April of 2004, Thom received his first recognition by academia when California State University at Fullerton staged a comprehensive retrospective exhibition of his work at the CSUF Grand Central Art Center. The exhibit was guest curated by author, performance artist, and curator Jeffrey Valance, who called the show *Thomas Kinkade: Heaven on Earth*. Valance was one of the rare art world figures who saw merit in displaying Thom's work to the public. The exhibition featured Thom's fine art, art products, and religious work, with original paintings, reproductions, limited edition collectibles, furniture, tapestries, and Christian artwork, including his celebrated *Kinkade Nativity Scene*. Some of Thom's recent paintings inspired by his travels abroad were featured in the main gallery, along with examples of his architectural designs, shown in blueprints, photos, and models. The Art Center space even built a gallery that resembled a quaint country church with pews and stained-glass windows for the nativity scene, and the opening event on April 3 included a sermon by Reverend Ethan Acres, who spoke on Thom's religious work. An actual marriage ceremony was held in the gallery's chapel during the course of the exhibition.

When we at the company first heard about the exhibition, we were all asking ourselves, "What's the hitch?" After all these years of being ridiculed and scorned, surely this couldn't be real. But there were supporters on the board of CSUF who believed in the value of a Thomas

Kinkade exhibit, such as Greg Escalante, who had read an article in the *New Yorker* in which Thom had bet the reporter that within his lifetime, he would have a major museum show. Escalante wanted to make that bet come true and took the article to the board, and the board voted for doing an exhibition. The result was thorough and thoughtful and genuine. And on the day of the opening Thom walked through the exhibition, beaming.

"Look at that. They've got a whole chapel set up. Isn't that marvelous? Haven't they done a wonderful job, Eric?"

"They sure have, Thom," I said.

"Nobody's calling me schlocky now, are they?"

"Certainly not," I said.

It was fun following him around, watching him exclaim at everything in sight. The experience of the evening was truly magical. All these years, the critical establishment had called him formulaic, insignificant, schlocky, and kitschy. On this night, Thomas Kinkade was in heaven. After waiting for legitimacy for so long, the validation was much needed, and a long time coming.

<p style="text-align:center">❧</p>

That year, despite posting losses, the Thomas Kinkade Company reached another milestone: the $2 billion mark in total retail sales.

<p style="text-align:center">❧</p>

By May of 2004, the licensing business of Creative Brands Group with the Thomas Kinkade Company was humming. We had increased our license contracts to over one hundred and were coming up with new licensed product ideas all the time. Ken was seeking out other investment opportunities, as I focused my time on the licensing business with Thom and other clients, such as Rachael Hale. It was certainly where the biggest profits were. It was something I saw to be true for over a decade. Nothing sold like Thomas Kinkade.

In the spirit of things looking up, Ken surprised me with a birthday trip to Cabo San Lucas in May of that year. He had invited Dan Byrne and Thom as well, and bought us all tickets. I had never been to Cabo, and didn't know what to expect. But Ken had been there many times, and assured me we would have a good time.

When we got to the San Jose airport, the first thing I saw after going through security was a large man dressed in a brightly colored Hawaiian shirt with a large straw hat, hunched over the airport bar. I immediately knew it was Thom. He had a cold Corona in front of him, and had lined up two shots of tequila. I was not surprised. Thom frequently started early and drank throughout the day. But the prospect of drinking with the Painter of Light so early in the morning was a bit intimidating. Nobody had his stamina, and we were all in for some nasty hangovers if we were going to try to keep up with him. Nevertheless I approached the bar, and Thom gave me a big hug and handed me a shot of tequila. All I could think was that it was going to be quite a trip.

After an uneventful flight on Alaska Air, we landed in Cabo San Lucas, where a private car was waiting for us. We all piled in, and soon Ken, Dan, Thom, and I were headed to the hotel. As soon as we exited the airport, Thom shouted at the driver to pull over. He had just seen a market and wanted to stop and go inside. He left, and we sat in the idling car for several minutes before he returned. I thought he might be looking to buy some Cuban cigars, but he came back with a six-pack and handed each of us a cold beer to drink on the way to the hotel. It was classic Kinkade; and it was his alcoholism. Thom didn't want a minute to go by that we weren't having fun, and the key part of fun was having a drink in your hand and a buzz going on. He was continuously feeding the needs of his addiction, and we were unknowingly feeding it, too, by wanting him to be happy. We cracked our beers and kept on driving.

Our hotel was the Pueblo Bonito Hotel, situated right on the beach, in the old town of Cabo San Lucas. Ken usually liked to stay in the nicer parts of town, at one of the luxury resorts such as the Palmilla,

Las Ventanas, and Ty Warner's Esperanza. But for Thom's sake he had chosen one of the older hotels, knowing his preference for history and charm. We were well set up, each with a suite of his own.

Just as we were getting settled into our rooms, we heard a rallying cry from Thom. He was down below, heading for the pool in his Hawaiian shirt, flip-flops, and a six-pack of Corona under each arm, enough for all of us to share. We went downstairs, grabbed a row of chaises longues, and relaxed by the pool for hours. Thom sat in the sun, turning red as a lobster, smiling at everyone and drinking his beers continuously.

Ken was working on his tan, while Dan cracked jokes relentlessly and Thom dipped in the water and came back out, then sat drying off in the breeze, smiling at us. We later had a big dinner and lots of drinks at a place called the Trailer Park, known throughout Cabo for its generous portions of steak and lobster as well as its supersize margaritas.

I woke up early the next day and made my way down to the pool where Thom was sprawled out on a chaise longue, tanning in the sun, with several drinks already behind him. It was ten in the morning at the latest, but that was how Thom rolled.

"Morning, Thom," I said as I spread my towel on the chaise and sat down, surveying the pool scene from behind my sunglasses. It felt good to be away from the day-to-day business of the office, and the low hum of worries the lawsuits were spreading in the company every day. And it was great to be with Thom, catching a carefree moment. Thom was a fun guy to be around, and two beers into the morning, he was definitely on to the fun.

Thom raised his head from his towel and, under the glaring sun, squinted at me with one eye. He wished me happy birthday and insisted I have a beer with him. The others came down around noon, and after a nice lunch at the pool, we walked down the beach to a well-known happy-hour spot called the Office, where the waitresses walked with holsters around their waists, carrying tequila shots and chasers.

Zigzagging our way back to the hotel, we came across a henna tattoo artist, and Thom insisted we all get one. I ended up with a dragon

and Thom got an eagle. Dan got a dolphin on his bicep, and Ken decided to have his name tattooed on his shoulder, which the tattoo artist misspelled as *Len*. We had a good laugh and called Ken "Len" for the rest of the trip.

Back at the hotel, Ken fell asleep from the heat while Dan, Thom, and I hung around the pool until Thom felt it was time to go into town. We roused Ken back to life and rode a cart drawn by a bicycle, which we had to pedal ourselves. We found a great Mexican restaurant and gorged on tacos, lobster, beer, tequila shots, and margaritas.

After finishing our dinner at the restaurant, we spotted one of Cabo's most notorious hangouts, called Squid Row. It was eleven at night by this time, and the place was jumping. We looked into the entrance and saw that it was jammed with people, the music pumping loudly. We looked at each other, uncertain; "Should we do this?" The place was full of twenty-somethings on spring break. We felt old, being in our thirties and forties. But Thom wouldn't take no for an answer and hustled us all in. We pushed through the crowd and worked our way to the bar. We were holding our Coronas when Dan turned around and asked, "Where's Thom?"

I looked at Ken, and Ken looked at Dan. All of a sudden I was very worried. The idea of Thom out alone late at night, missing in Cabo San Lucas after drinking all day, was a troubling scenario. We quickly paid our bill and turned to go and find him. Suddenly, I caught a commotion out of the corner of my eye. At the other end of the bar, several scantily clad girls had lined up on an elevated ledge that ran along the entire dance floor, and were dancing together with the crowd cheering them on. Then I saw him: Thom was climbing up on the ledge. He wanted to be dancing and swaying to the music with the girls. As he tried to climb up, one of the girls fell off. Thom had a bottle of beer wedged between his teeth and another one in his hand. Somehow he finally managed to get up on the ledge and started dancing.

I tapped Ken on the shoulder. "Turn around. You're never gonna believe this."

Ken turned to look, and his jaw dropped. There was the Painter of Light up on the ledge with all the girls, a beer in each hand, dancing to the earsplitting music. One of the girls got into the groove and started pouring beer onto herself. The other girls in the line joined in. It seemed to be a tradition at Squid Row. Thom noticed what they were doing and followed suit, pouring beer all over himself as well. Soon he was drenched from head to toe in beer, dressed in his loud Hawaiian shirt, shaking his hips with reckless abandon, a line of fifteen girls dancing with him. Dan, Ken, and I were in hysterics. Ken leaned in and whispered to me, looking worried. He said if the world knew what the Painter of Light was doing right now, it wouldn't be pretty, and I agreed. He said he hoped they never would. Then he clapped me on the shoulder and wished me a happy birthday.

I grinned. "Thanks for the trip, Len. I'll never forget it."

We stood for an hour and watched Thom enjoy himself, dancing to the music. We finally looked at each other. None of us wanted to, but finally Dan was elected. He hitched up his pants, walked over to Thom, and sweet-talked him off the ledge. Thom waved at the girls, and following Dan with a grin on his face, unsteady on his feet, swerved up to us, reeking of beer.

"How do you like my dance moves?" Thom asked.

"Travolta's got nothing on you," I said.

Then we all supported Thom out of the bar, dragging him into a bicycle cart, and pedaled him back to our hotel.

⚜

Meanwhile, back during a chilly spring in Des Moines, Dwayne and Sue Young quietly picked up the phone and dialed the number a friend had given them. The person who answered was a man named Norman Yatooma. He had vowed to stand up for the suffering gallery owners who had lost everything, and to take Thomas Kinkade and his company down.

Crossing the River Acheron

*Through me you go into a city of weeping; through me you go
into eternal pain; through me you go amongst the lost people.*
—DANTE ALIGHIERI, *Inferno*

Norman Yatooma's sense of justice for the underdog was strong. He
was a Christian family man from Detroit, Michigan, with four daugh-
ters at home, just like Thom. He believed in standing up for the disen-
franchised and victimized. And he spoke from experience.

On the day Yatooma was elected student body president as a col-
lege junior at Taylor University in Indiana, he called his father to tell
him the good news. His father didn't answer. Several more times they
missed each other's calls, trying to connect. Norman would never
hear his father's voice again. He was murdered the next day in a car-
jacking, shot in the head two times outside a Detroit convenience
store. No one was ever arrested, and the killing remained a mystery.
Norman never got closure on his father's death. Instead, he had to
take on the responsibility of protecting his family, which meant as-
suming the financial burden of supporting his widowed mother and
three younger brothers. His father's death had left the family utterly
destitute.

Norman vowed that his father's death would not be in vain. He
helped put his brothers through college, and graduated with a law

degree from Indiana University at Bloomington, ultimately starting a law firm of his own, Norman Yatooma and Associates. The firm specialized in litigation practice in franchise, class action, and corporate law. He also started a foundation called the Yatooma Foundation, named in memory of his father, Manuel Yatooma, to support grieving families who had lost one or both parents.

Yatooma cut a handsome figure with his boyish good looks and brash and vigorous personal style. He was driven to seek justice for his clients from his deepest core. When he was approached by gallery owners David and Nancy White, and later Jeff Spinello and Karen Hazlewood, he agreed to take their cases, outraged at what had happened to them at the hands of the Media Arts Group company. He made no bones about how he felt about Thomas Kinkade and his company ruining the lives and finances of hundreds of signature gallery licensees.

Franchising has always had its share of fraud and market saturation lawsuits. It wasn't unusual that lines were sometimes crossed. But when the Painter of Light, the beloved Christian artist Thomas Kinkade, was accused of fraud it was big news. Norman Yatooma filed his first lawsuit at the Oakland County Circuit Court in Pontiac, Michigan, against Thomas Kinkade, Rick Barnett, and Media Arts Group Inc. in October 2002. At the time 344 signature galleries were in operation, and Yatooma filed his first complaint on behalf of one of them, the Thomas Kinkade Carillon Gallery, alleging fraud and franchise investment law violations. Although the signature gallery program was intended to be a licensed distributor program, and not a franchise, the suit stated that under Michigan franchise investment law, the dealer agreements constituted a franchising sale.

According to Yatooma's first lawsuit and the many that were to follow, Media Arts had defrauded the signature gallery owners by flooding the market with canvas transfer paintings—paintings intended to be sold through their galleries exclusively—and also forcing them to buy products from Media Arts at inflated prices.

Yatooma was not the only lawyer fighting Media Arts in court over the failing galleries; at the time, there were ten other lawsuits in the country. But Yatooma was to become the most vocal and voracious lawyer to pursue Thomas Kinkade. In his first complaints alone, Yatooma estimated his plaintiffs' losses to be in the millions: $5.4 million for the owners of the Thomas Kinkade Carillon Gallery, and $2.2 million for another couple, David and Nancy White.

The attorney for Media Arts claimed that hundreds of galleries were doing well across the country, and that those filing lawsuits were the "disgruntled" ones because they owed the company money and didn't want to pay, or had mismanaged their business. He also claimed that the recession, and not the company's business practices, was to blame for the downturn in sales.

The Carillon Gallery case went into arbitration, as did many more to follow. Norman Yatooma would end up representing over twenty-five cases. Media Arts continually prevailed, on the company's argument that the signature gallery owners had signed a contract and that contract was binding, no matter how circumstances had changed. In other words, right or wrong, the gallery owners were out of luck.

Jim Cote, a dealer out of Detroit, filed a suit alleging fraud and sought class action status for other gallery owners who were in the same boat as he was. He was once the chairman of the Signature Dealers Council, a national group representing Kinkade dealers, but when he had his license revoked by Media Arts, he was also let go from his position as chairman. He was vocal about his feelings regarding the company and its practices, calling them "ruthless."

In addition to the allegations of market saturation, complaints were filed by former gallery owners based on the fact that the Thomas Kinkade University required them to attend a weeklong seminar, which cost $500, and submit a business plan at the time of attendance. Prospective gallery owners were encouraged to use an independent financial services agency, with offices in Monterey, among others, that

would put together a business plan for them. The cost of the business plan was $5,000. While the company claimed that prospective gallery owners were free to use any financial consultants, Norman Yatooma said the company made it clear that if they didn't use the services of the recommended consulting firm, they would have to wait a long time for their dealership. The gallery owners claimed the finance company inflated and distorted the numbers, making them unrealistically favorable to the company, deceiving the owners about the financial reality of what they were getting into.

The Harvard-trained PhD economist who drew up all these business plans for the signature gallery owners was finally called to testify before the arbitration panel. According to Yatooma, he broke down in the witness chair and admitted that he had to submit his business plans to the group at Thomas Kinkade University, so the group could adjust them before making the final recommendation to the new gallery owners. Media Arts categorically denied knowingly and purposefully influencing the economist to alter contracts in the company's favor. Nonetheless, the accountant's testimony ultimately ended up breaking the case for Yatooma.

More details emerged about the nature of the contract the gallery owners were asked to sign. There was a licensed signature gallery contract that was taken home for review. According to Yatooma, however, the additional retail sales policy contract was over a hundred pages long, and the prospective owners, after signing, were not allowed to take it home or keep a copy. That contract stipulated that gallery owners had to burn their entire inventory if the contract was ever terminated, and that selling the artwork at a discount was grounds for termination. Meanwhile, the artwork was being offered at a discount on QVC. Due to their contracts with Media Arts Group, the gallery owners couldn't even sell their inventory at a loss. Collectors, and even friends and family who had bought the artwork, later came back and confronted the owners, having seen what looked like the same artwork on television for half the price.

Yatooma also raised allegations about concerns regarding misman-agement and poor company strategy in terms of opening too many signature galleries in the same markets. In Detroit alone, in 2003 there were four left, two others already having closed.

The final and most important complaint of the gallery owners was the misuse of the Christian faith that factored so heavily in the Thomas Kinkade University training sessions. Signature gallery own-ers widely felt that their faith had been exploited, from meetings beginning with "Let us pray," to Media Arts representing itself as a Christian company operating with Christian values. They stated in in-terviews that they had been encouraged to let their guard down, and place their trust in the company based on their common faith. Gallery owners believed they were dealing with a company that embraced business ethics and guidelines different from secular-based companies and more like their own. The owners said they trusted that, based on assertions made at the university, and statements in subsequent meet-ings with Thomas Kinkade, they were in this endeavor all together, for a higher purpose.

Yatooma could make this claim because a vast video record of the training sessions and seminars at Thomas Kinkade University existed. It was the reason Yatooma was able to push for a judgment against Rick Barnett personally. There he was, on camera, speaking to prospective gallery owners for hundreds of hours, holding up the Bible and mak-ing promises. Rick finally received a personal judgment against him by the arbitration panel, based on the testimony of the economist and many hours of videotapes.

In all of his years running Thomas Kinkade University, no one questioned Rick's judgment or his actions. For one, he kept himself so insulated in Monterey in his own offices with his own staff, operat-ing like a separate company altogether, that no one was much aware of any of the details of what he was doing there. Thom trusted Rick explicitly, and Rick's was always the last word. No one saw it coming: that Rick would be personally named in the lawsuit. Least of all Rick.

I personally knew Rick as a good man. I don't believe he ever wanted to harm anyone. He was brilliant at his job. He was also a Christian man with a family he was devoted to, and whenever I interacted with him he conducted himself with class and sincerity. I've often thought that perhaps he got in over his head in a company of five hundred employees; a company making billions in overall sales. Maybe he got caught up in the race and didn't see the warning signs, like so many others who didn't see them. I know he always wanted to do right by Thom; he deeply believed in Thom's work and never questioned its value. Perhaps, like all of us, he got swept away by the wave of the company's success that just kept on rolling.

❧

In interviews, Norman Yatooma didn't mince words with the press over his opinions. He said, "Fraud is a terrible thing. It is horrifying when it is done in the name of God. The bottom line is, Kinkade has used God for profit."

For Thom, the public shame of the lawsuits, the negative statements being made in the press about him, and the depositions in which his character was called into question by the plaintiffs' lawyers were devastating. He had led his life with the desire to do good for people with his art. He had believed his sales were an indication of God's blessing for his work, and his own contribution to God's plan to spread his message in the world. He thought the galleries being opened were based on demand and market value, trusting fully in his team to run Thomas Kinkade University in his name and for his higher purpose. He saw his monetary success as a validation from God for his works and his function as a messenger. Whatever benefits he reaped, he felt they were deserved because they were given to him by God. Thom truly believed what he said. And he saw no contradiction between his enjoyment of the fruits of his labor and his purpose. To him, they were one and the same.

Ultimately, beneath his desire to spread the love and light of the gospel was his own deep need for love. The love he received from his followers sustained and fueled all his endeavors. The validation by the thousands of fans who would come to see him at his gallery talks fed his spirit and sustained him deep inside. The sudden turn in his admirers from love to hate, from adoration to contempt, was devastating to him.

After the lawsuits had been brewing for several years, Thom invited me to come to the Palace Hotel in August 2005, for us to go back to the Pied Piper Bar and Grill and have a drink and look at his favorite painting. I remembered the first time we had seen it together before the Fine Wine and Cigar Expo, and how animated and excited he was that day. This day was markedly different.

Thom seemed more subdued and thoughtful. He had gained some weight in the last year or so, and had taken to wearing a trimmed beard with his mustache. We had become good friends over the years, doing business together and having much success at it. I was his star pupil in many ways. I had always delivered for Thom and for the company. The licensing contracts exceeded one hundred by this time. They were all sound and achieving $250 million at retail, per year. If the gallery business had taken a major hit, the licenses never stopped producing.

We sat at the long counter, studying the Parrish painting in silence for some time. Somehow I couldn't help but feel there was more irony than ever in the image now. The pied piper himself, the Painter of Light whom so many had followed blindly, was being taken to court.

I felt for Thom then. And I also felt for the gallery owners. The stories of all the hundreds who had lost their life savings and had to declare bankruptcy were heartbreaking. I was a believer, like everyone else at the time. I remembered how I had even stopped Rick in the hall of his offices in Monterey some years before and asked him if he would let me have a signature gallery of my own. I remember Rick looked at me with an odd expression and said that I didn't want to do that. I told him I thought it would be perfect. That I could do it

in Solvang, which was close to my home in Santa Barbara. I said that I knew the work so well, it would be perfect, and that my wife could run it. Rick smiled at me then, and said I had enough going on with my licensing deals. "Are you saying I can't have a gallery?" I asked. He looked at me and nodded, affirming that, yes, that was what he was saying. Then he walked off. I don't know what he was thinking at the time, but in retrospect, I think he might have done me a favor.

Thom didn't want to hear about bad things, and he didn't want to talk about them. It was always a challenge to bring up serious issues with Thom because of his inclination to stick his head in the sand. Bringing up bad news entailed the risk of losing him in conversation. He would just change the subject, get off the phone, or leave the meeting.

By then, the lawsuits had become part of the fabric of the new world order that had set in the day Ken was removed as CEO. For years now, the company had been driven, not by mutual vision and passion, but by profit. Now the profit machine was collapsing on itself.

What I saw that day was Thom slipping away from reality.

I knew deep inside he would deal with the lawsuits the way he dealt with everything: by avoiding them. He would slip into his near-manic optimism about life. He would refuse to hear about anything negative. But he would always answer the call of the bottle. He would phone and say, "Eric, let's go to a dive bar" or "Let's go up to Tahoe and gamble." Anything that would involve a copious amount of alcohol, and a copious amount of escape. Perhaps his own deep need to see things as rosy, and to turn a blind eye to problems and ugliness, was the very pied piper's song that had led his followers down a seductive path of escapism. But ultimately the pied piper's promise was a fantasy that spelled doom.

I watched Thom with mixed emotions as he looked up at the great painting. He lifted his drink and pointed toward it, his eyes shining.

"They never understood him when he was alive, you know."

I remained silent, feeling that I just needed to listen to him.

"They thought he was just drawing nice pictures for advertisements. No one took him seriously. But just look at this painting. It's a work of genius. Who can deny it? Sometimes I think you have to die to be appreciated, Eric. That's how it goes."

He looked at me.

"Cezanne, Degas, Renoir, Toulouse-Lautrec, Matisse, all those guys in Montmartre in Paris in the late 1800s—they had it good. What a time to be alive. Everything was about being creative. They were about making their art. About expressing themselves. And they were much crazier than I've ever been." He laughed.

Listening to him talk, I could read between the lines. He wanted to be anywhere but here; he wanted to escape. His vision of the world, which he held on to so tightly, was an idealized version of the past. It was what made people love him and his images so much in the first place.

The day we sat in the dark bar, I couldn't help but feel that Thom's light was dimming progressively. It was a strange time, and the incongruity would last for years. The company kept about its business, printing and selling art and licensed products, and Thom kept painting his twelve masterpieces a year, as all the while the lawsuits continued. Thom would drink and paint, and drink some more. I could see that the drinking was slowly altering him. Looking at him that day, I couldn't help but think that his disease of denial was the company's disease, too, and that they were somehow on a parallel track.

⚜

By 2005, Norman Yatooma represented over thirty-five dealers from fifteen states. He told the press that some of his clients were suing for damages in the millions of dollars. With over twenty more cases pending, Yatooma was like a bulldog that wouldn't stop coming.

In the arbitration hearings that took place during that year, Thom was made to answer questions about his personal conduct that were

increasingly invasive and humiliating. He was relentlessly grilled by Norman Yatooma, who had a bizarrely uncanny knowledge of Thom's whereabouts and behavior very few people had been privy to. His character was shredded to pieces and his reputation dragged through the mud. If Thom denied an allegation, Yatooma would continue to press and pull out a detail from the specific event in question, which Thom just couldn't deny anymore. He was forced to confess over and over again.

Thom was asked whether he remembered attending a Siegfried and Roy show in Las Vegas. He claimed he didn't really remember going, but Yatooma followed up, asking if Thom remembered standing up in the audience and heckling the performers by yelling, "Codpiece! Codpiece!" until security had to escort him out.

Yatooma's strategy was to demonstrate the duality of Thomas Kinkade, in order to demonstrate the duality of the company. It was relevant to the argument that the company was selling a Christian opportunity, and thereby taking advantage of people's trust with the promise of reward and a joint godly purpose. As Yatooma put it, he was "going to bring this self-proclaimed painter of light out of the darkness."

In the depositions, Thom said he couldn't remember groping a woman's breasts at the signing party in South Bend, Indiana. Thom claimed not to remember, until his actual words were quoted back to him and he had to admit again that he had gotten out of hand. When Thom was asked about his ritual territory marking, he explained that he grew up in the great outdoors and peeing outdoors was merely a habit he had developed in his childhood. He denied he had ever urinated in a territorial fashion until the lawyers asked him whether he had not indeed relieved himself on the statue of Winnie-the-Pooh at the entrance of Disneyland, on the way to a meeting with Roy Disney. They asked if he hadn't said, "This one's for you, Walt!"

Over and over, Thom was forced to admit to rowdy, drunken, and inappropriate behavior, including the time he unzipped his pants in the velvet-lined elevator of the Bellagio Hotel in Las Vegas and pissed

in the corner. The shame was crushing, and Thom couldn't figure out how the lawyers knew the things they seemed to know.

Unbeknownst to Thom, the lawyers had a powerful advantage: a secret source. They had an informant with a seemingly endless supply of knowledge; anecdotes and details that forced Thom into confession over and over again. That source was Terry Sheppard.

It was Terry whom Norman Yatooma had recruited to aid in the fact finding of the case. Terry spoke to the legal team extensively about his experiences with Thom. Yatooma also questioned other signature gallery dealers, employees of the dealers, other dealers not represented by Yatooma, vendors, QVC employees, salespeople, and associates of Thomas Kinkade. But Terry Sheppard was able to provide some of the most embarrassing details about Thom's life.

Thom would later publicly declare the allegations that leaked out of the hearings were "ridiculous" and "crazy." But the information was out, and it went viral. The ensuing shame and humiliation caused by the destruction of his credibility and reputation, and the relentless interrogation of Thom and repudiation of his character, were all too much for him.

Ordinarily, Thom lived in a protective bubble of his own making, in which he preserved his self-image and the image others had of him. It was the image of the world and of himself, as he needed to see it; the same image he replicated in his paintings over and over again. This rosy filter was how he transformed a trailer home into a cozy cottage in his mind and his memory. It was how he created a world, as though by magical invocation, that would forever deny life as it really is: sometimes beautiful and sometimes ugly; harsh and imperfect. Thom was relentlessly positive as a form of self-defense.

The Harley rides, the houses, the money, the toys, the adulation of the fans, the ministry of good, the very idea that God was his art agent were all crutches to keep him from having to look at the underbelly of his own life and behavior, and ultimately to keep him from facing the demon of alcoholism inside. He never wanted to hear any bad news, least of all about himself. Somewhere deep inside, he must have been

a terribly insecure person. The reckless abandon with which he threw himself into life, his appetite for it, had a flip side. It made him vulnerable to disappointment and despair. I believe Thom never wanted to feel that despair. I believe drinking was his answer to never having to face the real world, and himself.

<div align="center">✤</div>

In 2005, Thom was asked to become the ambassador of light for the Points of Light Foundation, which was begun by President George Herbert Walker Bush in 1990 to promote the spirit of volunteerism. Thom was only the second person to be asked to become an ambassador, the first having been George H. W. Bush himself. As an ambassador of light, Thom traveled nationwide to raise awareness and money for the Points of Light Foundation and the Volunteer Center National Network, serving over 360 Points of Light volunteer centers across America.

Meanwhile, business continued to be down, and to offset the decline in revenue and to drum up sales, Thom was sent by the company on national tours of signature galleries, promoting himself and the art and doing damage control, like a politician trying to compensate for a disgraceful scandal. On these tours, he would visit as many as three cities a day, talking to people and selling loads of paintings as he went. It was a good way to keep himself occupied, help him forget about the depositions, and connect with the myriad fans he still had. Even with the ongoing bad press generated by the lawsuits, Thom was much beloved by many, and the road trips helped him to remember his fan base and bask in the adulation of those who remained loyal.

Thom would stand behind his podium with the Painter of Light seal and talk straight from the heart, all of his sentiments pouring out of him like the redeeming wine of communion. He would talk about the paintings and his childhood and the need for simpler times; the scripture, the calling, and his love for his wife. It was as though there

was a Jekyll and Hyde duality, slowly creating an ever-widening fissure in his personality. He could tap into that good part of himself whenever he stepped before his fans, in whose eyes he was once again validated as the great man and painter he so earnestly wanted to be. Then he would be incapacitated by the muckraking depositions and the ugly image in the mirror that were thrown up to him over and over again in the hearings, and later in the press. The depositions painted that other side of him; the side he was unconscious of, the one he didn't want to know. But it was the drunken Mr. Hyde who slowly began to take over.

<p style="text-align:center">❧</p>

Yatooma focused on the unfair exploitation of faith and religion in signing up the new gallery owners. "Thomas Kinkade University is where my clients drank the Kinkade Kool-Aid," Norman Yatooma told the press. "Thomas Kinkade had a revival-like atmosphere. They would close in prayer and join together in worship. Everybody would leave with their head spinning—now sign on the dotted line," he said. "They thought they were going to make money by sharing the light."

Yatooma eventually won the case of Jeff Spinello and Karen Hazelwood, which Media Arts appealed all the way to the US Supreme Court. But the court refused to hear the case and sent it back down to the lower courts. And this is where Yatooma finally claimed victory.

On February 24, 2006, Jeff Spinello and Karen Hazlewood were awarded a total of $3 million in damages sustained and interest accrued, in the course of opening and operating their two signature galleries in Virginia. The case Yatooma made on their behalf was that they had both based their decision to invest in a signature gallery on the reputation of the Painter of Light. The themes of light and religion had been emphasized throughout the weeklong seminar at Thomas Kinkade University. They had been told Media Arts was different from other companies, in that it did business in keeping with a faith-based mission. They were told Media Arts would support them in spreading the light,

and that their business was blessed. Jeff Spinello said that in hindsight it was all a scam. Spinello and Hazlewood had lost everything. Having invested their life savings in the construction of numerous signature galleries and vast quantities of Thomas Kinkade's art, they were left financially destroyed at the end.

A three-member panel of the American Arbitration Association finally ruled against the Thomas Kinkade Company, finding that it had created "an environment of religiosity" and "failed to disclose material information" that might have kept Spinello and Hazlewood from investing.

By March 2006, a week after losing the arbitration, the Thomas Kinkade Company filed a countersuit against Norman Yatooma's firm, alleging it had illegally eavesdropped on the arbitration hearings by improperly transmitting a live feed over the Internet to a witness in the case. In fact, Yatooma's associate Joseph Ejbeh had the court reporter provide a live feed to Terry Sheppard, who was providing Ejbeh with impeachment material during his examinations of company employees. Terry Sheppard, the witness, was also named as a defendant in the lawsuit, which sought damages in the millions. The plaintiffs in the case for the Thomas Kinkade Company included Rick Barnett and Ken Raasch.

Yatooma called the lawsuit by the Thomas Kinkade Company "asinine." He argued that under the law, the live feed itself was not illegal. The court agreed that no law was violated, since there is no expectation of privacy in a judicial proceeding and therefore there can be no illegal eavesdropping. However, Ejbeh was sanctioned by the arbitration panel for initially denying his use of the live feed, before Yatooma corrected his misstatement before the panel. Ejbeh explained he was only trying to protect Terry Sheppard. The Thomas Kinkade Company's claim of illegal wiretapping was dismissed in the Michigan court.

Although Thom had initially been named in Yatooma's claim seeking millions, along with Rick Barnett and the Thomas Kinkade Company, he was not found personally liable. Thom just couldn't be

tied to any of the decisions that were made. He couldn't be personally linked to the fraud misrepresentations. Thom was in his studio, painting most of the time. He went to the offices as little as possible, and was quite ignorant of the day-to-day operations. Thom was ultimately exonerated.

But the damage was done to his reputation and his sense of himself.

CHAPTER 9

The Bad Boy of San Jose

He put the glass to his lips, and drank at one gulp. A cry followed;
he reeled, staggered, clutched at the table and held on, staring
with infected eyes, gasping with open mouth; and as I looked,
there came, I thought, a change—he seemed to swell—his face be-
came suddenly black, and the features seemed to melt and alter—
and the next moment I had sprung to my feet and leaped back
against the wall, my arm raised to shield me from that prodigy,
my mind submerged in terror.
—ROBERT LOUIS STEVENSON, *Dr. Jekyll and Mr. Hyde*

According to an article in the *Los Angeles Times*, in August of 2006 the
FBI opened an investigation into allegations of fraud perpetrated by
Thomas Kinkade and his company. The Painter of Light, whom the
country knew for his religious themes and sentimental romantic im-
ages of cottages, gates, bridges, and lighthouses, had suddenly come
under the scrutiny of the feds. Norman Yatooma's allegations in the
chambers of the arbitration hearings had begun to resonate in the
outside world. Had fraud been perpetrated by Thomas Kinkade, the
artist admired for his wholesomeness? Executives at the company, and
friends who had known Thom well for ten years or more, wondered
how it had all happened; how someone who started from such a sin-
cere beginning could come to this.

The management decisions that had proliferated galleries, and sold too many paintings at too large a discount, were continuing to have a detrimental effect. Thom's simpler times were only getting more and more complicated.

Federal agents were scouring for a case, and the unhappy dealers were certainly willing to speak to the investigators. After all, they felt Thomas Kinkade and his company had exploited their Christian faith to entice them into investing in their signature gallery franchise. They had been subjected to unfair competition by their own company, and undersold in discount stores. After a dealer was awarded $3 million, dozens more came out of the woodwork to lodge complaints. Investigators sought anything they could find that might amount to a federal case, perusing documents detailing the business relationship of the galleries with the Thomas Kinkade Company. The FBI agents, whose investigation was being coordinated out of the San Jose FBI office, were combing through endless stacks of dealer agreements, retail sales policies, training materials from Thomas Kinkade University, and all correspondence, including email. Everything the company and Thomas Kinkade had been involved in with the signature galleries came under scrutiny.

All Thom had ever wanted was to turn his poverty into prosperity. But the dream had turned into a nightmare. And even though nothing ultimately came of the FBI investigation, things still were only getting worse.

Norman Yatooma announced he was going to file a class action suit on behalf of the collectors who had bought the canvas transfer paintings by Thomas Kinkade, believing they were a good investment. He also planned a class action suit by the shareholders of the company, who had once held shares of great value that they had been forced to sell at a significant loss in 2004.

Yatooma alleged Thomas Kinkade had driven the stock price down from $30 to $4, so he could buy the company back cheaply and take it private again for merely $33 million of his own money. Nothing ever

came of these allegations, but to Thom, and to those of us witnessing the legal battles, it seemed Norman Yatooma would not stop until he had vindicated everyone the Thomas Kinkade Company had affected by the unfortunate over-proliferation of signature galleries.

Yatooma was effective, speaking the same Christian language associated with Thomas Kinkade. "I am a person of faith myself, and I'm really disturbed by Kinkade's use of God to perpetrate a scam," he said.

At the onset of the lawsuits, the company had made a key decision, as the galleries began failing and many galleries hadn't made their payments for up to a year and a half. Executive management decided they needed to stay firm. Instead of forgiving and forgetting along Christian tenets, they would give no quarter. There would be zero leeway. They could not appear weak, lest they open the door to an impossible situation where everyone who wasn't doing so well, or had a bad spell, would come and ask for a handout; for lenience. They calculated that by putting a tough defense team—including the well-known defense attorney Howard Weitzman, best known for his participation on the O. J. Simpson dream team—on the case, they could keep battling until they exhausted the resources of the signature gallery owners who were suing, and who were bound to have far fewer resources than the company. Eventually, they not only beat every signature gallery owner who filed a lawsuit against them, but also prevailed in their own lawsuits against those dealers, forcing many of them into corporate and personal bankruptcy.

This strategy became the key factor in how things would turn out. It forced them into a hard-line position from which there was no return. Instead of working out a settlement, or trying to find a solution with the ailing galleries, they were now forced to take the most aggressive and damaging course of action toward their own gallery owners. The litigious strategy set the stage for a long and hard battle.

In the wake of the conflicts, Thom retreated more and more. He was increasingly absent, increasingly unpredictable. He withdrew into himself, most likely as a means of spiritual survival. Just like the

promise his paintings held, he sought a place where he could feel safe. He yearned to retreat to a place better than the one he was in.

And there was no better place to escape than into the bottle.

"It's in my blood—I'm Scottish," he would explain about his love of whiskey. "It's mother's milk for us. This is what we drink."

Thom threw up a protective shield around himself. Now he seemed to increasingly take on the persona of a man's man, perhaps to steel himself against all the darkness bearing down on him. Thom became the rugged man, the hunter, the biker, the outlaw. He assumed the persona of the biker artist; started to grow his hair long and wear leather jackets. He was the big burly biker sitting astride his Harley-Davidson.

He cultivated a Hemingwayesque vision of himself as a kind of bulwark against his own sensitivity and pain. He had always admired Ernest Hemingway, not only for his writing, but also for his drinking abilities and manliness. He transformed himself into the image of a bohemian artist, an outsider and rebel; a man running from darkness. It was as if he was trying to act like what was happening didn't faze him, although I knew it had to affect him deeply. Thomas Kinkade, Painter of Light, now also had "fraud" and "hack" attached to his name.

On July 1, 2006, CNN aired a Larry King interview with Thomas Kinkade and Robert Goodwin, the president and CEO of the Points of Light Foundation, to discuss their new book, *Points of Light: A Celebration of the American Spirit of Giving,* and to promote the foundation's mandate to encourage the spirit of volunteerism in America. In the interview, Thom talked about his nonprofit work with the Salvation Army and the series of auctions at which he drew an original sketch on the back of a canvas transfer painting and auctioned it off for the Points of Light charity. Nanette had been involved in his charity work for the Make-A-Wish Foundation as well as his Salvation Army work, all along.

During this period in 2006, I was spending less time in San Jose and more time at home with my wife and kids in Santa Barbara. For the family's sake, I preferred running the Creative Brands Group licensing

business I handled with Ken out of my home office, rather than from the offices Ken and I had established for CBG in San Jose. I made many trips up to San Jose during that time, where I planned a week of meetings with Thom and executives at the company, to lay out our latest licensing plans. The company often put me up at the upscale Hotel Valencia.

The neo-Spanish hotel was perched over the bustling street life of Santana Row, a premier shopping boutique area of San Jose, just across the street from the Valley Fair Mall. On one of those many business trips, I rented a suite with one bedroom, two bathrooms, and a large living area. I had a meeting the next day at the Thomas Kinkade Company, but had let Thom know I was in town. He told me he wanted to see me.

"Eric. My brother Pat's in town. Let's get the guys together for a game of poker. Do you have a nice room?"

I stood on the balcony of my spacious suite and looked down at the bustling shoppers below. As the bellboy placed my bags in the closet, I looked around at the well-appointed, brand new hotel and said, "Yeah, I have a nice room."

"Great. We'll have a night at your hotel. That way I can get out of the house."

❦

Poker games were an annual tradition. A core group of men from the company—Dan Byrne, James Lambert and myself, and once upon a time, Terry Sheppard—were a staple at any party Thom held. Ordinarily we would meet at Thom's Ivy Gate Cottage, where we would play poker into the night. Thom always kept his studio well stocked, and there'd be plenty of drinking and playing until someone won the table. We'd play Texas hold 'em, seven card stud, five card draw, high low eight; whatever the player whose turn it was to call the next game decided he wanted to play. We'd always have a lot of fun, sitting around the table, joking constantly, and talking football, baseball, and

girls. We'd all be drinking, but where the rest of the guys would have one beer, Thom would have three. By ten o'clock Thom was well lit and full of liquor. He would then get up, open the French doors of his cottage, and relieve himself in the bushes. He'd always draw a lot of laughter and disbelief when he did it. And he'd always say the same thing.

"The Good Lord gave us the great outdoors to relieve ourselves. If he had intended for us to use bathrooms, Adam and Eve would have had facilities."

Everyone would laugh and shake their heads when Thom was making his jokes. But it became a natural fact of life that, every poker night, Thom refused to use the excellent and well-appointed bathrooms in his cottage, and instead enriched the great outdoors with his bodily fluids.

⚜

On our poker night at the Hotel Valencia, we played long into the night. Room service came up three times and brought whiskey, red wine, and chilled bottles of white wine in silver ice buckets, and popped the wine corks as we swirled our glasses and nodded approval for another bottle. There were also cases of beer on ice, and they were dwindling fast. Room service also brought treats from the in-house restaurant.

It was a nonsmoking room, but every one of us had a cigar wedged in our teeth, dealing out cards and raking in the chips. As I tapped the ashes into the overflowing ashtray, I worried whether I would get into trouble with the hotel the next day.

It was a boisterous affair. We ate and drank and smoked and gambled the $400 each of us had on hand, so that by the end of the night, in a game of acey-deucey, one of us was sure to walk away with close to $3,000.

By ten o'clock, as though set on a timer, Thom got up to relieve himself. And he could barely stand. True to form and tradition, he forsook the use of the bathroom and walked to the balcony just like

he did at Ivy Gate Cottage, threw open the doors and walked to the edge of the deck, unzipped, and started relieving himself over the railing. Suddenly we heard voices and cries from below. Shouts of outrage came from the busy street, where unsuspecting pedestrians were clearly being showered.

Dan Byrne called out that there were people walking down there.

Thom swayed and looked down at the street and saw the scattering pedestrians beneath his stream of urine and started laughing hysterically. He zipped up and staggered back to the table, where everyone else was in hysterics.

I tried to get a word in. "Thom. Please, use the bathroom. People walk by on the street. I could get in trouble here."

My mind flashed back to the time in San Francisco when the police had Thom spread out on the hood of a squad car for drunken and disorderly behavior. I had talked the officer out of an arrest that night. I didn't want to press my luck a second time.

Not much later the restaurant had closed, room service was done for the night, and the stash of liquor was depleted. Even the minibar had been raided and emptied down to the last bottle. Dan Byrne had just won the table and was collecting his cash, as the rest of the men started getting up, groaning, stretching, and lamenting having to get up early the next day for their various jobs and meetings. Only Thom leapt out of his seat and exclaimed, "No! Don't go! We're just getting started!"

But the guys grumbled, shook their heads, and grabbed their car keys.

One by one, they waved off Thom's protests, grabbed their jackets, extinguished their cigars, and got ready to go.

"You guys are no fun."

Thom looked around the table. There were half-empty glasses, poker chips, and empty plates spread out in a mess. Suddenly Thom grabbed a 16-ounce empty glass from the table and started filling it with liquor from every glass the guys had used. He poured it all into his pint glass: whiskey, beer, champagne, wine, vodka tonic. He filled

the glass to the brim until it became one horrible-looking brown mixture of every last drop of alcohol left in the place.

Thom stood and looked at the concoction in his hand. Then he tilted his head back and started pouring it down, gulp after gulp. He managed to drink about half the glass before coming up for air. He stood and recoiled, looking around the group with a shocked expression. Everyone was staring, suspended. His eyes seemed glazed and crossed. I thought, "Dear God, don't let him throw up right now. Don't let him throw up in my executive suite at the Hotel Valencia."

Thom's eyes rolled into the back of his head for a second, and I feared the worst. It was like watching the transformation of Dr. Jekyll into Mr. Hyde right there in front of all of us. It was frightening to see. Then he cleared his throat, tilted his head back, and downed the rest of the glass.

The men were stunned. Thom put the glass down, exhaled, and wiped his mouth. I walked over to him and put a hand on his shoulder.

"Come on, Thom. I'll call your driver. I'll tell him you're ready to go home."

He looked at me and nodded; docile, teetering.

"Sure. Time to go home."

I walked him down to the street and made sure he got into the limousine in which his faithful driver, Bo, was waiting for him. After he drove off down Santana Row, I scurried back to my room and started cleaning up, already dreading the possibility of a hangover the next day.

The next morning, I dragged myself out of bed and pulled myself together with a couple of Advil. I barely made it in time for the 8:00 a.m. meeting at Ivy Gate Cottage at Thom's house. When I arrived, I expected to find him sleeping. Or certainly, if awake at all, hurting very badly.

As I walked around the cottage along the path of roses to the back patio, I found Thom sitting at his easel, painting the blooming trees and flowers in the garden. He saw me and perked up, his rosy cheeks glowing. I was always stunned at his constitution. He beamed at me.

"Hey, Eric! Beautiful morning! The birds. The sun. What a great day to be alive."

No matter how many challenges Thom faced—no matter how many lawsuits came bearing down on him, or how many drinks he'd had the night before—he could always paint. It was the one most consistent thing in his life, and sitting before his easel was probably the only place he always felt safe.

In September 2006, Thom painted the Elvis Presley estate Graceland for its upcoming fiftieth anniversary. He traveled to the estate in Memphis, Tennessee, set up his easel, and painted the mansion from the grounds near the street, with its gate open, two pillars inviting the viewer inside, where Graceland perches atop a knoll. In March 2007, he returned to Graceland for the festivities and presented the painting to Priscilla Presley. Thom was a fan, and he identified with Elvis.

The similarities were sometimes unnervingly ironic. When Thom went on auction tours for the Points of Light Foundation, at which he would give a talk and auction off a handmade sketch that he drew onstage, he'd quip that the drawing would be valuable long after he was gone, and that the lucky collector would someday proudly show his grandkids his own original Thomas Kinkade. Then he would joke that the grandchildren would exclaim, "Thomas Kinkade? He isn't a real person. I thought he was just a myth!" Then he'd add with perfect comic timing, "And soon there will be Thomas Kinkade sightings all over the place."

⚜

Thom became the American painter. Every iconic image came under his brush. Baseball parks, from Fenway to Yankee Stadium. Nascar and Indy races. Cities, from Chicago to Charleston, Kansas City, Seattle, Philadelphia. All were commemorated in his paintings. In 2008 he signed a deal with Disney and painted his first in a series of Disney images. It was called *Winnie the Pooh I*. Cinderella, Snow White, Pinocchio, and Tinker Bell soon followed.

Despite his growing personal troubles at this time, Thom made another dream come true: the making of a TV movie based on his life, with Lionsgate Studios. Called *Thomas Kinkade's Christmas Cottage*, it was to star Peter O'Toole as Glenn Wessels, the painter who mentored him as a young boy. I remember Dan Byrne was amazed at the fact that here he was, as CEO, jetting back and forth to Hollywood for script meetings. He chuckled that they were even asking him his opinion about the lighting.

I laughed with him. "Well, as CEO of the Thomas Kinkade Company, you better know something about the light."

I even sat in on one Lionsgate meeting, watching Dan Byrne speak as the credibility consultant. Dan would comment on whether or not Thom would have said a particular line.

To me, the executives at the studio seemed openly disparaging of the movie. It seemed like a cynical exercise for them, as they simply wanted to make a sickly sweet tearjerker for a certain movie-of-the-week audience of mostly women, and any of the Christian Thomas Kinkade fans. I didn't feel it had much of a chance of being a great movie, but it meant a lot to Thom.

For Thom, making a movie was perhaps his last big dream come true. It brought him full circle to his days in Hollywood as a background painter on *Fire and Ice*. He was back where everything had started, and this time he was a central character in the script of his life. It was a chance to hold on to the myth of his wholesomeness that was slipping through his hands. He was drinking pretty heavily those days, and when he went on set, I was told he sat in his director's chair with a drink in hand.

Later that year, Dan Byrne quit the company. The pressures bearing down from the lawsuits, the changes in Thom and his increasing absence, and the chaos and instability in management finally made him take leave for good. John Hastings, who had worked with the company in the past, was installed as the new CEO. Hastings had been

the director of a premier printing company out of Atlanta, a division of Hallmark. He was well qualified, since he was actually intimately familiar with the replication process of the Thomas Kinkade art by that time, and understood the market well. And so the sixth CEO in seven years took the helm at the Thomas Kinkade Company.

<div align="center">❧</div>

As Thom withdrew, Nanette became more and more important. She always had the future in front of her and the past in the rearview mirror. She was sensible, logical, and wise. She came to executive meetings. She became his voice. She stepped up when Thom couldn't. In the years that followed the shaming depositions, the relentless lawsuits, the humiliation of the implosion of the signature galleries, the plummeting market value of the art, and the financial woes of the Thomas Kinkade Company, Nanette was more and more there as Thom was increasingly absent.

Nanette's husband, the father of her four daughters, was slowly disappearing from their lives, drawn into an abyss by the bottle. It must have been difficult for her to watch, and lonely to experience. In 2009, she even staged an intervention with Ken in order to try and stem the rising tide of his alcohol consumption. Thom promised to cut back, but quickly fell back into his usual routine. He just couldn't see that he had a problem.

In the years when the lawsuits began, Nanette emerged from the shadows for the sake of her husband, who couldn't do it for himself anymore. She presented herself with dignity and stood up for Thom's legacy and achievements, as I see her do to this day. And in the years I watched Thom's decline, I admired her continuing strength.

Nanette knew that, underneath his joviality, Thom was a deeply insecure man. He was always trying to prove himself. He needed constant validation and acceptance from everyone around him. It must have been hard for her to watch his decline, and to slowly lose him in spirit although he was still present in person. The years of depositions

and lawsuits had visibly eaten away at him. The loss of the love, from so many who had once admired him, was devastating to him. I know she saw him slipping away, as we all did; every day a little bit more.

❧

That year, amid the chaos and net losses from the lawsuits, the Thomas Kinkade Company reached over $3 billion in total retail sales.

❧

Norman Yatooma had attempted to collect payment on the judgments handed down by the arbitration panel against the Thomas Kinkade Company for years, but the company had stalled continuously and still hadn't paid, leaving his clients in ongoing misery. Yatooma wanted what was right: that his clients be paid the sums ordered, to help them put their destroyed lives back together, or what was left of them.

The first installment of $500,000 due to Karen Hazlewood and Jeff Spinello had been owed for years. The company seemed to think that if they didn't pay, they could always survive the ensuing legal battles and draw things out indefinitely. Two subsequent payments of $1 million and $1.5 million were due within a year's time. Finally, Norman Yatooma resorted to his own style of taking care of business, intended to get results for his clients. He felt it was simply wrong for the Thomas Kinkade Company not to pay his clients after essentially ruining their lives. So he went after the money in the only way he knew would guarantee results: he hired several moving trucks, called all the media outlets in San Francisco, and with a court order in hand, drove to Morgan Hill to collect what rightfully belonged to his clients. If he couldn't get the awarded judgments in money, he was ready to take merchandise equivalent in value.

Helicopters circled above the Morgan Hill company headquarters. Local news vans cluttered the street with their satellite dishes, broadcasting into the homes of America. Reporters stood with cameramen,

reporting live from the scene. Local sheriff's department deputies were on hand, monitoring the event and prepared to force the court-ordered release of artwork in lieu of payment. The media's hounding approached the intensity of a high-speed car chase on the freeway.

Norman Yatooma instructed his moving vans, which had their gates rolled up like gaping mouths ready to swallow the company whole, to back up to the loading docks of the facility. He knew the public specta-cle increased his leverage, and that forcing the issue would, after four years, get results. He called Thomas Kinkade a deadbeat, and said the company had breached their agreement, adding, "Kinkade's word is as worthless as his artwork."

Ken and Rick must have been watching the circus from their tele-visions at home, while Thom was more likely painting in his studio, avoiding the matter entirely.

Finally, with the cameras rolling and the morning news broadcast-ing the scene live, the front door of Morgan Hill opened just a crack and a hand held out an envelope. Norman Yatooma approached the door and took it. In it was a check for $500,000.

God's Own Intervention

Be sober. Be watchful. Your adversary the devil prowls around
like a roaring lion, seeking someone to devour.
—1 PETER 5:8

On June 3, 2010, the Thomas Kinkade Company filed for bankruptcy. It was just one day after the second installment, a $1 million payment, was due to Karen Hazlewood and Jeff Spinello, after the first payment of $500,000 had been handed through the door at the company's Morgan Hill headquarters. Norman Yatooma threatened to once again come to get it personally, with moving trucks and helicopters, if the payment wasn't made. Before he had the chance, Yatooma received an email from the company lawyer saying the Thomas Kinkade Company had filed for Chapter 11 protection, and therefore an automatic stay on all payments was in effect.

Bankruptcy was the final step in the mounting ills of the company. The gallery boom had long collapsed. More than 150 galleries had already closed, as early as 2006. The business was still struggling in the aftermath of the loss of income from the galleries, and from the huge legal fees incurred during years of battling with Norman Yatooma and a host of other lawyers.

Thom continued his output of twelve masterpieces a year. None of his personal struggles were ever apparent in his work. He painted

as vibrantly and beautifully as he always had. And he valiantly went on the promotional tours to the remaining 150 galleries, to help stir the collectors' market and bring in some extra income. But it wasn't nearly enough to sustain the huge overhead of several hundred employees and the company's Morgan Hill headquarters, which was the size of ten football fields.

As I later learned, senior management at the company knew they had to talk to Thom. John Hastings was doing a good job in a tough situation. He sat Thom down, along with his executive team, and made him hear him out. He told Thom the company was running out of money. Thom asked him what he meant by that. Hastings explained that business was down, and the lawsuits had cost them greatly. He told Thom they needed him to loan the company more money. He suggested Thom take out a loan on his house in Monte Sereno, or on his house in Carmel-by-the-Sea, or on his ranch in Hollister. He said Thom might even have to take out loans on all of them. But that he needed to step up now if he wanted to save the business.

By this point Thom had already loaned the company a lot of money, and he just didn't have any more. He eventually did have to take loans out on some of his properties to sustain his company. It was a major wake-up call about just how bad things had become. Thom owned his company 100 percent; a company that had achieved sales in the billions. Everything should have been great. But now it was sucking the life out of him and draining him financially.

For Thom, having to have that particular conversation was terribly defeating. It must have felt like part of him wanted to die. Knowing him as I did, he would have been mortified, horrified, and embarrassed. He was always afraid of losing everything he had. He had talked about that fear with me many times, and told me it never left him. The memory of going hungry in the trailer park was permanently part of his consciousness. He was always afraid that one day everything he had might be taken away from him.

To have to mortgage his houses and go into debt to save his company was devastating. The money kept his dream alive; Thom took it

as a sign that what he was doing was still good, and that he deserved the blessings he had. He had to believe everything was under control so he could concentrate on painting. He had to trust that the company would be successful as long as he followed the advice he was being given by his team.

The prospect that Thom might lose everything—that the company he founded, based on his mission to give people hope and provide joy, was failing—was difficult for him to endure. It wasn't just about the art; it was also about the entire brand. The lifestyle. His faith. How could things have gone so wrong when all he ever wanted to do was right?

Thom listened to the executives on the board. He did what he had to do; he took out the loans and saved the company. But from that point on, he was a changed man. The carefree Thom, the man who never grew up, the ebullient Thom I knew so well, was less and less to be seen. Instead, a darker side came out. Nanette told me later that it was as if she was watching the light in Thom slowly go out.

I can only imagine how deep the despair inside him must have been. What began in his garage had grown into a business, and then into an empire. And now it was crumbling. The highs had been so high, and he had felt so invincible for so long, that a low point didn't even seem possible. Thom certainly never entertained the notion. For him, the ride had seemed endless. And now it was all imploding.

In hindsight, I could see that the company had grown too fast, in part because of pressure from Wall Street. And it had been sold out by the sales machine. It had been exploited for short-term profit instead of responsible long-term fiscal planning. And the revolving door of CEOs, six in seven years alone, even though some of the executives were immensely qualified, couldn't sustain the most extraordinary phenomenon of an art business in the history of art.

I believe this moment was the beginning of an unwinding death spiral for Thom that would take less than two years to fully unravel.

After the first intervention had failed, Nanette staged a second one in the spring of 2010, this time bringing her daughters with her, as well as Ken and Thom's brother, Pat. It was her last-resort effort to save his life and to save their marriage. She had fought and hung in valiantly, but she had become increasingly alienated from him. There was just no reaching him anymore. The Thom she knew was disappearing fast. There comes a time when the disease progresses into such a detrimental state that the only thing that matters is to save the alcoholic from himself, even if nothing else can be saved. Recovery programs often counsel that most addicts won't stop until the family gives them an ultimatum and they face losing everything. This was Nanette's last resort. With everyone present, she confronted Thom with the message "Get sober or lose us."

Thom was more than devastated; he was furious. Ken described to me later how Thom was forcibly led away by medical assistants and taken to a rehab facility, literally kicking and screaming. This ultimate humiliation was too much for Thom and resulted in the end of the marriage. He could never forgive Nanette for the shame and mortification he was made to feel. As he was being dragged off, Ken told me Thom had looked at Nanette and said, "How can you do this to me?" Sadly, Thom rejected Nanette and his family from that point on. I know how much Nanette and his daughters meant to him, and I can only imagine the depth of the disease that would allow him to be separated from them. The monstrous shame inside, mixed with the siren call of the addiction, sadly destroyed Thom's family in its wake.

Within a month, Thom was back to drinking, even worse than before. And Nanette, his beloved Becky Thatcher, filed for divorce.

Less than two weeks after the Thomas Kinkade Company declared bankruptcy, and shortly after Nanette had filed for divorce, Thom was out at ten o'clock one night in his beloved Carmel-by-the-Sea, driving himself home after spending the evening in town. He headed up the winding path along the ocean, the Monterey pines pointing the way to his beach house.

A local police officer saw that Thom's 2006 Mercedes was missing its front license plate and pulled him over. Speaking to Thom about the license plate, the officer suspected alcohol and called the California Highway Patrol. When they arrived they proceeded to give Thom a field sobriety test, checking his horizontal gaze tracking, making him walk and turn, and do the one-legged stand. The California Highway Patrol made a determination that he was indeed impaired and took him to the Natividad Medical Center in Salinas, where his blood was drawn. He was booked into the Monterey county jail, where the police report later described him as polite and cooperative. He spent the rest of the night in jail before posting bail in the morning.

A week later, a lawyer for Thom entered a not-guilty plea at the Monterey county courthouse in Salinas, asking for additional time to retest the blood samples. A pretrial was set for a month later.

Thom texted me a few days after the arrest and said, "Can you believe these guys, Eric? I only had five beers!"

The story spread like wildfire in a Southern California Santa Ana wind. Newspaper articles and websites exploded everywhere with the news. Bloggers couldn't get enough.

Thom always elicited strong emotions in people, both good and bad. Christians saw him as a prophet, a beacon of hope, and a messianic figure. Art aficionados strongly disliked him from the very beginning, and didn't hesitate to say so. After Thom's drunk-driving arrest, attacks on his person and his art took on a fevered, vitriolic pitch.

The mug shot of his DUI arrest went viral on the Internet. The photo of him with hair in disarray, eyes glazed and vacant, and red face and even redder eyes was shared, derided, and a source of copious mirth on the blogosphere. An "I Hate Thomas Kinkade" Facebook page sprang up. Bloggers called Thom pompous. They said his art sucked. They called him the Painter of Blight. They said the light had, all these years, been emanating from the bottom of a bottle.

It wasn't just the DUI that made the news. It was the fact that the Painter of Light's company filed for bankruptcy, that his wife filed for divorce, and that he was arrested for drunk driving—all within the space

of two weeks—that made the real story. All the pieces put together made for a terrible image for Thom, and a feeding frenzy for the media.

A week before Christmas of that year, Thom entered a no-contest plea. His blood alcohol level had been found to be twice the legal limit by laboratory tests. He was sentenced to ten days in jail, with mandatory attendance at a nine-month DUI offender program, a fine of $1,846, and five years of informal court probation. The bloggers thought he was getting off too lightly. One blogger wished him a "Merry Fucking Christmas."

Contrition requires confession, and Thom didn't think he'd done anything wrong. He didn't feel he deserved the hatred raining down on him, or that he had caused it in any way. He lived inside a self-protective shield of denial at all times. He couldn't see his own sickness; the alcoholism eating away at him. He couldn't see how his avoidance of conflict made him allow bad things to happen, simply by default. He couldn't fathom that by so fervently wishing things to be whole and beautiful, he turned a blind eye to ugliness, and therefore the ugliness crept into his life and rooted in.

The few times I saw Thom in those days, he never talked about what was going on, or whether it was bothering him or not. Over three hundred signature galleries had closed, but we never talked about it, because Thom never talked about problems. If you brought them up, he would change the subject. But he drank more, and he looked more miserable beneath his endless hilarity and late-night antics. The toll on his psyche was written on his face, and his body was taking a beating. The humiliation and the dying dream were eating him alive.

Thom had spent his life following his dreams. He painted his heart out, and dedicated his message to the god he fervently believed in. He had enjoyed the fruits of his labor and the pleasures of the world with a kind of naïve entitlement. He loved beauty in all forms, from landscapes to the female form. He had put his vision into the world and declared it good, and he intended that his vision do good for people. He had enjoyed the effect he had on people, he loved their admiration, and he believed in his ability to serve their needs. He wanted to en-

velop his audience in a memory, a feeling, a world that held a sacred, safe place for them.

Thom didn't judge others. He wasn't a preacher, nor did he claim to be. He didn't condemn those who didn't follow the god he worshipped; he only witnessed to those who already believed like he did. Being Christian doesn't automatically make you a hypocrite if you acknowledge that you are also flawed. Of course, he didn't see his drinking as a flaw; he didn't see his passions and boundless curiosity as flaws, either. Nor did he see his images, soft and inviting, easy on the eye, sentimental, romantic, and inherently pleasing, as flawed.

Thom's work questioned the modern art mandate that art had to be inaccessible, cerebral, or negative in order to be legitimate. Was all art not simply a creative representation, in a variety of mediums, by one human being, of the world around him, in the way the artist understood that world? It seems that in contemporary art circles, if religion is affirmed as opposed to derided, the artwork is scorned. But should Thomas Kinkade have been ashamed of his religion?

When people have success in America, they are lauded and respected as long as they remain successful. When they lose that success, they are often descended upon like a wounded animal by a marauding horde of hyenas. Thom was under constant attack in the blogosphere after his DUI. After the lawsuits. After the truth of the Painter of Light's alcoholism became a public fact.

What made Thomas Kinkade fair game? I'm certain that part of it was that he shook up a basic notion of the modern art world, which venerates the concept of the original. But is there inherent value or lack of value in the original versus the identical copy? Thom's reproductions throw up interesting questions, and it will take more time to unravel the answers. It is really a conceptual question. Is art only art in the original? Is the *Mona Lisa* less art when depicted in a coffee table book? Did the words in the Bible become less meaningful when they were printed by Gutenberg's printing press, rather than hand-painted by one monk for over a year? And who is the arbiter of this value, if not an art market that is most interested in its own survival?

Modern art has its own rules by which it sustains itself. Art dealers are making and breaking artists all the time. The modern art market inflates prices, collectors dump art and ruin careers, and dealers guarantee bids at auctions to protect the market value of their favored artist. There is a considerable amount of manufacturing and manipulation involved in keeping a stable collectors' market humming. These practices aren't necessarily any better or any more salient than Thom's copious reproductions. They are all about creating and sustaining value, and selling to a market willing to pay. Art is a market, and it is a for-profit market. The conventional art world supports that market. Market values are intangible, driven by critical validation and scarcity.

At the height of his success, Thom drew criticism and envy for success that was largely deemed undeserved. When the business practices of his company were exposed through years of lawsuits and depositions, the art world felt redeemed. And when Thom's drinking problem was exposed by his mug shot's proliferation in cyberspace, he became fair game for all forms of venom and derision.

Perhaps Thom's greatest fault, in the eyes of others, was how much he profited from the sale of his art. But is it any less shameful to sell a shark suspended in formaldehyde for $9.6 million, as did Damian Hirst in a Sotheby's auction, than it is to sell a replica of a painting a hundred thousand times?

⚜

Slowly the light went out in Thom. I visited him at Ivy Gate Cottage one evening around ten o'clock, planning to stay the night in his spare bedroom so we could spend some time together, catching up. By this time, I had already left Creative Brands, but took great pleasure in hearing that the licensing business was essentially keeping the company afloat. While the print business was slow from the closed galleries, and the costs of the lawsuits had impacted the company's income

severely, the licensing stream still made the company millions in pure profit. Licensing had always been the redheaded stepchild in the company compared to the art business. "Eric is making calendars," was the pervasive attitude I sensed. While the company was opening galleries, licensing was an afterthought. But the calendars people would joke about made the company well over $1 million in profit every year. Without licensing, the company most likely wouldn't have survived.

When I reached the cottage, I knocked and heard no answer. I looked in through the windows and saw Thom lying on the floor, passed out at the foot of his easel. I later heard the housekeeper often found him this way in the morning when she came in to clean. It was the first time I saw him myself, lying on the bare wood floor, just steps away from his bedroom door. The image was disconcerting, but even then I didn't understand why he didn't just go and sleep in his own bed. I still couldn't fathom the severity of his disease, not understanding that he couldn't even make it that far at the end of a long day of drinking. I went inside and shook him awake.

"Thom, buddy, wake up. What are you doing sleeping on the floor?"

He came to, incoherent and groggy, and I just managed to get him to his bed. The next morning he was his usual self, wide awake and painting before I even got up. The previous night's spree was forgotten, as if the world was reinvented every morning, before the drinking would begin again.

❧

Thom now lived in his studio permanently, separate from his family. When I saw him months later, the transformation that had taken place in him was quite staggering to behold. It was Kafkaesque. I had recently seen press photos of Thom at the Kentucky Derby; his face, unrecognizable to me, was puffed out, his eyes narrowed and lifeless, his smile wan and forced. It didn't look like there was anyone inside the altered physical shell that was now Thom.

When I entered his cottage the day I went to visit him, I was shocked. He had gained weight, and now weighed nearly three hundred pounds. He looked terribly unhealthy, sweating and pale, with red splotches on his face from all the drinking. He had grown his hair long, but there wasn't enough hair to grow, so he had resorted to getting hair extensions to fill out the bare spots, which only made it look worse. He wore his biker gear; his leather jacket, his torn jeans, and biker boots. He looked like a huge, angry rebel surrounded by the beautiful scenes on canvases scattered throughout his studio. It was an absurd sight. He had taken to wearing multiple skull rings, their pirate death faces grimacing from the short fingers on his small hands. He was utterly transformed from the Thom I had known for nearly two decades. I was alarmed to see him in this state.

He was edgier and less jovial than his usual self. And when he told me about how Nanette and Ken had ambushed him for an intervention and dragged him to rehab, he said, "They're all out of their minds!"

I told him I thought they were worried about him, but he brushed it off, telling me there was nothing to worry about. He said he didn't have a problem; that they were the ones with the problem.

This wasn't the Thom I knew. I could see that desperate measures were necessary. Thom wasn't the ebullient life force he always had been. The constant criticism and derision had obviously plummeted him into a deep despair and depression that he didn't seem to be able to pull himself out of. He was dying inside. His organs were failing. His mind was fuzzy. Only his painting hadn't slowed down; he was painting as much as ever, always at his easel. It was his sanctuary and his place of truth. No matter how physically ill he became, Thom was always a true artist. There was no denying his passion and God-given talent; it was what he was born to do.

I left his studio that day with a heavy sense of foreboding. Where would his trail of despair end?

It was the last time I ever saw him.

Meanwhile, Thomas Kinkade Company, despite its shrunken sales base and the ongoing losses from the lawsuits, quietly crossed over the $4 billion mark in total retail sales.

❧

Months later, Thom traveled to Portofino, a picturesque seaside resort in the province of Genoa, nestled along the Italian Riviera. Italy and its Adriatic villages were favorite subjects of Thom's for his paintings, and always a good excuse to take a vacation. Thom packed his painting supplies and flew to Portofino to paint, taking along with him a young, pretty girl he had recently met at the Hacienda bar. Thom and Nanette had not finalized their divorce at this point, and their separation was not largely known. But Thom wasn't speaking to his family much in those days, and a trip would have seemed like a good opportunity to get away from it all.

A few days into Thom's trip, I was told CEO John Hastings received a phone call at his office at Morgan Hill. On the other line was the young girl, crying so hysterically that he could hardly understand what she was saying. He finally managed to grasp that something had gone terribly wrong. Thom had been drinking heavily and was out of control. Apparently he hadn't moved in his bed for two days, and the girl was afraid for his life. Hastings asked the girl if he was breathing. She said, "Yes." He managed to get out of her that the hotel was trying to protect Thom from a scandal; they were worried about the press getting wind of it, since Thom was a prominent figure. Then she dissolved into crying again. John Hastings thought of the press and the scandal and the liability, and hung up the phone and drove right to the San Francisco International Airport to take the next nonstop flight to the Genova/Sestri airport. Then he drove to Portofino.

When he arrived at the Imperiale Palace Hotel ten hours later, he asked the front desk for the Kinkade suite. The hotel manager personally ushered him up to the room, whispering, "Thank God you are here."

As John entered the suite, he was hit by the smell of booze, sweat, and urine. The curtains were drawn, and the girl was huddled in a corner, curled up in a fetal position, quietly crying. John approached the bed where Thom lay naked, motionless, and soiled. Two empty whiskey bottles stood on the bedside table, and one, nearly empty, was clutched in his hand.

John picked up Thom's three-hundred-pound frame and dragged him naked into the bathroom, where he began to wash his body in the bathtub. Thom slowly came to as the girl hurriedly packed their belongings in the other room.

John got Thom down to the lobby by pushing him on a luggage cart. When the valet brought up the Mercedes Thom had rented, it was covered in dents and scratches on all sides. The girl explained that Thom had driven the winding coastal roads drunk for days, a bottle wedged between his legs, repeatedly smashing into the low stone walls and guardrails of the steep cliffs of Portofino, nearly plummeting them down to the shore. This had been the auspicious beginning of a weeklong binge that finally left him immobilized in his hotel bed.

Thom and John Hastings and the girl boarded the next plane and flew back to California, where Hastings made sure to get both Thom and the girl home safely.

Only weeks later, Thom ended up in a hospital bed, his body completely paralyzed from the neck down due to acute alcohol poisoning. For two weeks he had no use of his limbs and no sensation in his body, which had gone into toxic shock. It took two weeks of detoxing before he slowly regained the feeling and the use of his arms and legs.

Doctors told him that if he had just one more drink, it would kill him.

They told Thom there was just one decision for him to make—whether to live or die.

A Light in the Darkness

While I thought I was learning how to live,
I have been learning how to die.
—LEONARDO DA VINCI

The Thomas Kinkade Company announced it was emerging from bankruptcy on July 15, 2011. It had a new plan to repay its debts, and a growth strategy to reinvigorate Thom's visibility in the marketplace. The company promised more paintings, more collectibles, and more venues and outlets to sell these products. It was even planning on opening new branded galleries in new locations. By this time, Ken and I had fulfilled our ten-year contract to exclusively represent the Thomas Kinkade Company's licensing business. Robert Murray, counsel for the Thomas Kinkade Company, declared he was certain of a swift approval of the growth plan in bankruptcy court.

It was one year after the bankruptcy filing, and a year after Thom's DUI. I had amicably parted ways with Ken Raasch by then. I wanted to branch out into celebrity brand licensing and investing, something Ken wasn't interested in doing. Ken decided to remain with Creative Brands Group, and I opened a new company in order to focus on popular consumer brands, as well as celebrity and personality-based brands, for licensing, endorsement, and other strategic partnership agreements. I would also make strategic capital investments, particularly

in the fashion and beauty industry. It didn't change the nature of our ongoing friendship; only our business relationship.

John Hastings was doing a remarkably competent job as CEO, pulling the company out of its low point. He had also cleaned house in the process, removing all vestiges of Barnett's Thomas Kinkade University and anything related to the lawsuits.

John Hastings wasn't a sentimental man, but he was practical. The company had, to a fault, been run on friendships, allegiances, and the buddy system. Friends were hired, then fired, only to be hired again. Thom's sentimentality was reflected in, and perhaps exploited by, those working in the company all those years. It had been a kind of family affair, and if you were in the "family," you could do wrong and still remain a member. To his credit, John Hastings changed all that, to the benefit of the company.

<center>⚜</center>

Thom was sober for the first time; certainly for the first time in the sixteen years I had known him. He began working out, getting fit, and seeking help for his health in a facility in Palm Springs. For the first time in a long while, there was hope and clarity in his eyes. He set out to heal himself physically and also spiritually. He began visiting friends and family he hadn't seen in many years, some of them going back to his childhood. In some of these visits, he would simply go to sit with someone and reminisce. With others, he went specifically to make amends, to ask for forgiveness, to set things straight and tie up loose ends.

Thom sought out Tony Thomopoulos on one of these visits, after not having seen him for ten years. Tony and Thom had lunch together, and Thom told him about his renewed outlook on life, and how he was finally sober. But Tony remembered feeling a sense of uneasiness. Thom seemed off to him, not the same Thom he once knew. Not least of the reasons for this feeling was that Thom, perhaps as part of his new bohemian style, was wearing blue nail polish that day.

Although it might have been a sign of recovery and returning health for Thom to make his rounds and visitations, I had a sense that he knew somewhere deep inside that he was saying goodbye. Thinking back I couldn't help but think of the many times Thom had made predictions of his early death.

"I won't be around to see it, but —" he would preface his sentences.

"When I'm gone, the art market will rethink my value," he would say.

"Isn't it strange how so many of the great artists in the world don't live for very long?"

"I'm like van Gogh, or Lautrec, or Hemingway. I've come to do an important job, but I won't be around for the long run."

He would say it matter-of-factly, like the idea didn't frighten him. Perhaps he felt it was the mark of a great artist to die young. It was certainly a commentary on his priorities that any fear he ever had hovered around losing money, as opposed to losing his life.

Thom even visited Nanette's parents in this period of visitations and contrition. He spent a considerable amount of time with them, in fact. From what I was told by Ken, the only persons he didn't visit, and never forgave and didn't ask forgiveness from, were Nanette and his daughters, the youngest of which was fifteen, the oldest twenty-two. After the intervention, he just couldn't face them, and their interactions were tenuous and strained. His shame and misplaced sense of betrayal must have been so deep that he allowed himself to be separated from his family.

Nanette, whom he immortalized in his paintings, and his daughters, whom he honored in his work by naming cottages and houses after them, were what he cared about the most. His marriage of thirty years had helped to create everything he had, most importantly the lovely daughters he adored. I didn't believe in his reluctance to see them, or his defensive stance regarding his newfound freedom. Perhaps if he could have forgiven them, he would have been truly healed.

Instead he lost those he loved the most.

Six months after the separation, a new woman entered Thom's life. She was attractive, with long dark hair and a big wide smile: Amy Pinto-Walsh. Besides her pleasing features and her considerable intel-

lect, she had a figure that could be described as voluptuous. This was not surprising, given Thom's particular taste in the female anatomy. After a brief period of dating, Amy moved into Ivy Gate Cottage with Thom, and finally into the main house.

Amy was in her forties when she met Thom. She was well traveled and worldly, born in India and raised in Kuwait. She was a model student when young, valedictorian in her class, and a good citizen, involved in her church. She wasn't just attractive; she was also smart, with a degree in electrical engineering from the University of South Carolina. She was married once and had two daughters from the marriage. When she met Thom, she devoted herself to him very quickly. Nanette and her daughters moved out of the Monte Sereno estate, and Thom and Amy moved into the main house. Amy and Thom continued a relationship that lasted for eighteen months.

Despite his attempts at staying sober, Thom's health was bad; he was teetering on the edge of survival with hypertension and heart disease, and his body and organs were deeply damaged by alcoholism.

Thom had mortgaged his houses and used up most of his available cash to help the company survive through its turmoils. The very thing he had feared his entire life was haunting him now; he was running low on resources, with only real estate to his name. And he hadn't even begun the divorce proceedings, which were bound to deplete him even more.

Patrick, Thom's brother, who was still an associate professor in Fort Worth, Texas, had steadily been involved with the company on the side, publishing books and often going out on the meet-and-greet circuit when Thom wasn't up to the task. In late 2011, Patrick traveled to the Talladega Superspeedway for the press conference announcing the release of Thom's latest painting, *This Is Talladega*, in which Dale Earnhardt's car is seen speeding along the track at Talladega while crossing the finish line. Patrick knew about his brother's alcoholism and saw him finally get sober. But he also saw the toll that negative press and aggregate losses had taken on his psyche, even if Thom acted to the outside world as if it didn't bother him.

Rick Barnett left the Thomas Kinkade Company after the lawsuits. He had become a very wealthy man through his long, loyal involvement with Thom, and it was surely a personal loss for Rick. But it must have been a personal loss for Thom as well, since Rick had been his confidante and his supporter for all those years.

In the summer of 2010, Rick Barnett formed a new company, International Artist Management Group; IAMG, a strange inversion of MAGI. Rick formed this company with Greg Burgess and Brad Walsh, the same Kirby colleagues he had hired at Media Arts. Their press release stated that they would be creating "superstars" in the art world, the way they had done with Thomas Kinkade.

IAMG called their artists "masters of light" and showed their work in the Masters of Light Gallery. Rick also renamed his Thomas Kinkade National Archives Gallery the Masters of Light National Archives Gallery. The venture lasted two years, and according to some of the artists who were represented, it then ceased operations as quickly as it had opened.

After I left Creative Brands Group to form my own company, Ken kept it going for some time, even though it operated only to maintain what little business was left to be managed.

In the last few years of Thom's life, I began to lose touch with him. I felt he was hiding from me, from his family, from the world. All those times we spent together, when Thom was talking about his family and his past, and espousing his values and the idea of simpler times, just didn't mesh with who and what he had become. Amy Pinto was another factor that alienated him from some of his former friends who were loyal to Nanette. It was sad for me. I missed my friend Thom but, in some sense, to me he was already gone.

After Thom's separation from Nanette, Ken seemed to take on the role of replacement confidante. Thom needed Ken, and for two years Ken tried to save him. Ken talked to him about his relationship with Pinto and his estrangement from Nanette. Although Thom was painting as always, his body was giving out. Ken sent him to doctors and specialists, suggested rehab, encouraged his sobriety, and spent a lot

of time trying to change him in any way he could. After all of their ups and downs, Ken remained loyal. Ken was Thom's confessor, his bodyguard, and his brother; that bond was real from the day they met. They had quarreled along the way, but the love they had for each other was deep and everlasting. Even the house debacle had clearly been forgiven when, in 2012, Ken put his house on the market to be sold in exchange for $29 million in Facebook stock.

A month before Thom died, Ken and Thom traveled to the Lyndon B. Johnson ranch in the Texas Hill Country. There is a picture of Thom kneeling in a field of bluebonnets, smelling the soothing fragrant flowers. Ken told me later that it was the best thing he and Thom ever did together. There was something about the fact that Thom was close to death that made remembering it so special.

Ken remained the one steadfast friend in Thom's life, until the very end.

<div align="center">⚜</div>

What is the mark of a great artist? We can measure auction bids, asking prices, critical acclaim, and museum retrospectives. Or $4 billion generated in the name and the work of one artist. And who decides?

What would sixteenth-century art historian Giorgio Vasari and the scholars at the Accademia delle Arti del Disegno, the first art academy in Florence, have said standing in front of works by three artists—Robert Rauschenberg, Franz Kline, and Thomas Kinkade? They would have dismissed the first two as painted by lunatics, perhaps the work of disturbed children, accidents of errant paint, blasphemous and heretical at worst. And while they might have dismissed Thom's technique as falling considerably short of the skills of their alumni Michelangelo Buonarroti or Benvenuto Cellini, he might still have been the only one not ridden out of town on a rail.

Thom's work is easy to digest. The colors of his flowers and landscapes are *super* natural. The forms of his naturescapes are exaggerated and fantastical. His representation of the world is überroman-

tic, pushing beyond the unreal into the surreal. Perhaps it reminds us of the whimsical backdrops of a painted animated film: magical and shamanistic.

Thom made countless people happy with his art. Millions who bought his paintings had never bought a painting before in their lives. The notion that they might step into a gallery and purchase a work of art was simply inconceivable to them; an inaccessible possibility until Thomas Kinkade came along. He made them feel like they belonged at the table. He made them feel like they could take pride in their home, and display an actual work of art on the wall. He made them feel like they, too, could play in the playground of the art world. That they could own something precious, something they enjoyed looking at every day.

Art doesn't have an expiration date; you don't grow tired of a painting the way a song might wear itself out in too frequent listening. Twenty million homes, and how many walls—how much joy did Thom spread with his art?

When the question comes down to money, there is no easy answer. Does a painting become more or less beautiful based on its fluctuating value in the marketplace? The art market, like any market for that matter, is an illusory thing, determined by intangibles. During the Dutch golden age, tulip mania gripped a fevered market and then collapsed. At its height a single tulip bulb cost ten years of a craftsman's salary. The speculative market is fickle and transient, but a tulip remains beautiful. And a Thomas Kinkade painting remains something that gives people joy.

Ken Raasch said, in the *Forbes* magazine article about Media Arts in 1998, that everything the company did had to carefully fit Thom's image—and make people feel good about themselves.

The billion dollar painter made millions of people feel good about themselves until his dying day.

But as Thom's perpetual light shone in every home of his collectors, his own light was slowly being extinguished.

The Good Friday End

I'll never have enough time to paint all the pictures I want to.
—NORMAN ROCKWELL

On a bright and sunny Good Friday morning, April 6, 2012, Amy Pinto-Walsh called 911. According to news sources, she told the emergency dispatch operator that she was with Thomas Kinkade, and he had been drinking all night and wasn't breathing.

A Santa Clara county ambulance arrived at the house at 11:16 A.M., where the emergency technician found Thom in his bed, not breathing, not moving. He began CPR, but couldn't revive him.

Nanette was out of the country, traveling with her four daughters in Australia at the time. Ken was the nearest friend who could be contacted. He rushed over immediately.

Ken pulled up at the Monte Sereno house in his BMW, not long after the ambulance had arrived. He rushed inside as his wife, Linda, followed. The house seemed empty and surreal, except for a commotion heard upstairs. Ken didn't see Amy Pinto anywhere. Linda went to check on Amy, and Ken headed upstairs to the master bedroom. Thom lay stretched out on the bed, the EMTs attending to his body. Ken stood in the room taking in the hard reality of seeing his dead friend lying before him. The EMTs looked at Ken with sympathy.

"I'm sorry. He's gone," one of them said.

Ken neared the bed as tears formed in his eyes. They asked him to identify the body, and he did.

We had all known Thom's death was not only possible, but most likely to happen, given the severity of his progressive alcoholism. But it was still a shock to Ken, who had hoped it wouldn't come to pass.

The coroner arrived, examined the body, and wrote up a report. When he was done, the EMTs prepared the body and the stretcher to move Thom out of the house and into the ambulance. Ken came over to them and helped lift his friend's body onto the stretcher. He followed the body all the way out to the ambulance, staying with Thom as long as he could.

While Linda waited downstairs, she walked through the quiet rooms, past pictures of Thom's daughters, all of whom were her godchildren. How many happy moments had they experienced together over the years? How devastated would the girls and Nanette be when they heard?

Amy later spoke to the *San Jose Mercury News*, saying that Thom "died in his sleep, very happy, in the house he built, with the paintings he loved, and the woman he loved."

Ken helped to load Thom's body into the ambulance and watched the EMTs close the door with a heavy heart. In tears, he said a silent goodbye to the man with the great appetite. His appetite had finally killed him.

Epilogue

End? No, the journey doesn't end here. Death is just another path.
One that we all must take.

—J. R. R. TOLKIEN

Ken called me from the car as he was driving away from Thom's house. He sounded shaken, his voice unsteady. He told me Thom was gone.

I had to pause a moment to comprehend.

"What?" I asked.

Ken told me Thom had died in his sleep, and that Amy Pinto was there. The coroner thought Thom had died in the night. Pinto called for help at eleven that morning.

Ken added that Thom had been drinking heavily and Amy said he'd had some Valium.

"Oh my God, this is awful." I was so shocked. "How are you handling it?" Ken said that at least Thom was in a better place now.

I couldn't believe it. The Thom I knew, the boisterous Thom, the full-of-life Thom, came vividly to my mind. I asked Ken where Amy was. Ken told me that Amy was staying in the house. He couldn't reach Nanette, who was in Australia. He also told me Amy had said she had a new will that Thom had written by hand that she would produce at a later time.

Ken asked me if I'd ever heard of Thom taking Valium, and I said I'd only heard Thom speak proudly of how he never took any pills. Ken was distraught about having to tell Nanette and expressed his regret that, despite trying for all those years, he wasn't able to save him.

"It's shocking and sad. The whole thing. I'm so sorry," I said.

In a broken voice, Ken said Thom had been his best friend.

"Keep me posted. Tell me if you need anything. Tell me how I can help," I said.

I hung up, and felt helpless. It was hard to feel anything else. The shock was too great. I still couldn't fathom the whole thing. But somewhere inside, lying just beneath the shock, was a feeling slowly waking in me. There was a first tinge of relief and closure. For how many years had we watched Thom drink to the point of being suicidal? The stories of Portofino, the hospital paralysis. He had been on a mission his whole life. Only recently it seemed that mission was to kill himself slowly.

Most of all I felt an empathic pang of the pain I knew he must have been in. He had loved life so much, and he loved what he did. He never complained about anything, always projected a positive attitude, and saw the good in everything. Losing his family had been the worst thing that could happen to Thom.

There was much wrong with Thom's life in those last few years in which I hardly saw him. The rapid demise of the company must have hurt him deeply, to see all those dreams fizzle and slowly take everything he had. His alcoholism was so severe it affected his body, and his mind. How could he feel anything but bad about himself? But most of all, I know he was suffering deeply from his estrangement from his family. He couldn't handle shame. Shame kept him from dealing with his problems. Shame kept him away from his friends, because he didn't want them to see what he had become. Shame kept him from reaching out and embracing his family when they tried to save him from himself. It was heartbreaking. I understood that a part of him had to want to die. There was nothing else left for him. Once he lost his family, he was no longer the Painter of Light.

❖

A week after Thom's death, Nanette and the girls had returned to California and begun their grieving process. The girls had been es-

tranged from their father for over a year. At their ages, twenty-four, twenty-one, seventeen, and fifteen, they were old enough to understand the complexity of his problems and the circumstances of his untimely death. But it was still a shock. After all, he had only been fifty-four years old. And they would miss their father, who had made things so magical for them, terribly.

A funeral was held five days after his death. Ken and Linda, and Nanette and the girls attended, with close friends and family. Thom's sister, Kate, his mother, Mary Ann, his brother, Patrick, were all present to bury their brother and son. And Ken banned Amy Pinto from attending.

Days later, NBC news reported that the Kinkade Family Trust had obtained a restraining order against Amy Pinto for violating a confidentiality agreement she had signed when she first became involved with Thom. The news reports stated that Amy would not leave the house and ignored requests that she pay $12,500 a month in rent.

Amy Pinto then revealed the two handwritten wills, which she said Thom had written in the last months before his death. The wills were controversial because they were barely legible, written in a messy and shaky handwriting. They stated that Thom was leaving the main house, the studio, and $10 million to Amy, and that she should open a museum in his name and assume possession of the contents of the main house, which included nearly $100 million worth of art. After Thom's death, no one knew what the value of the property and the paintings might end up being; it was anyone's guess, and it was worth fighting for.

The battle over the estate went to court on June 12, 2012. During the hearing, the *San Jose Mercury News* reported that, "Pinto-Walsh clutched a heavy silver pendant in the form of what appeared to be a dragon. After the hearing, she declined a request for an interview and wouldn't explain the symbolism of the pendant. But Pinto-Walsh, who is of Indian descent and raised in Kuwait, held the dragon in front of her throughout the hearing, as though it had special spiritual or sentimental value."

The two handwritten wills were disclosed in the courtroom and showed none of Thom's manual dexterity. If there was one thing Thom could do until the end, it was paint. The handwritten wills were scrawled almost illegibly. One will read: "I Thomas Kinkade, hereby bequeath to Amy Pinto-Walsh $10,000,000 in cash from my corporate policy and I give her the house at 16324 and 16342 Ridgecrest Avenue for her security." The other specified that Amy Pinto-Walsh should be given another $10 million from the policy to establish the "Thomas Kinkade Museum" at the house, and also gave her administrative control over the estate's invested assets of over $66 million. In court Amy stated that Thom had loved her; that they planned to marry in Fiji, and had been shopping for an engagement ring.

Meanwhile Nanette, who had been married to Thom for over thirty years and borne him four daughters, produced the will (actually their living trust) she and Thom had written up in the year 2000, in which he set out the terms of how his assets would be distributed among Nanette and the children.

By this time, the coroner's report had determined that Thom died of a combination of a "lethal level of alcohol" and Valium.

Twenty-four-hour guards were stationed inside the gates of the Monte Sereno house to protect the furniture, paintings, and other valuables while Amy Pinto was living in the house. Four months after Thom's death, and months into the court hearings, Amy still refused to move out. Daniel Casas, the lawyer for Nanette, spoke to the press and said Amy was holding the estate "hostage." Nanette had to endure Amy's living in the home in which her children were born and in which she raised her family for nearly twenty years. Meanwhile, Nanette's daughters didn't even have access to some of their belongings.

Amy Pinto finally paid $11,000 monthly in rent and remained ensconced in the home. The battle over the estate raged on for eight months, Amy and Nanette landing in court numerous times until finally on December 19, 2012, the two came to a settlement, rumored to be in the eight figures. For months, Amy had stated in the papers that she would clear her name of accusations of being a gold digger, and

show herself to have been Thom's soul mate. Before she could, she accepted a deal in the settlement of the estate.

Nanette and Amy issued a statement: "Putting Mr. Kinkade's message of love, spirituality, and optimism at the forefront, the parties are pleased that they have honored Mr. Kinkade by resolving their differences amicably." Nanette paid a high price once again to be able to return to her life and ensure security for her daughters.

The three nobodies were now only one. With Rick gone from the company, Ken was the sole survivor. He had experienced staggering success, endured being removed from his own company, and felt the trauma of the death of his best buddy. He was still standing in the end, as the one who actually made it.

I've thought about my time with Thomas Kinkade many times since his passing. I've wondered how things could have gone so wrong. I've wondered how a Christian company could have fought the people who were their lifeblood with such vehemence, so as to contradict their own purported mission statement to do good in the world, and to spread the light of God. I've wondered whether it all cost Thomas Kinkade his life, and if anyone saw the irony in the fact that he realized his worst fear in the end: he died penniless, his life mortgaged to the hilt, and his assets tied up in real estate.

I can only imagine the personal toll that year took on Nanette. Battling Thom's mistress, who occupied the family home, keeping her and the girls away, must have been a living nightmare for her. When did she have a chance to grieve?

The cost of Thom's sickness was ultimately astronomical. It took away a father from his daughters, and ended a genuinely special marriage of thirty years. The Tom Sawyer and Becky Thatcher from Placerville were torn apart.

The disease took away a friend from all of us who knew and loved him, and cost a beloved painter to the many fans who believed in him and stood by him through it all. The disease took away a special light that shone on this planet, a light of hope and love and peace.

Most of all, Thom's sickness cost him his life.

Thomas Kinkade was an artist, a true artist in every sense. He devoted his entire life to his craft. From the boy who could draw, to the man who spent hundreds of hours painting a single masterful work, he had a vision for what his art meant in the world, and what he was expressing with it from deep inside himself. There was no choice for Thom but to be an artist. He was put on this earth for one purpose, and he knew it.

I spent sixteen years in friendship with Thom. I sat for hours and hours listening to him talk about his life and his art. I can say that he was deeply genuine in his desire to serve God by his gift, and to be a messenger of hope and comfort for people who looked at and enjoyed his art. There was nothing cynical about it. It came from a deep well inside him, a deep, sincere need. Perhaps it was his own need for hope and comfort. Perhaps his early life struggles, when his own young world was always on the brink of survival, made him so deeply aware of the need to feel safe and secure.

His enthusiasm for life was unmatched. There is no one I know who takes in life with as much passion and open-hearted joy as he did. Sometimes we call people who live closer to the spiritual reality of life "crazy." But for Thom, life was a spiritual experience. We've been trained to believe that anything religious or spiritual takes place inside the defining walls of a church, or in a contemplative, or silent, or serious mode. Thom got up every day and threw the shutters open wide, and opened his arms to the world. He took in the glory of nature, which he saw as synonymous with the glory of God. He saw God in the world around him, and he never took it for granted. He was truly a joyful man, and he wanted to impart some of that spiritual sense of the world to the people who saw his images. At his core, Thom was a man who served God in the best way he knew how, with the gifts given to him.

Perhaps there was a part of Thom that knew he had to die in order to take care of his family, when his mortal shell couldn't do it any-

more. Was it poetic justice or God's grace that the love of Thom's life, Nanette, inherited the real estate, the company, the original paintings, and the benefits of a life insurance policy the company had taken out on Thom, reputed to be valued at $60 million.

Thom had to die to become the artist whose legacy would live on, separating the person and his personal habits from the work itself. Now the work can stand alone. Now the work remains in the world, with only its pure meaning and its intentions.

I separate the business of Thomas Kinkade from the work of Thomas Kinkade. He wasn't a businessman in any way, and he didn't understand much of what the business was doing. This is not to say that he wasn't responsible for what happened to the people who invested in his art and his galleries. He was responsible and culpable by default, and by his own weakness and avoidance. He wanted to see the good, but he ignored the bad. He wanted to live in the light, but the shadow followed him. The story of the man ended tragically, but the story of his legacy is triumphant. Thom's light will forever be in the world.

Since his passing I have missed my friend, and I miss him to this day. I know that his suffering has ended, and in a sad way, I feel good about that.

Nanette now carries on his work, and Ken is once again involved in the Thomas Kinkade business. Which waters Rick Barnett is sailing these days, I don't know, but surely he must have felt regret when Thom died.

Since my time with Thom, I've continued my branding business and continue to license products, and I have been lucky enough to be around to watch my children grow up. But there isn't a day that I don't think about, or am somehow reminded of, my friend Thomas Kinkade, the most colorful and talented person I have ever known.

Acknowledgments

We would like to acknowledge many people who helped in the process of bringing this amazing story to life. Most of all we would like to thank our families for bearing with us through months and months of phone calls, conversations, writing, and the painstaking editing process to make sure that memories were checked and details were confirmed over and over again. We would especially like to acknowledge Lacy Lalene Lynch and Jan Miller from Dupree Miller agency for believing in this project and helping us steer this large, and sometimes unwieldy, ship into port. Thank you Georgina Levitt and Amanda Murray from Weinstein Books for helping us manage the process of funneling a massive amount of information into a consumable story. Special thanks to our editor Leslie Wells, and Kevin Leichter. And lastly, thank you to all of the people whom we interviewed over the past two years, and who shared their stories and their memories with us about Thomas Kinkade, who will not be named here, but to whom we are extremely grateful for their contributions.

Index